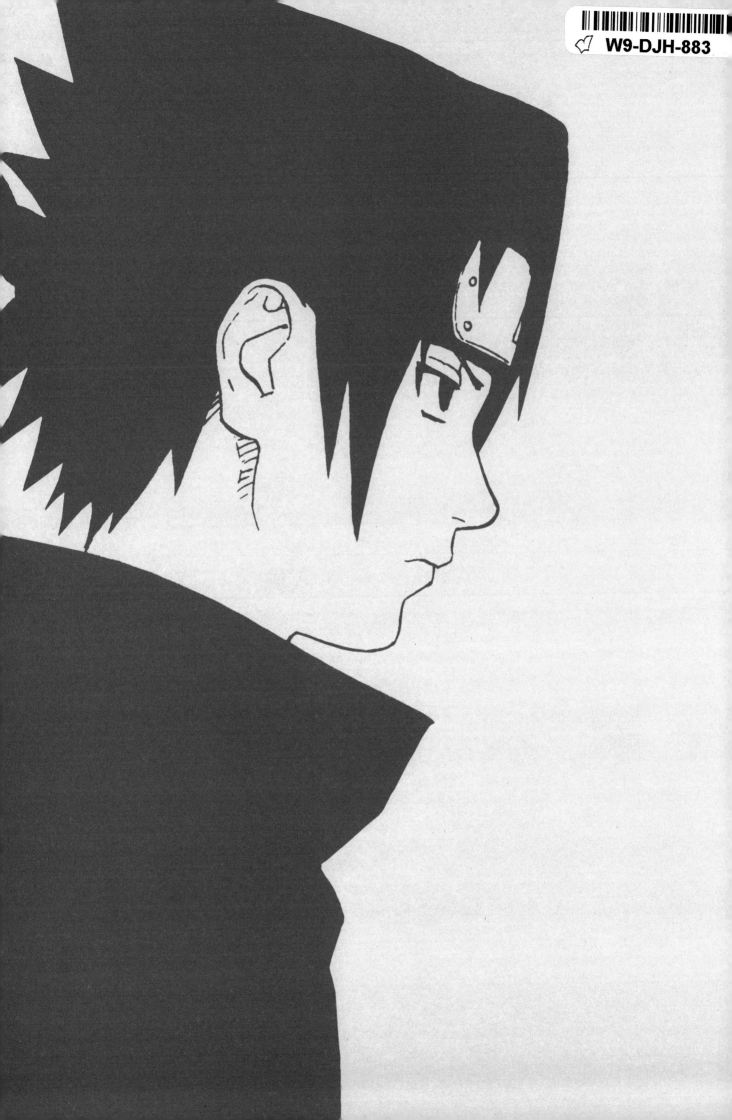

渦 うず

岸本斉史 画集
きしもとまさし

UZUMAKI
by MASASHI KISHIMOTO

The Art of 巻
NARUTO

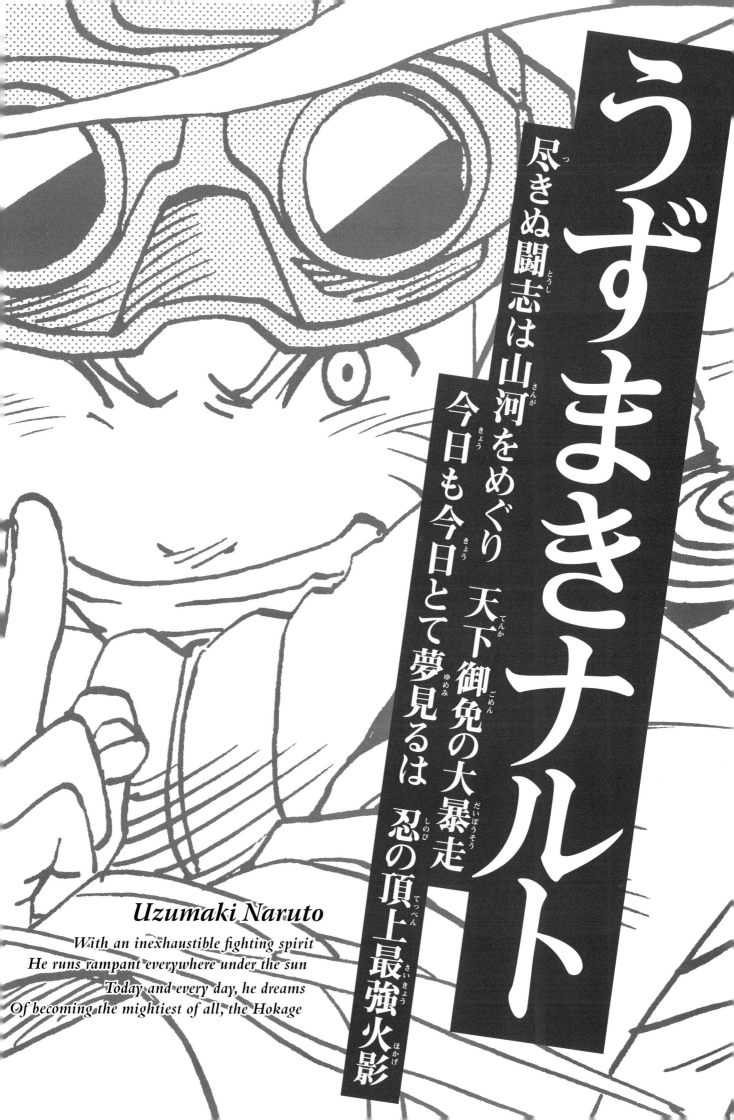

うずまきナルト

尽きぬ闘志は山河をめぐり
今日も今日とて夢見るは
天下御免の大暴走
忍の頂上最強火影

Uzumaki Naruto

With an inexhaustible fighting spirit
He runs rampant everywhere under the sun
Today and every day, he dreams
Of becoming the mightiest of all, the Hokage

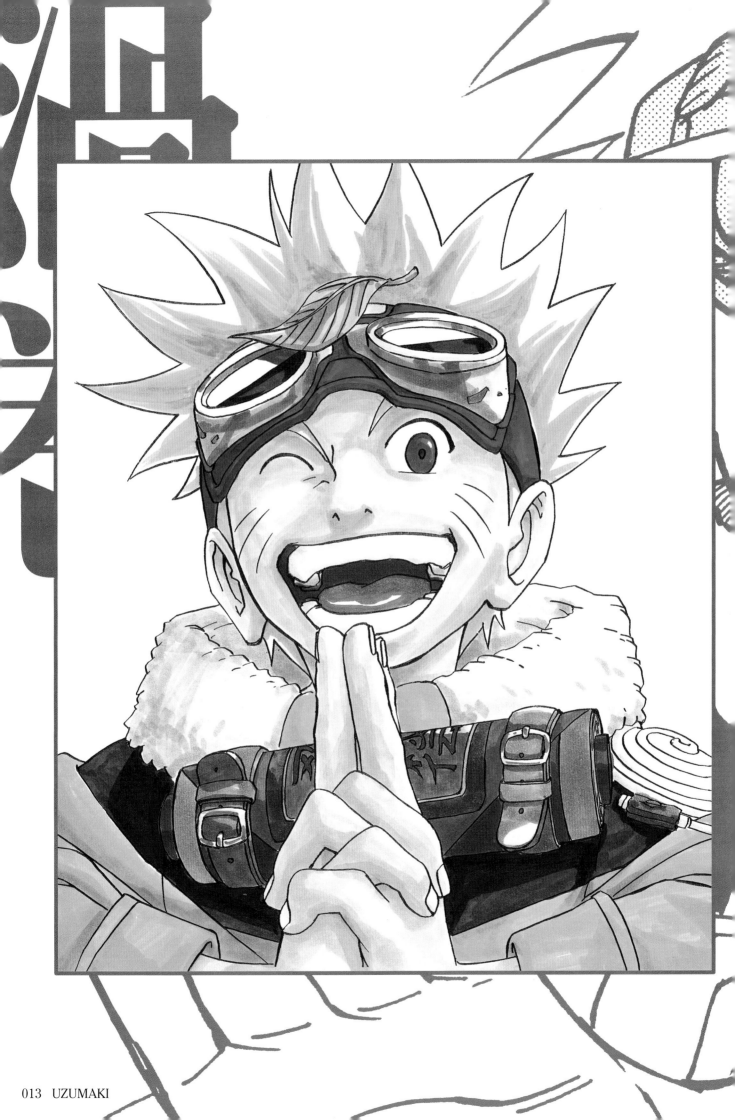

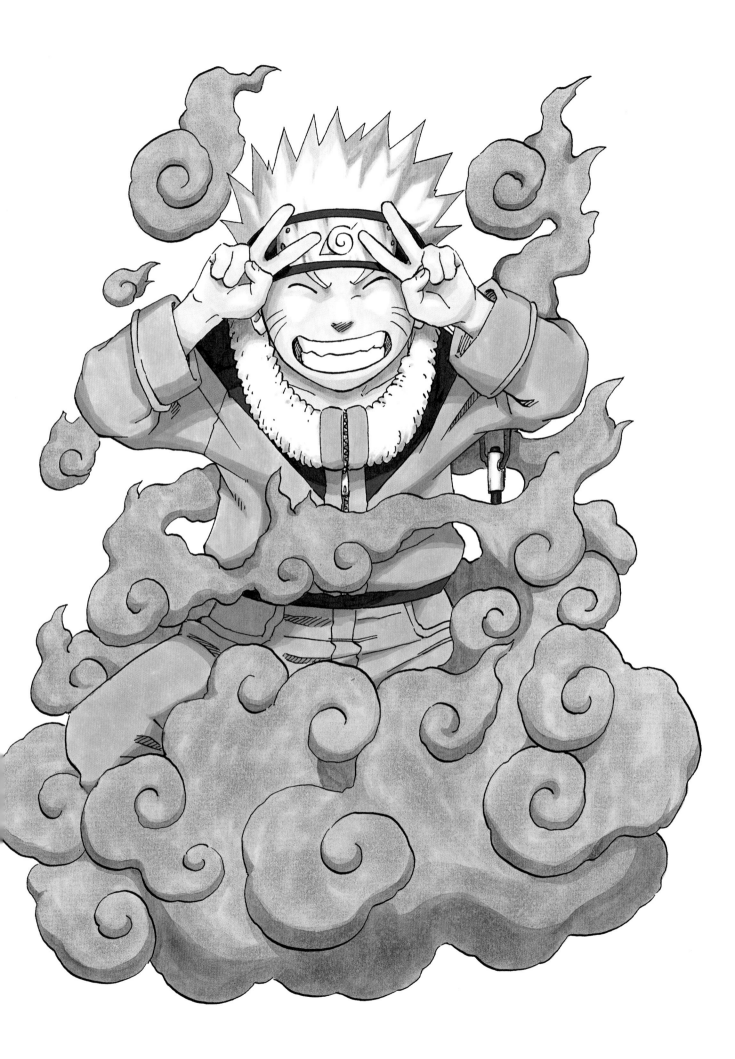

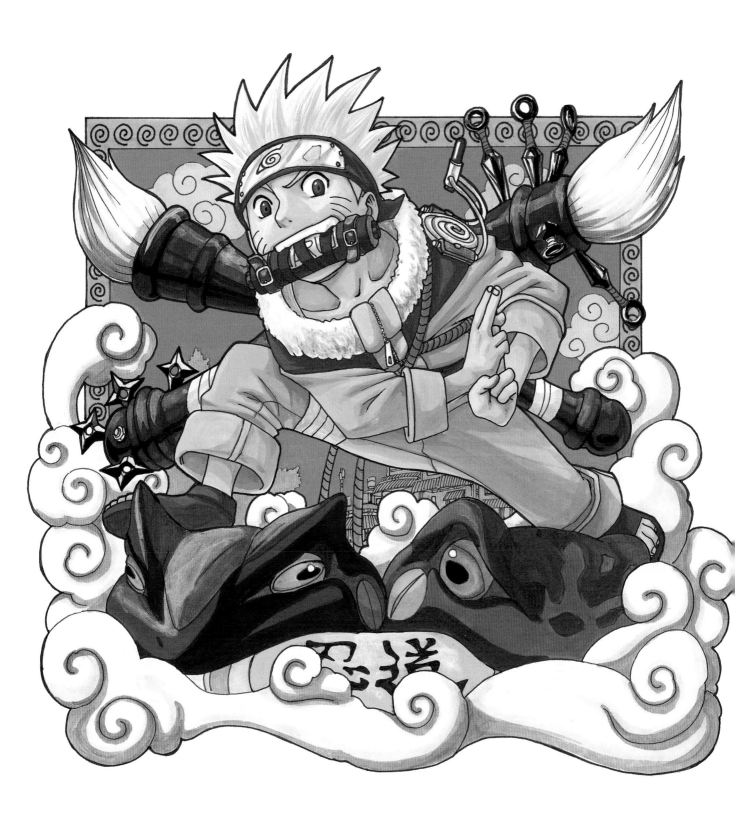

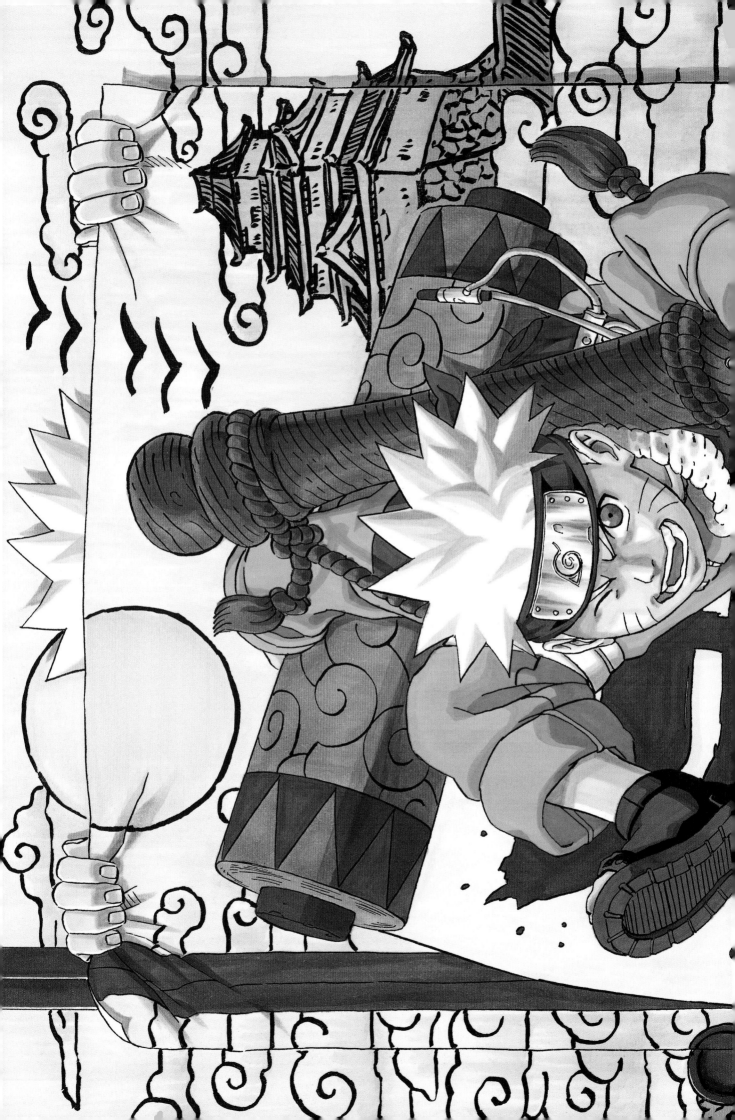

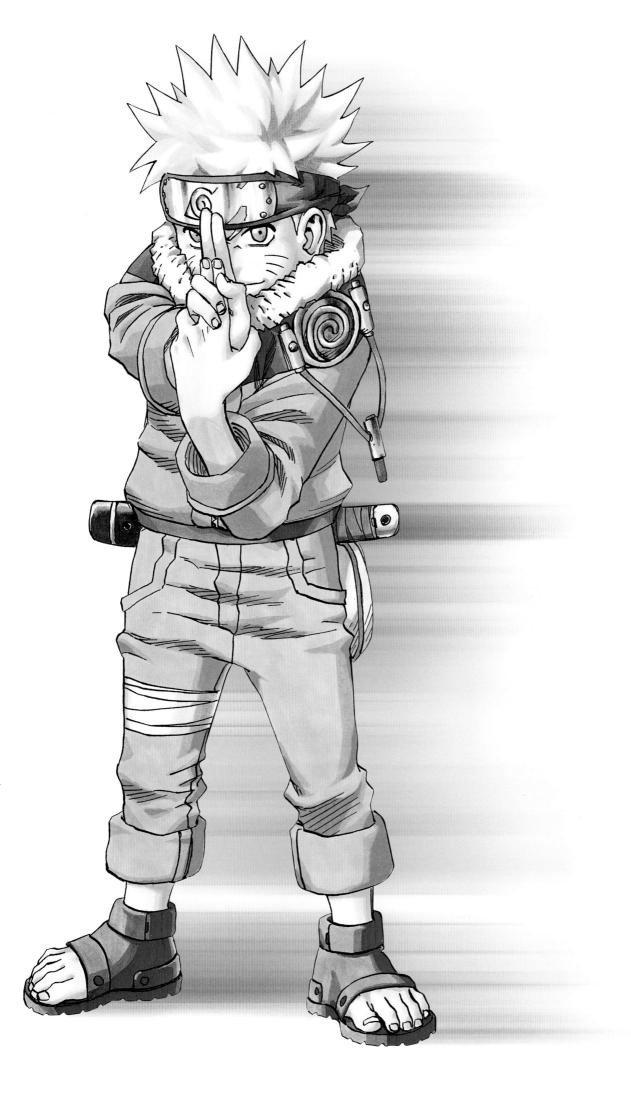

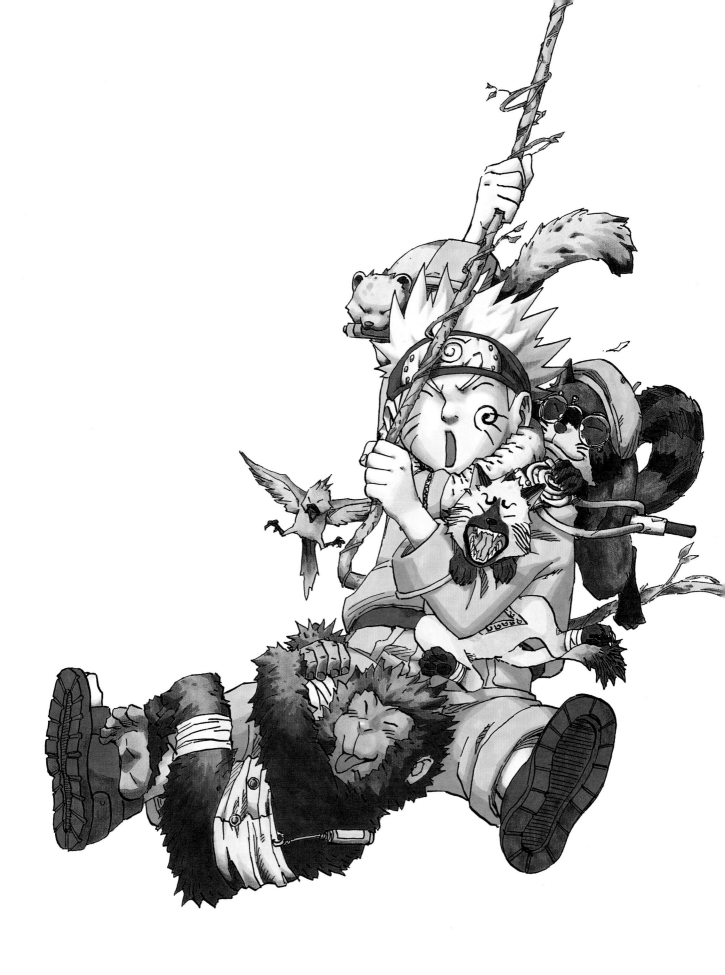

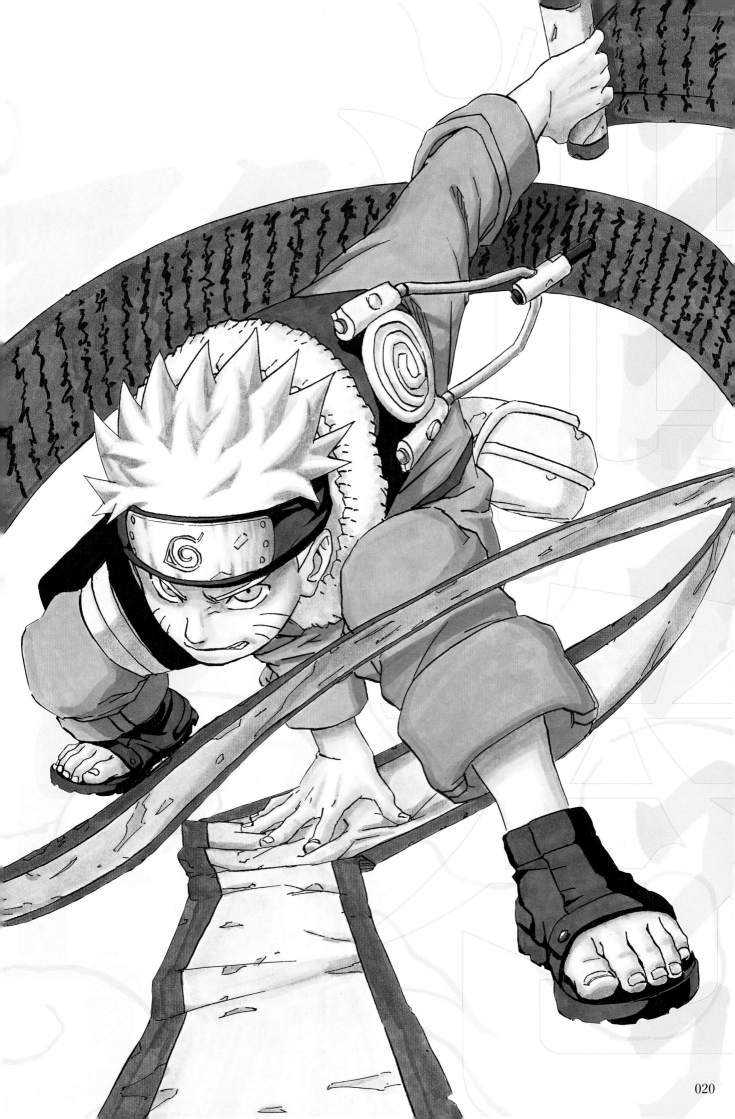

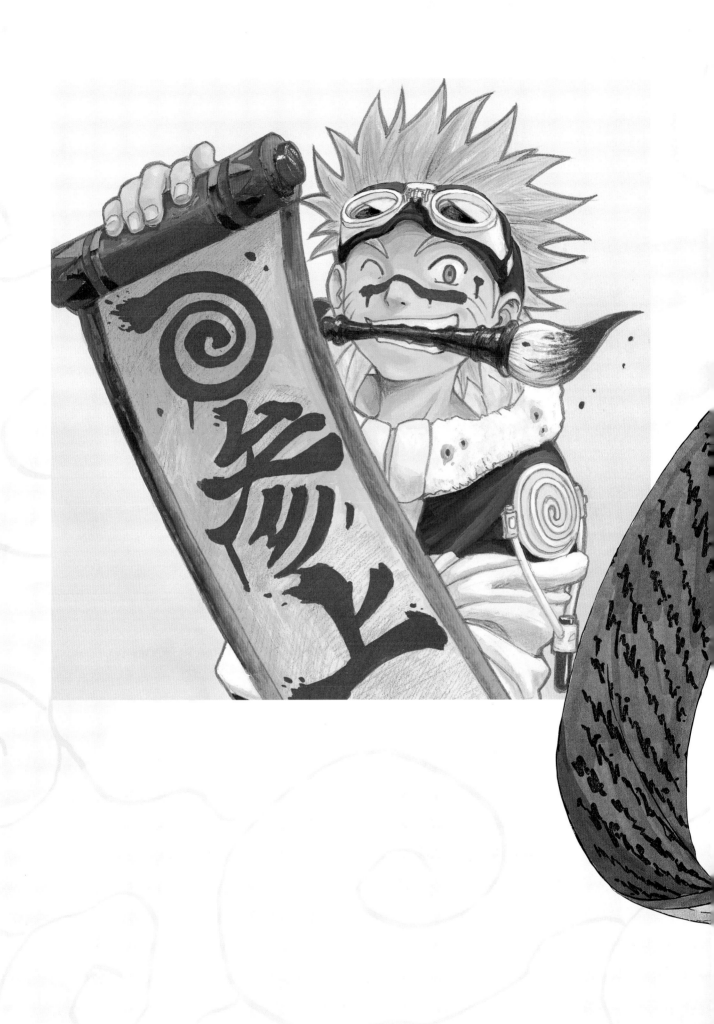

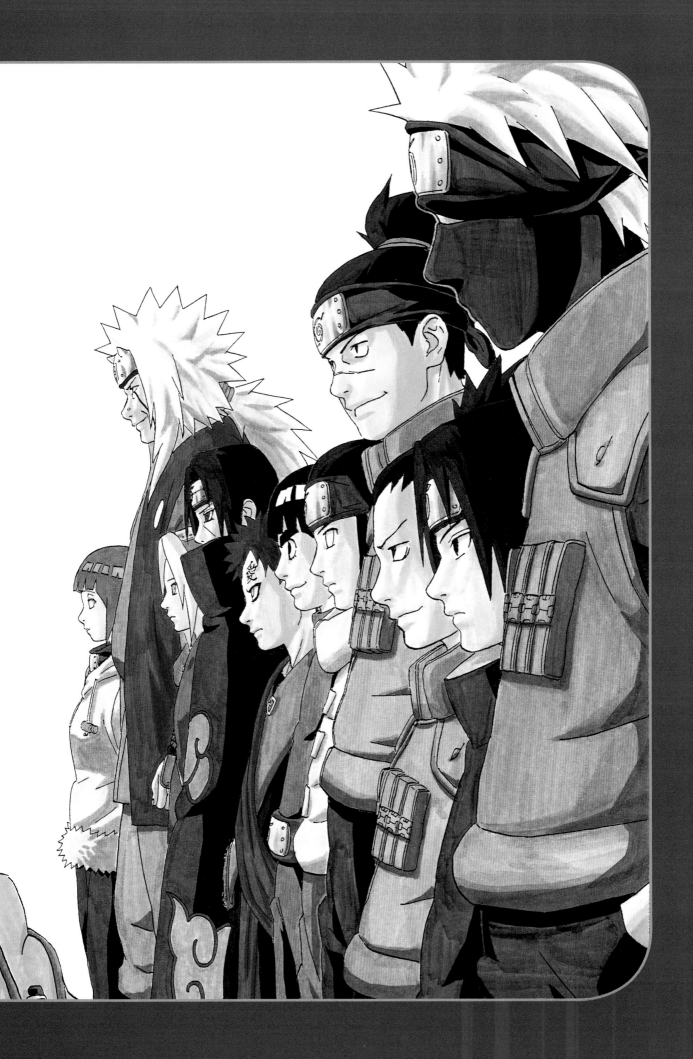

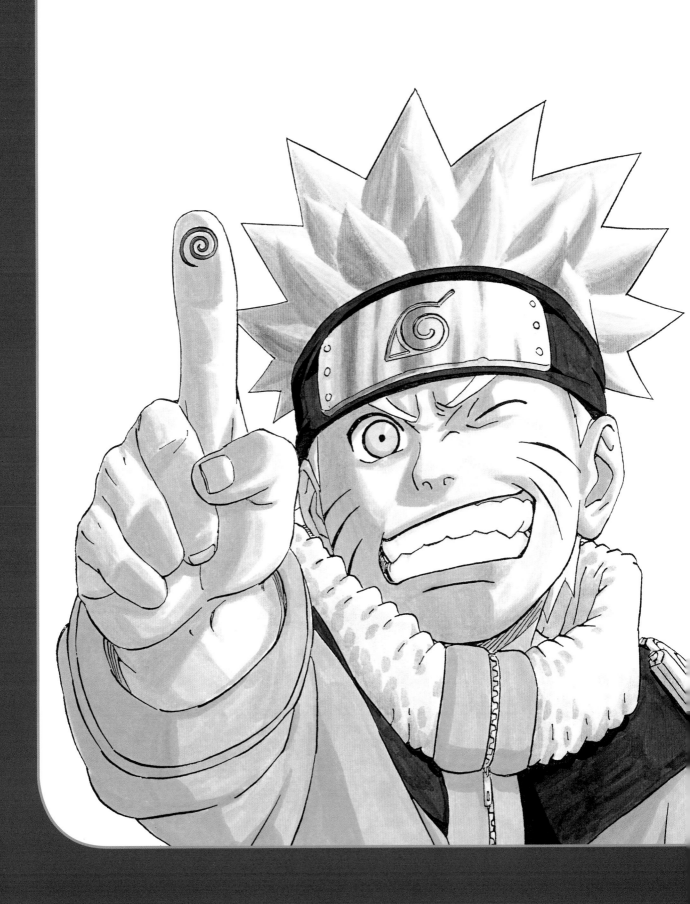

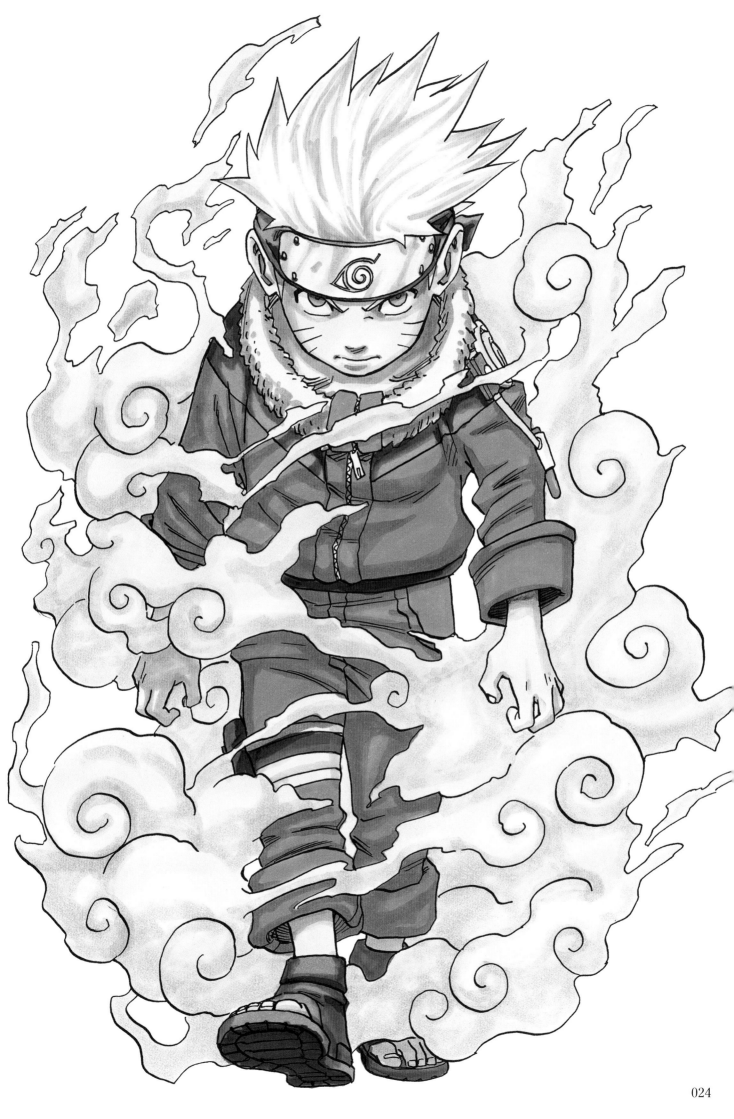

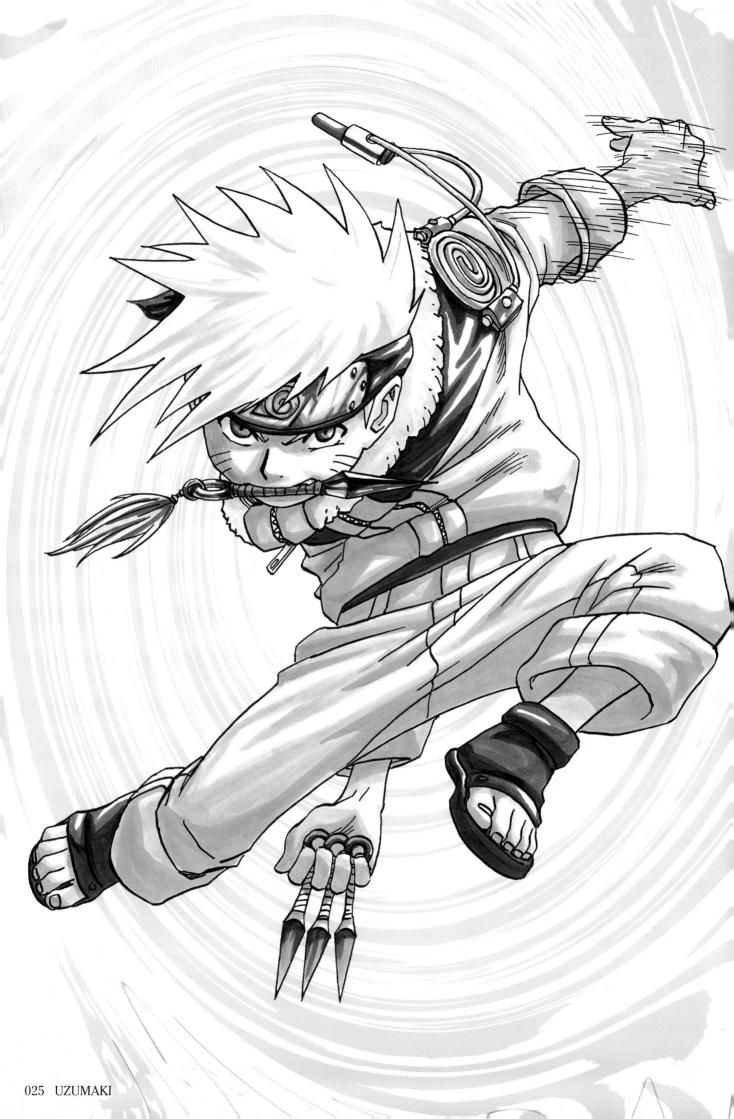

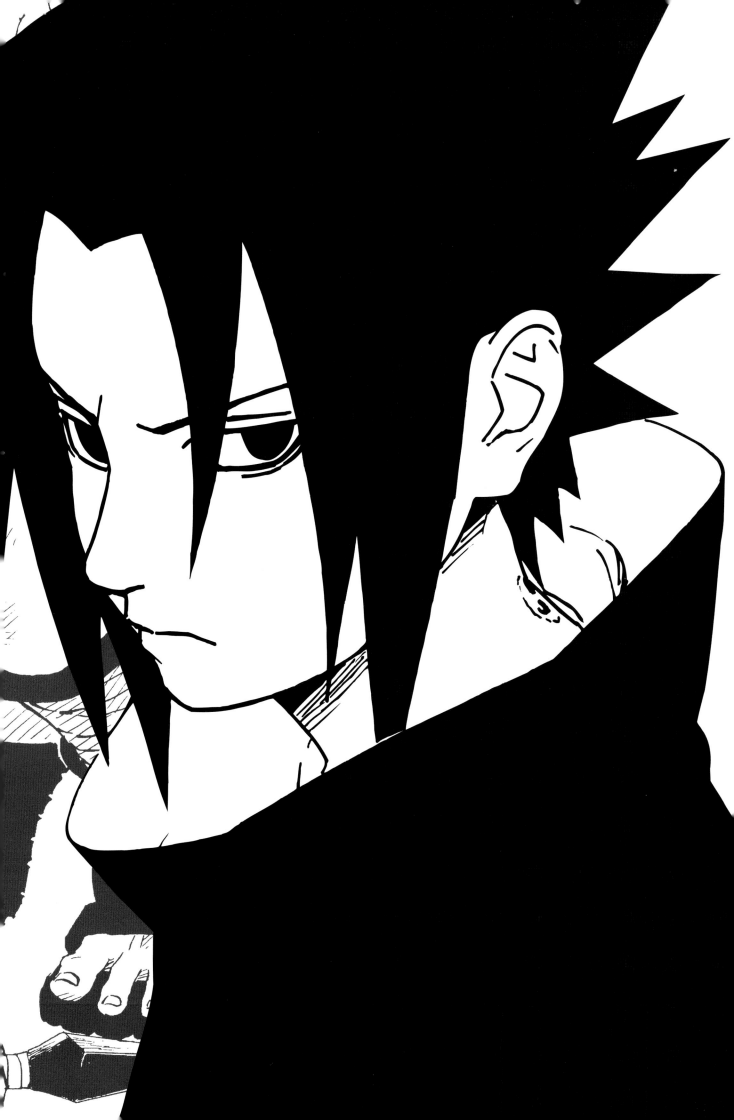

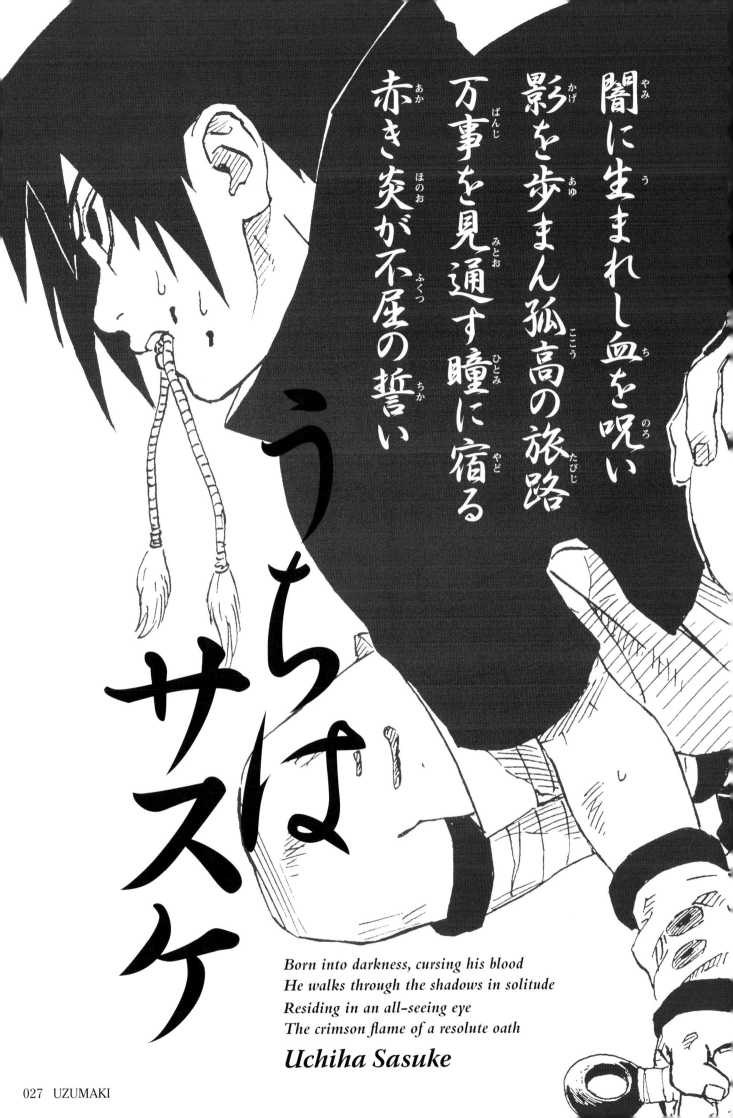

闇に生まれし血を呪い
影を歩まん孤高の旅路
万事を見通す瞳に宿る
赤き炎が不屈の誓い

うちはサスケ

Born into darkness, cursing his blood
He walks through the shadows in solitude
Residing in an all-seeing eye
The crimson flame of a resolute oath
Uchiha Sasuke

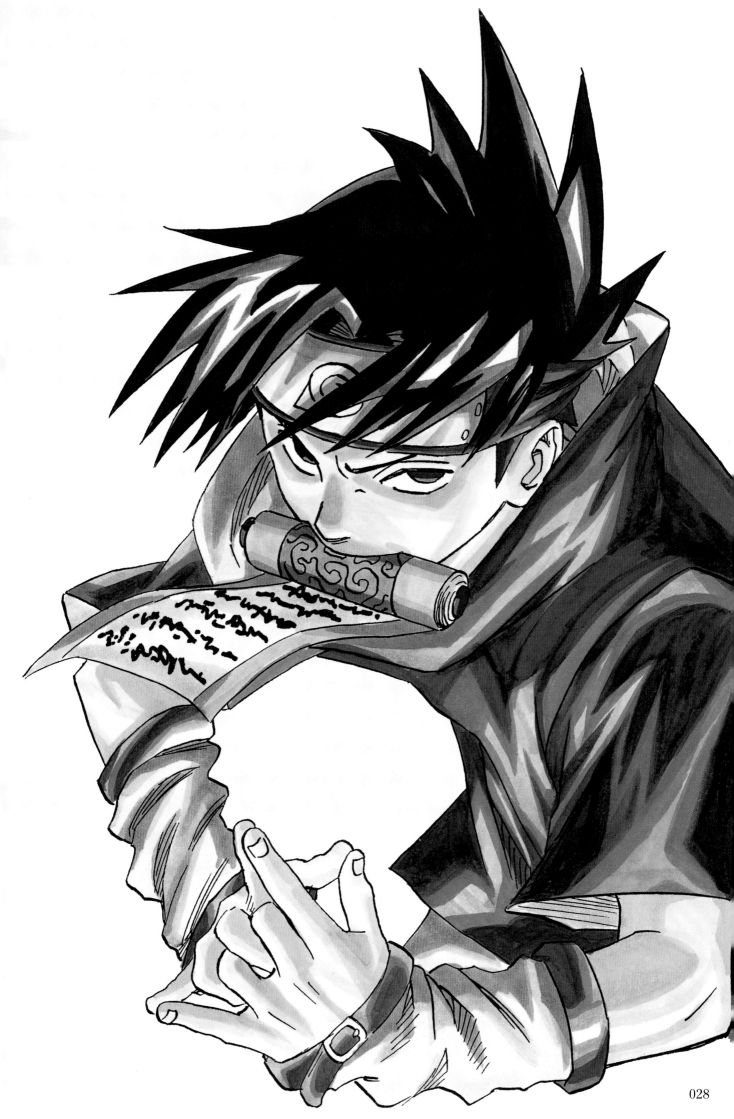

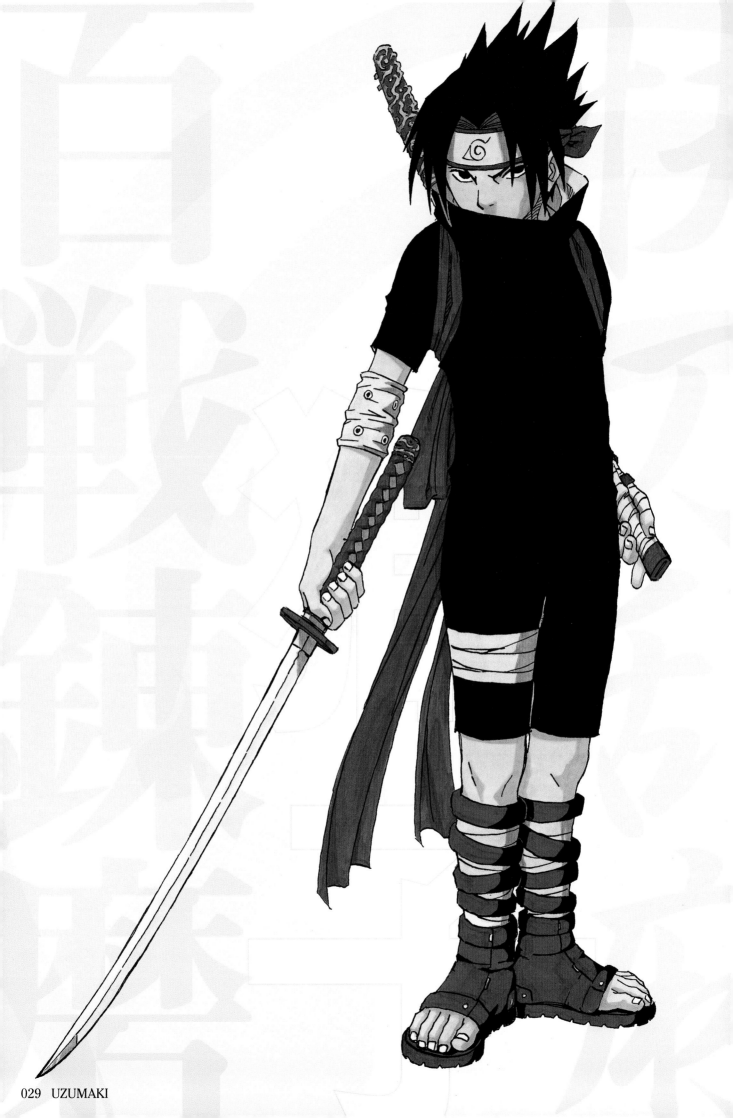

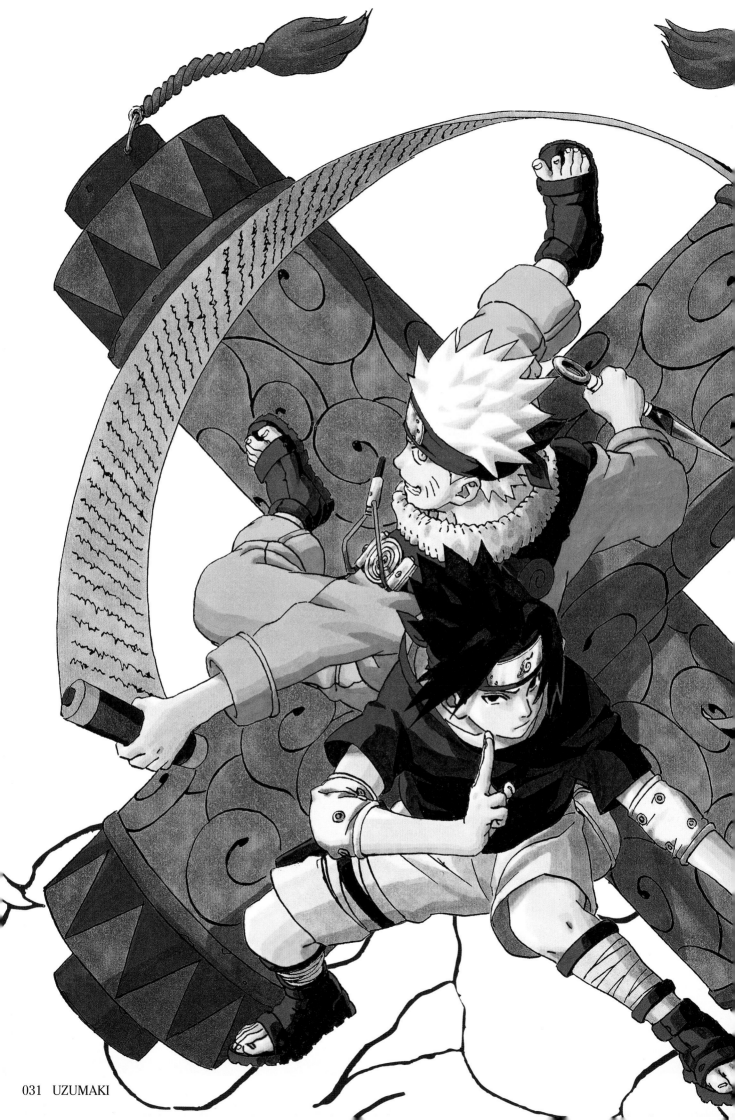

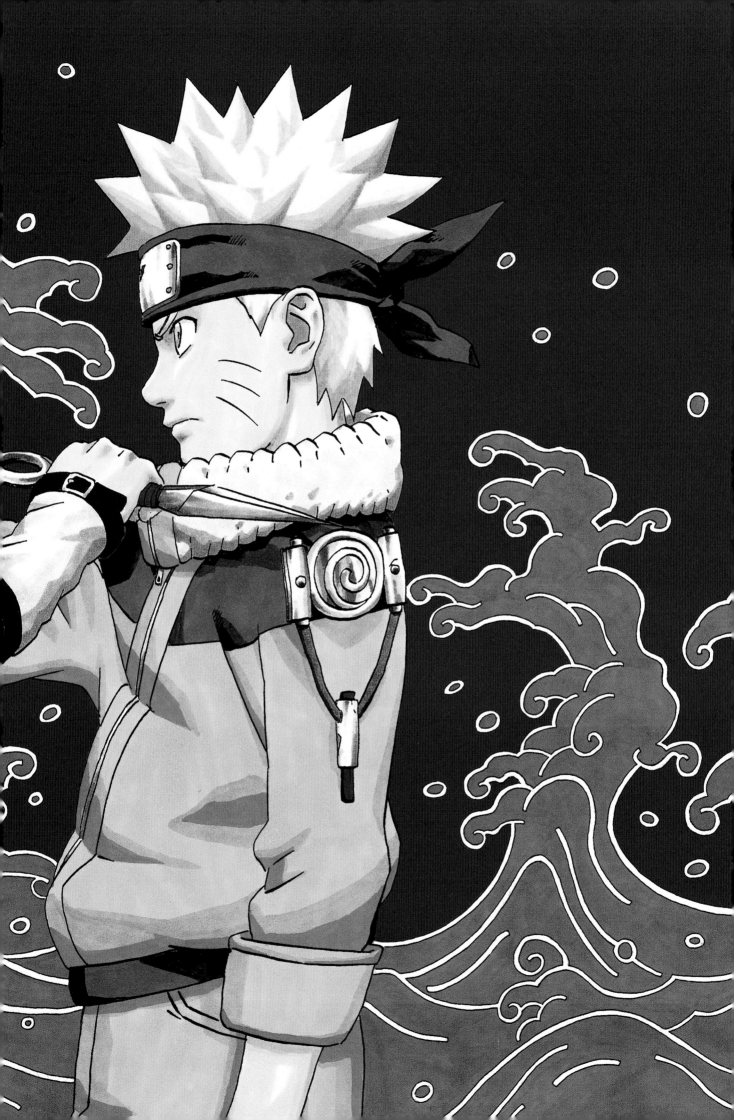

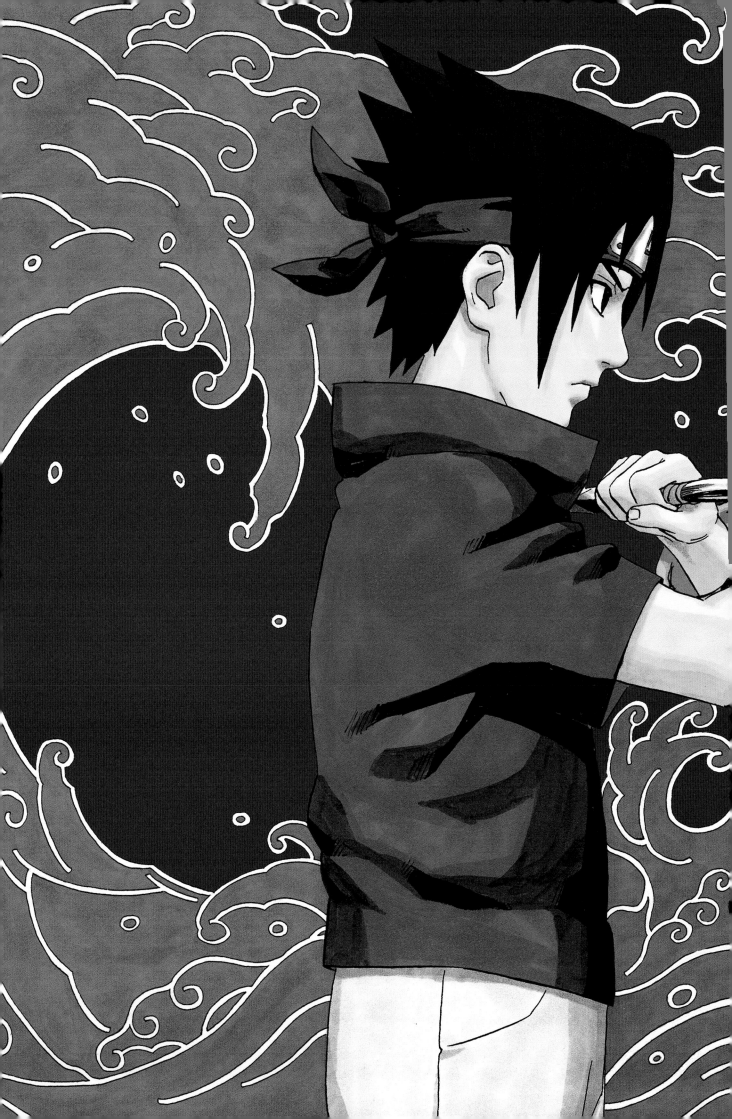

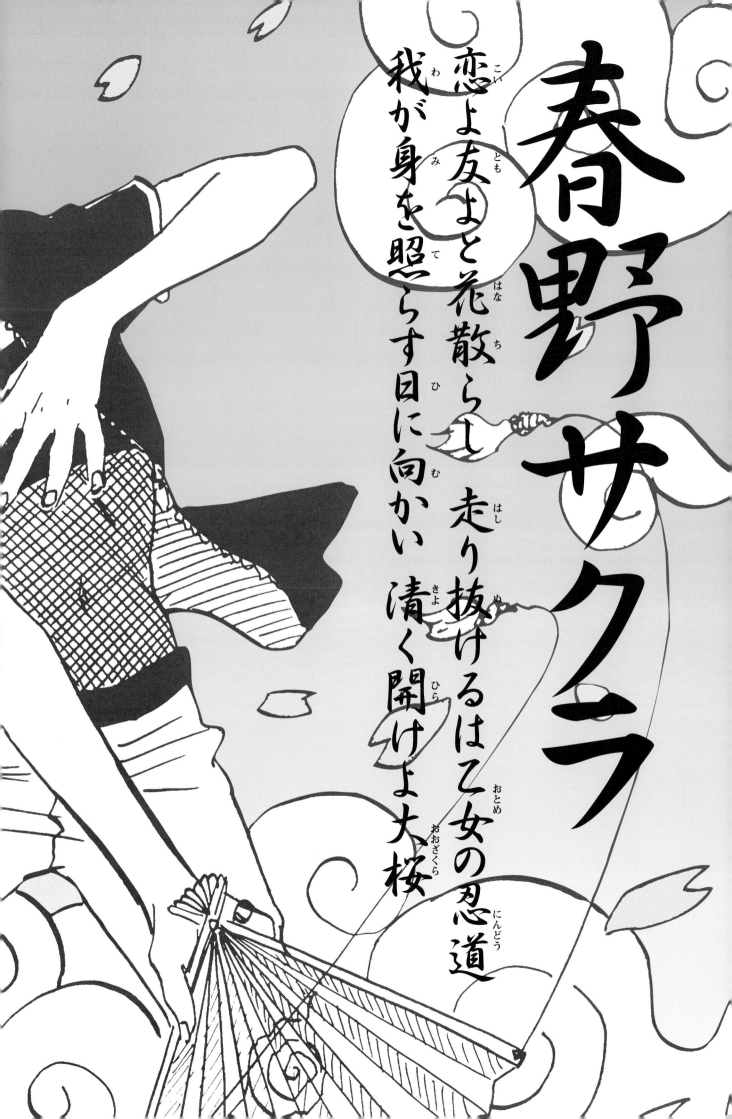

春野サクラ

恋よ友よと花散らし　走り抜けるは乙女の忍道

我が身を照らす日に向かい　清く開けよ大桜

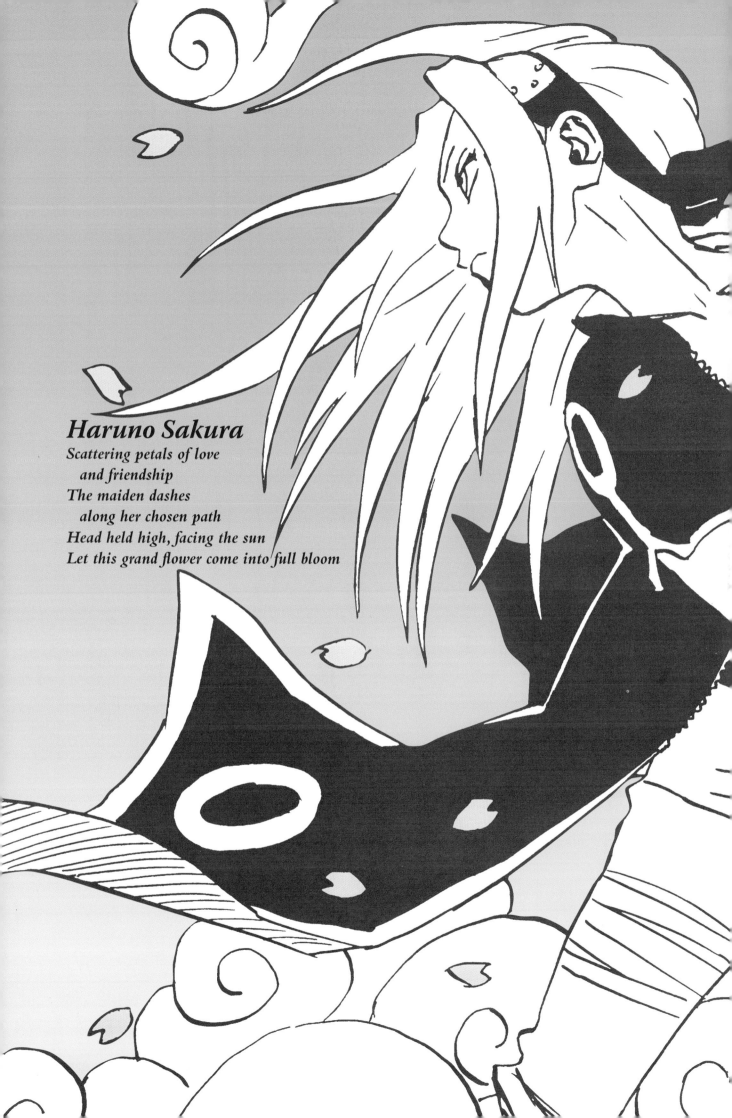

Haruno Sakura

*Scattering petals of love
and friendship
The maiden dashes
along her chosen path
Head held high, facing the sun
Let this grand flower come into full bloom*

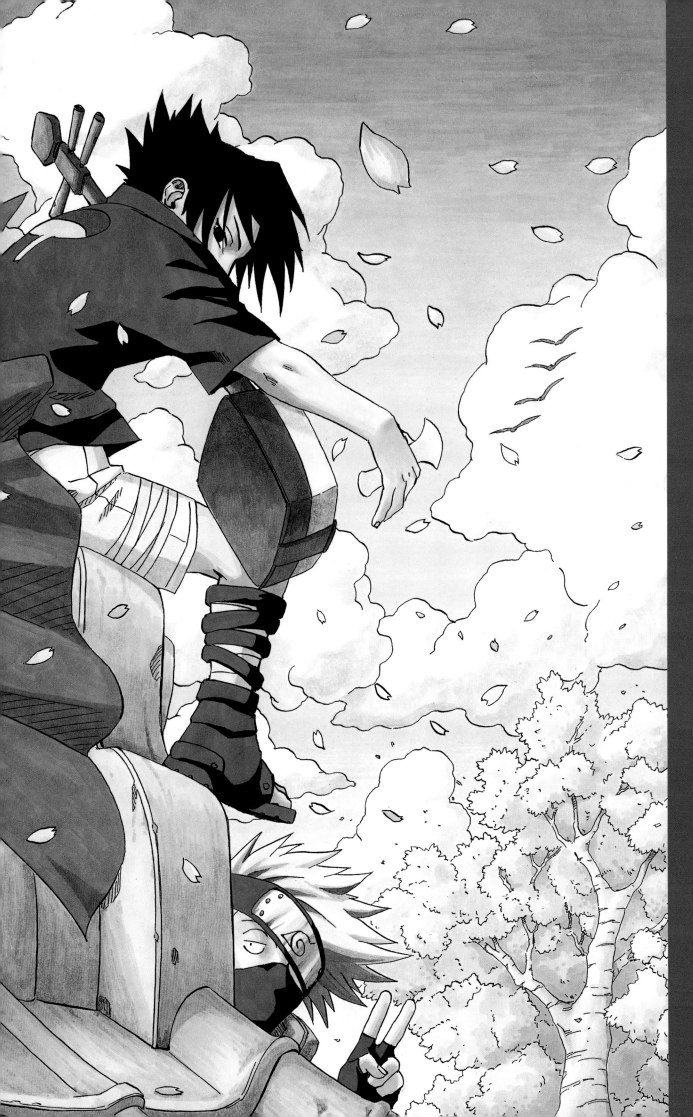

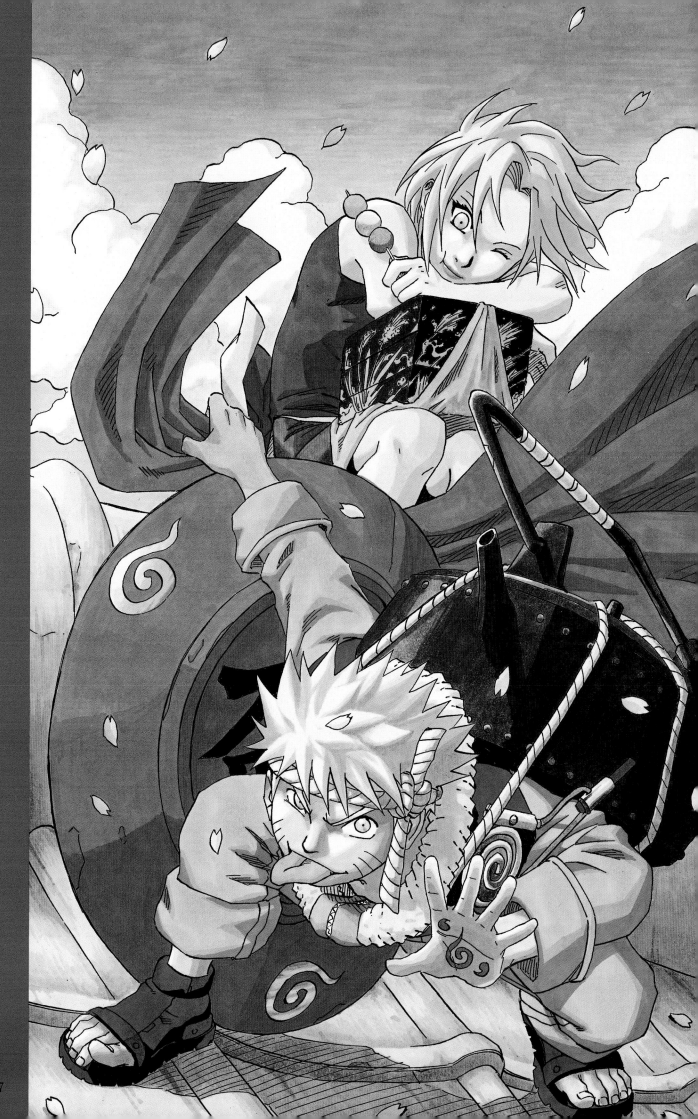

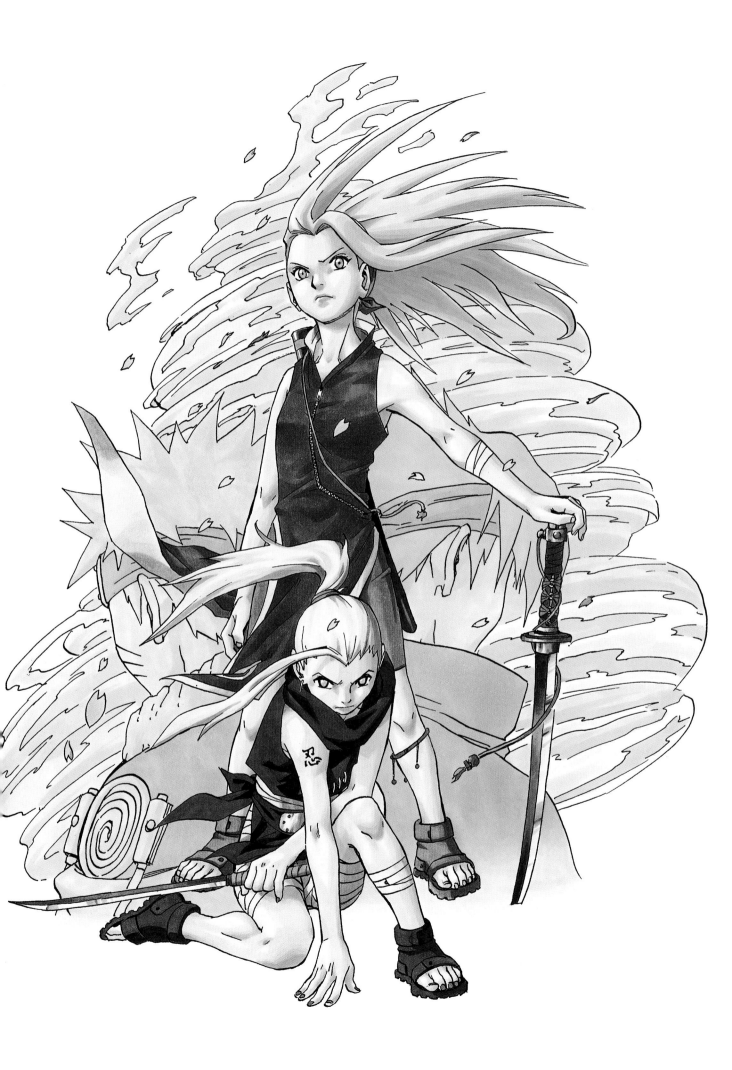

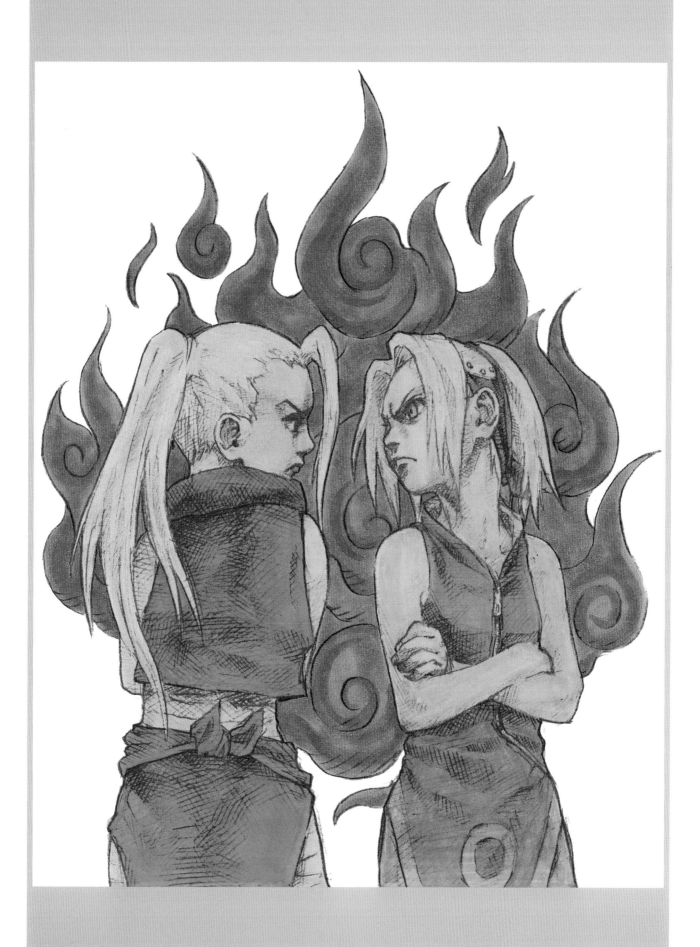

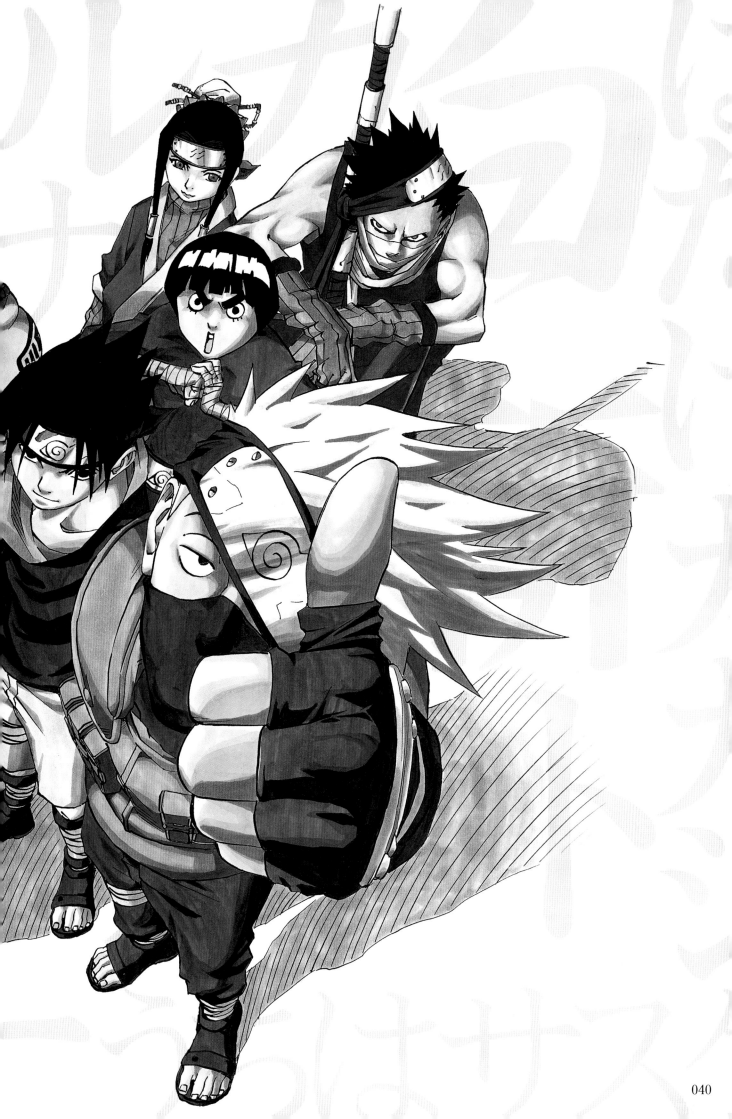

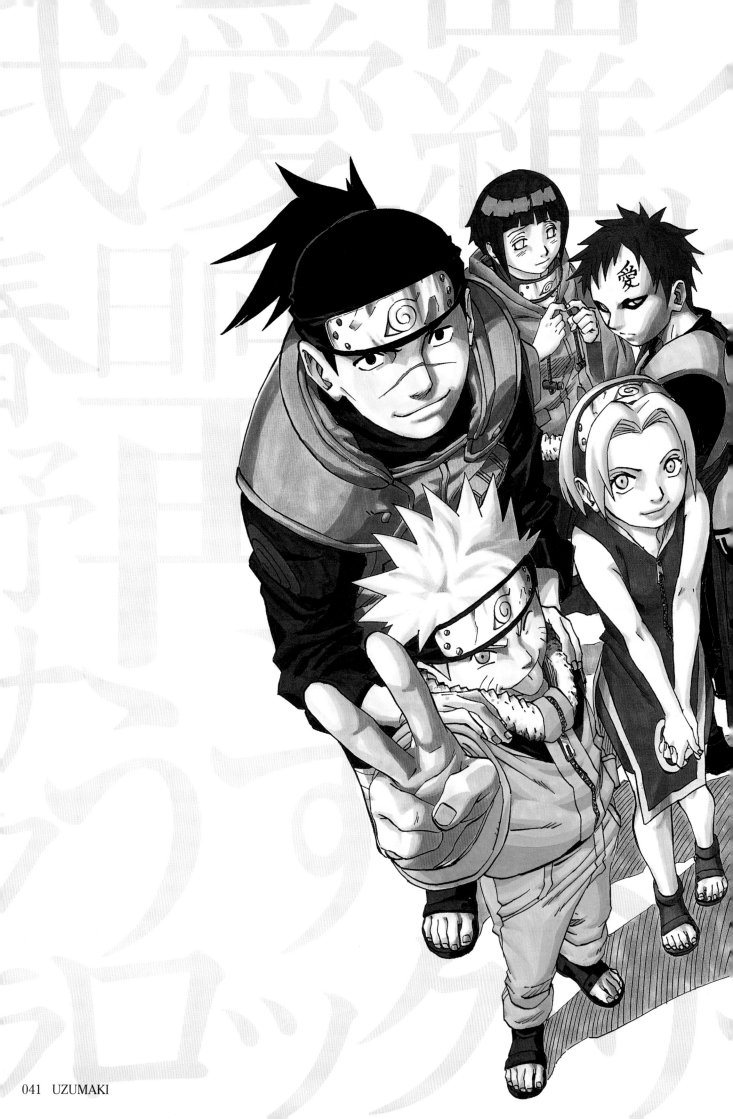

本ノ葉隠れの里

The Village of
Konohagakure
Cell 7

*Slashing their way
through light and shadow
Four shinobi stake
their lives on a mission
Living for today,
never thinking of tomorrow
Single-minded,
they forge ahead!*

第七班

光と影を斬り裂いて

任務に身を賭す四人が忍

明日をも知れない今日を生き

ただひたすらに突き進む！

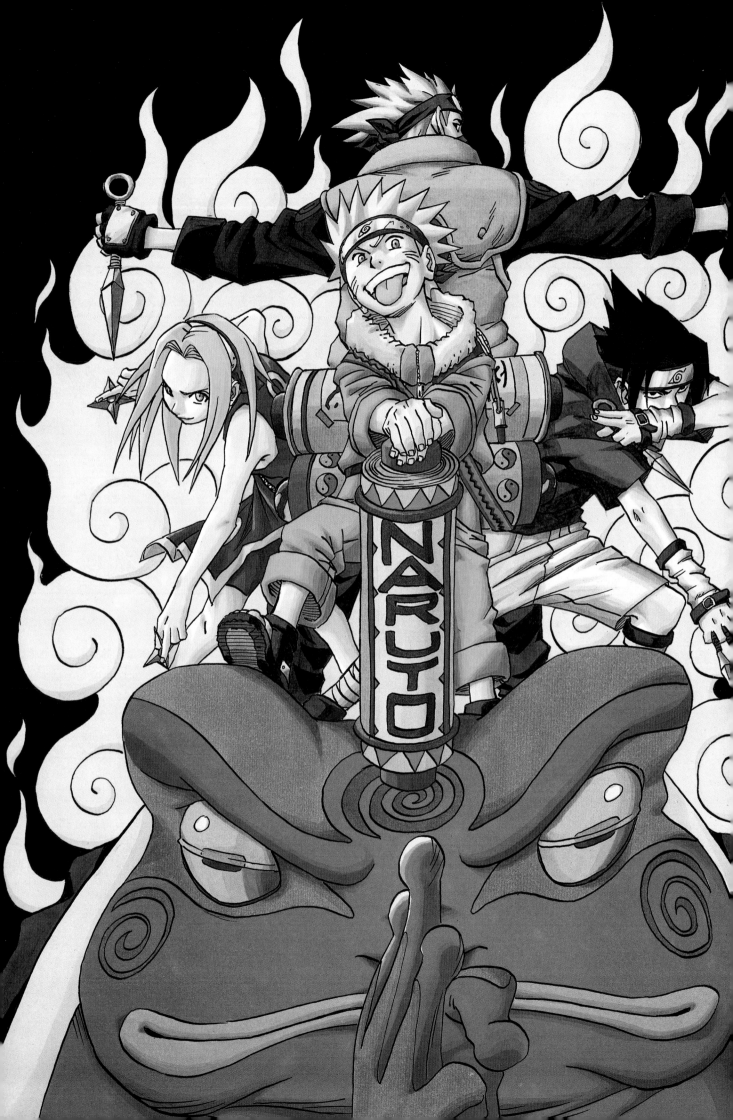

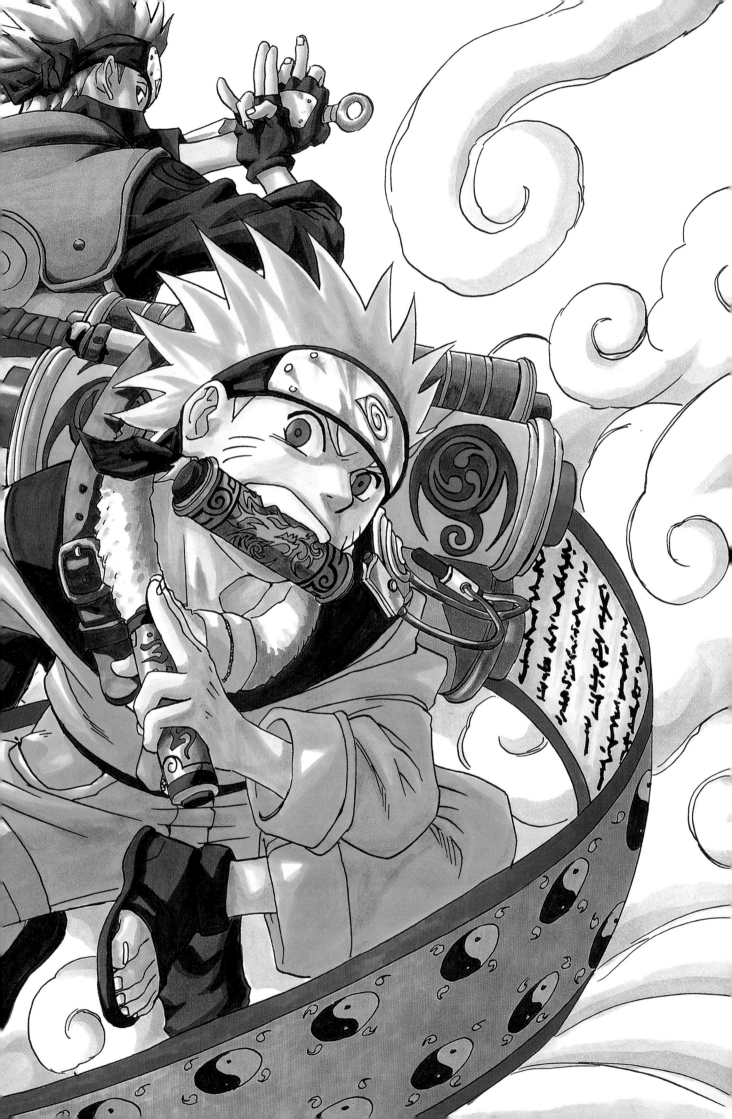

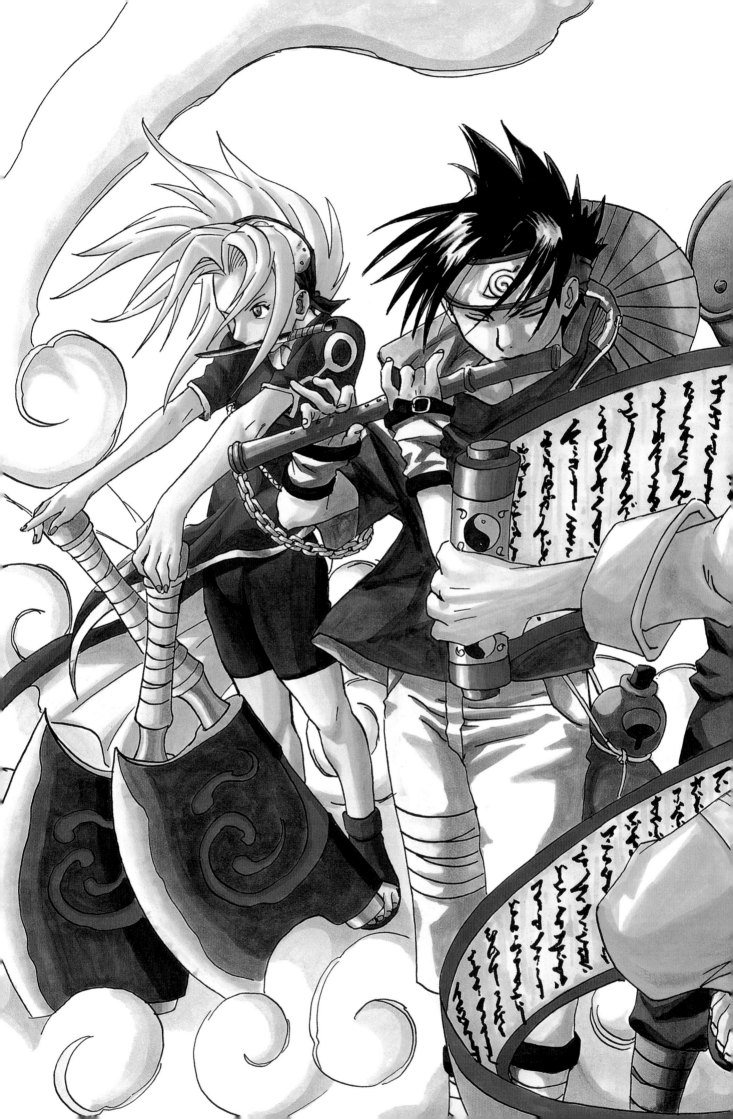

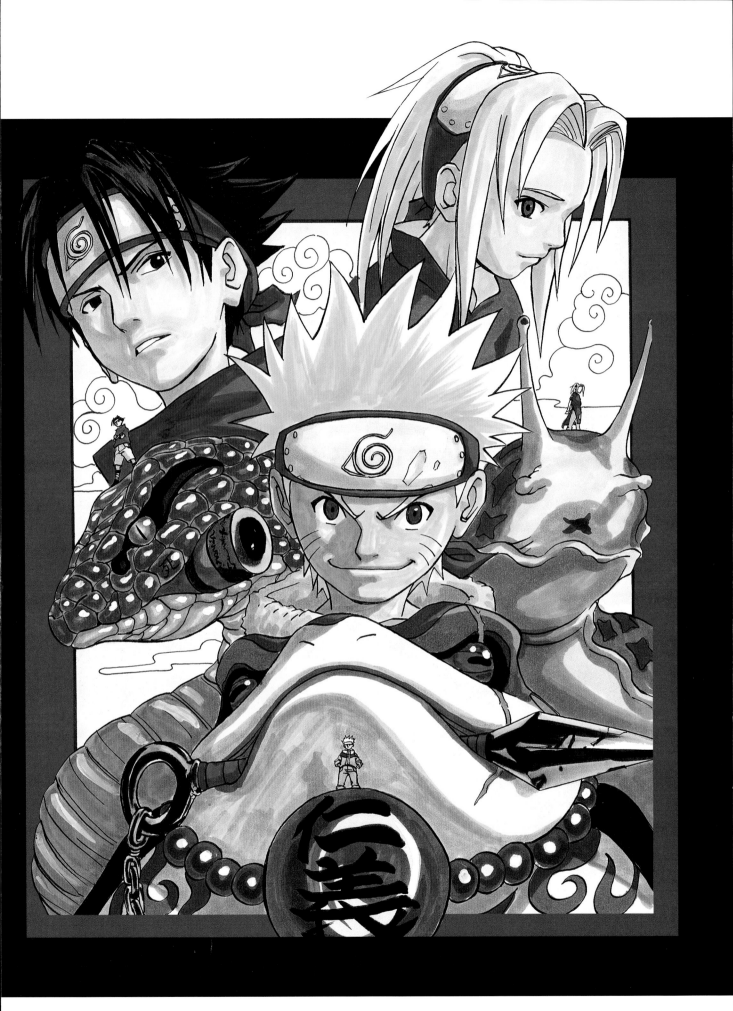

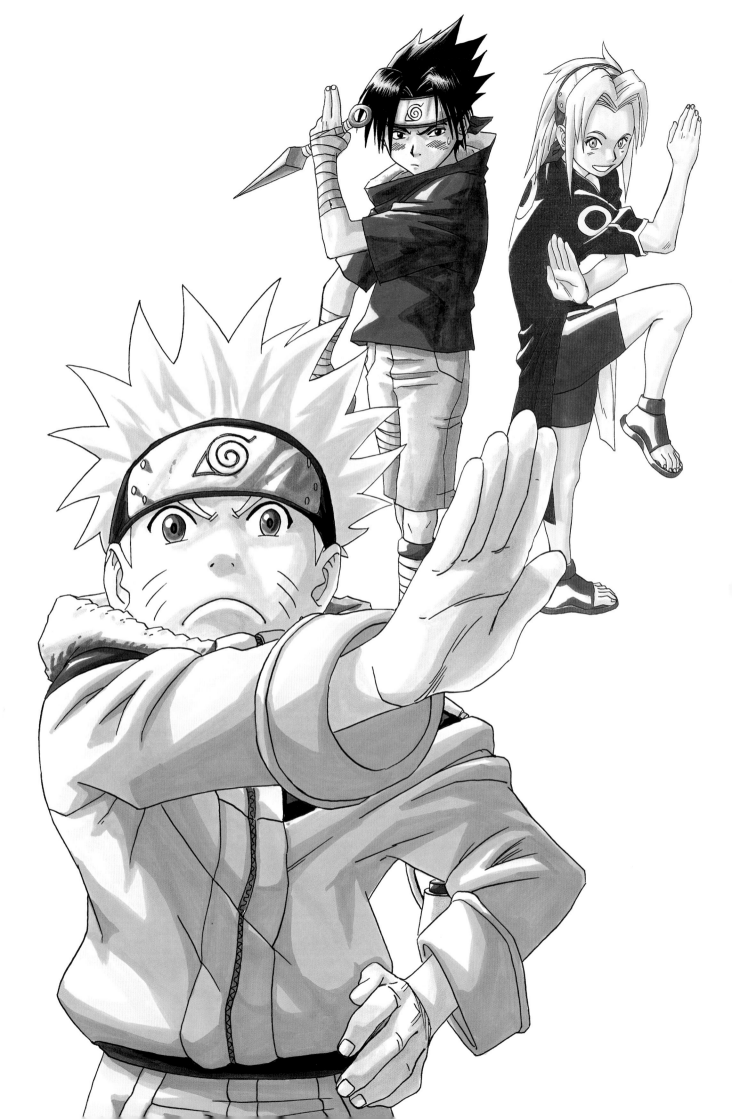

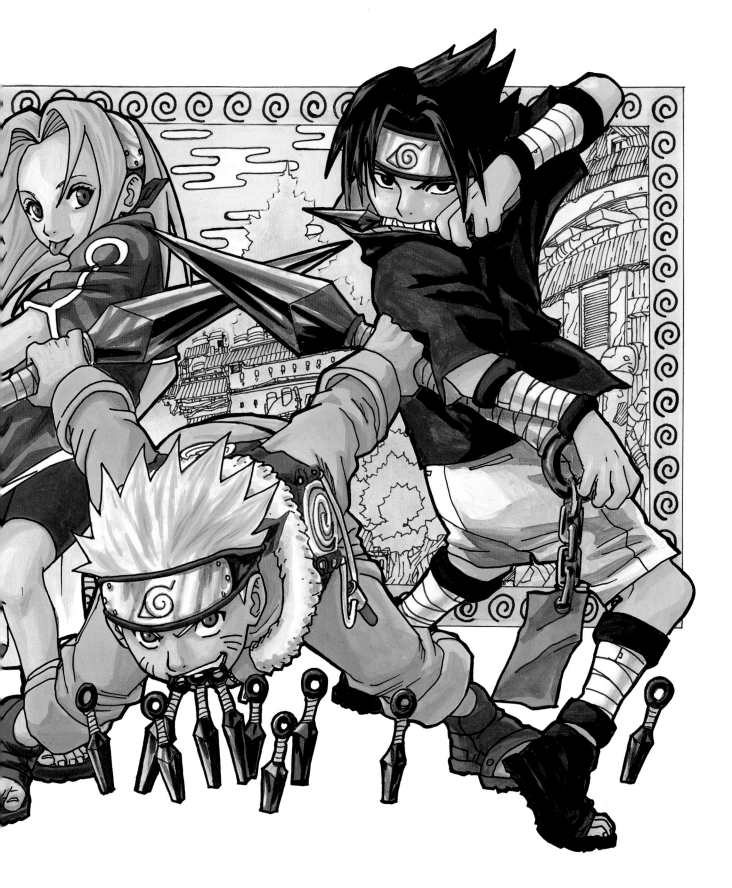

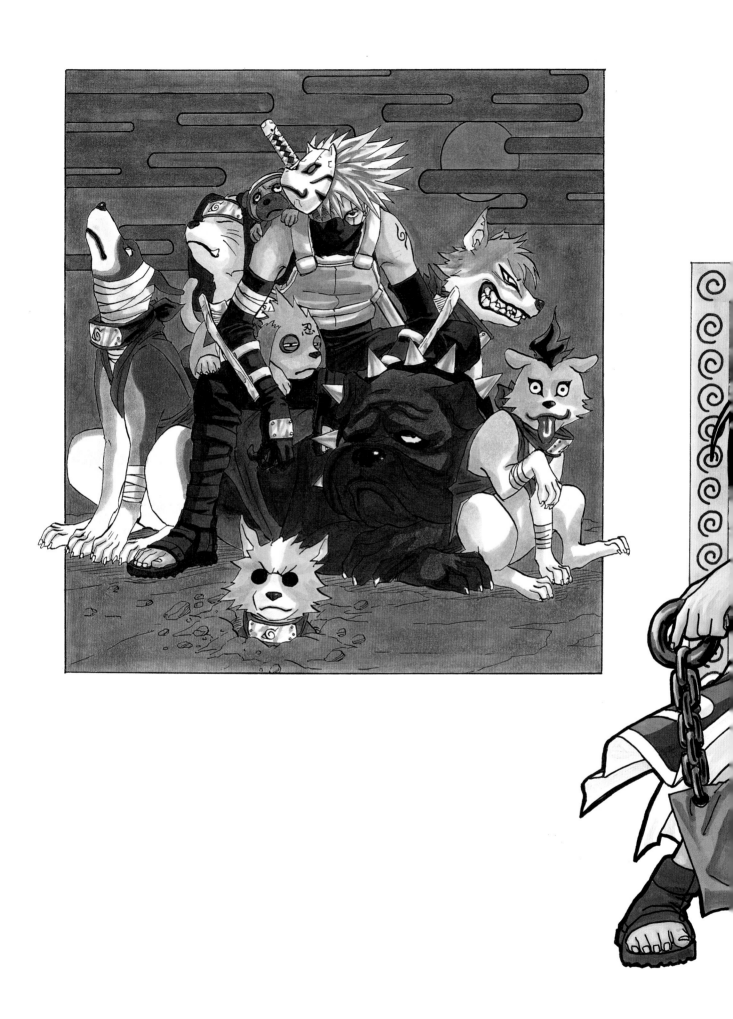

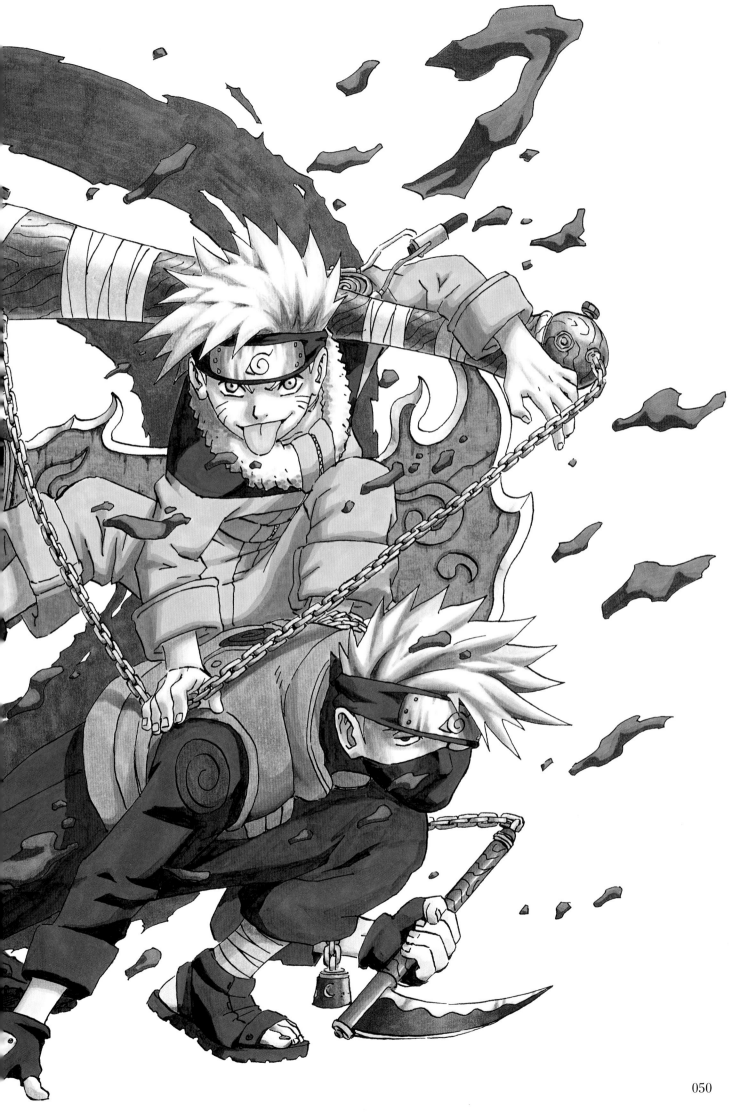

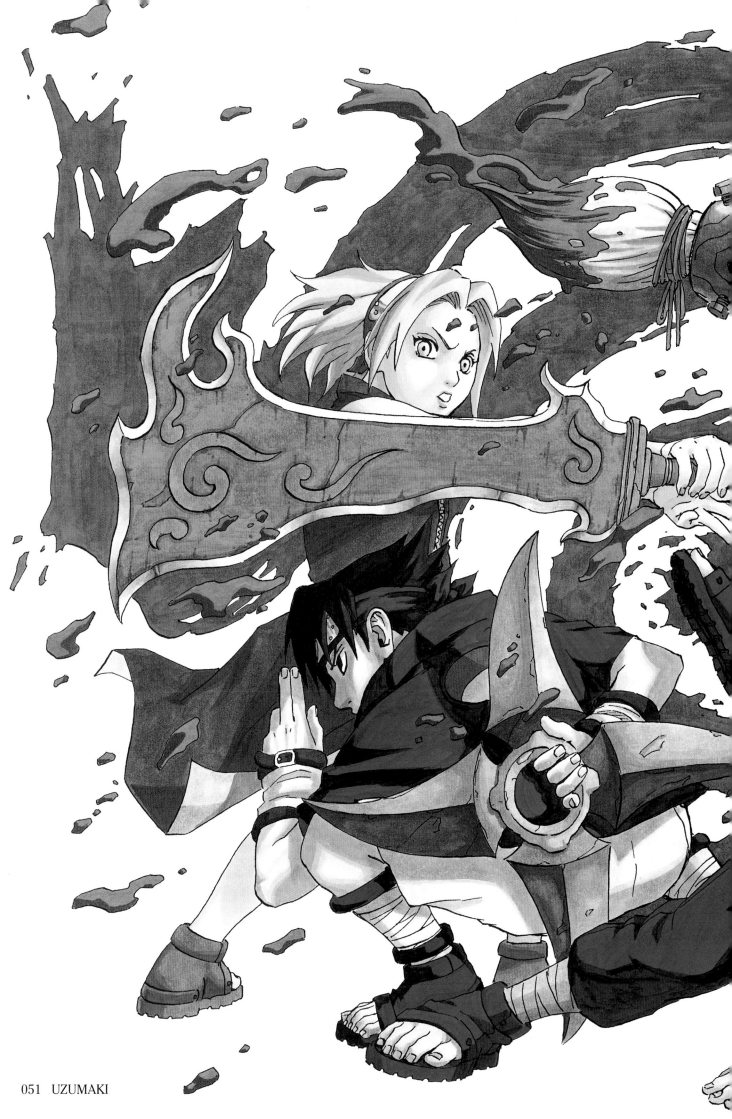

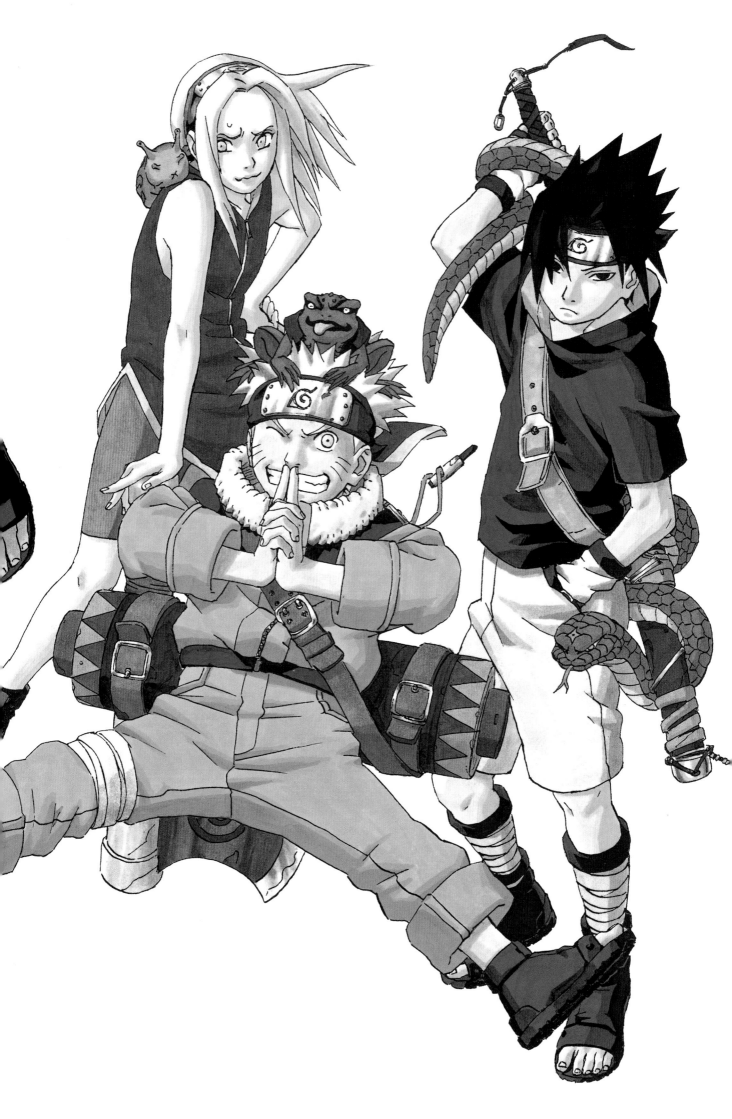

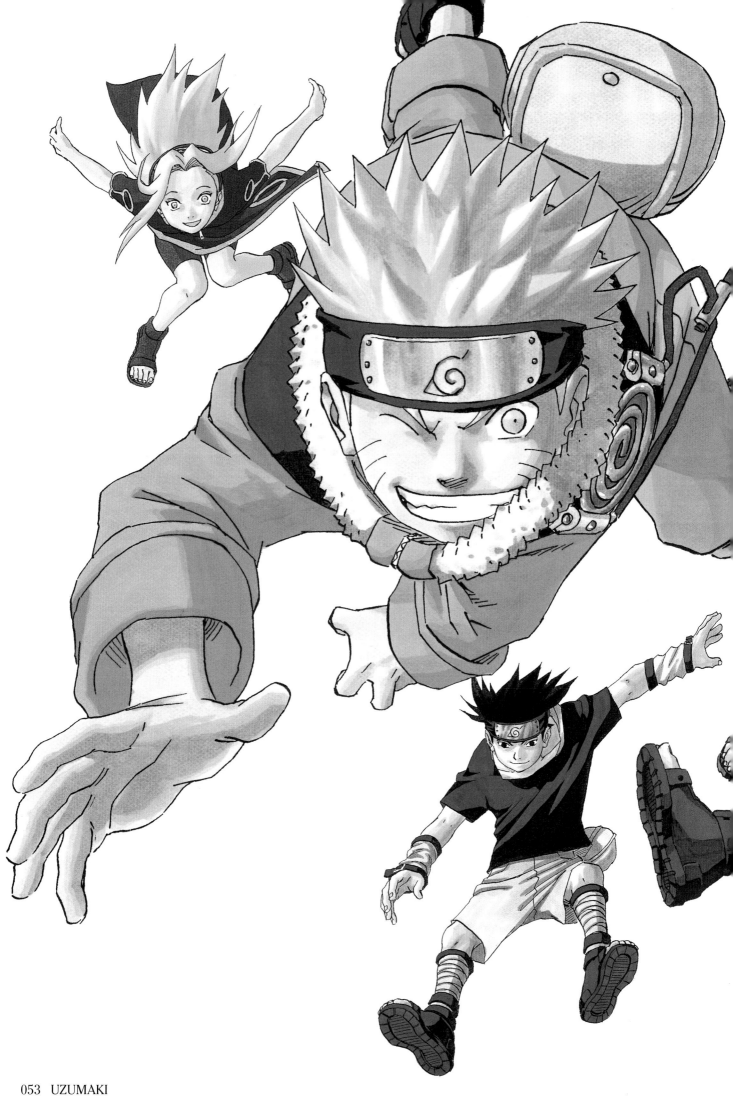

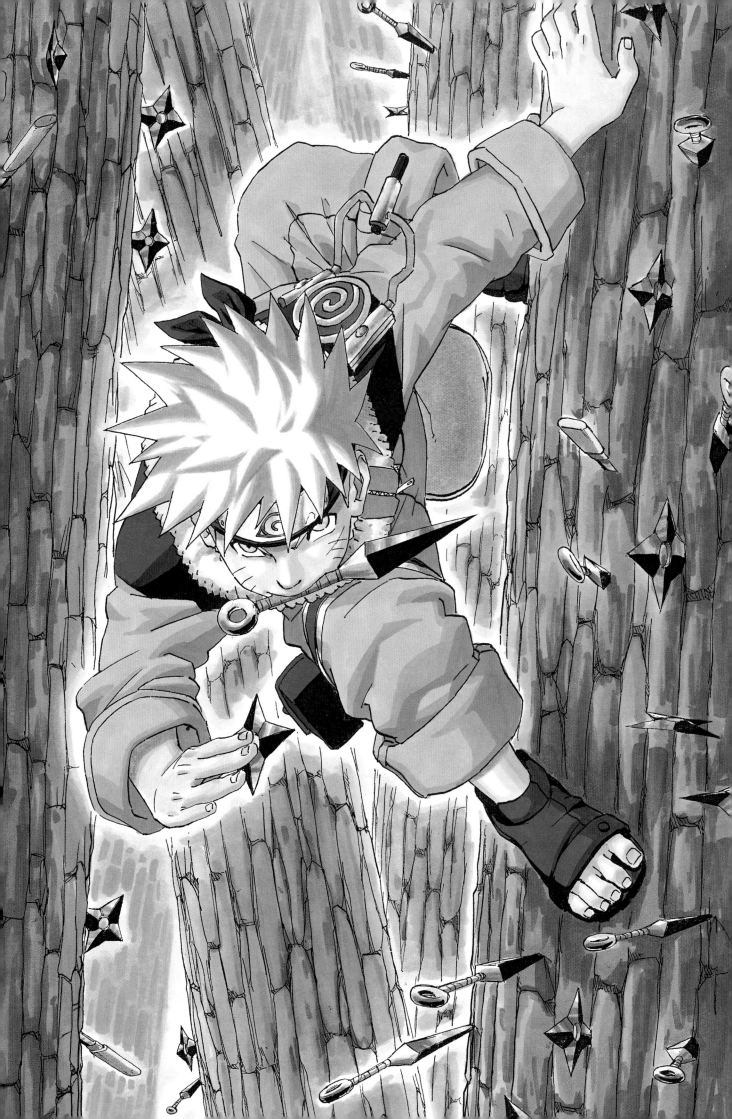

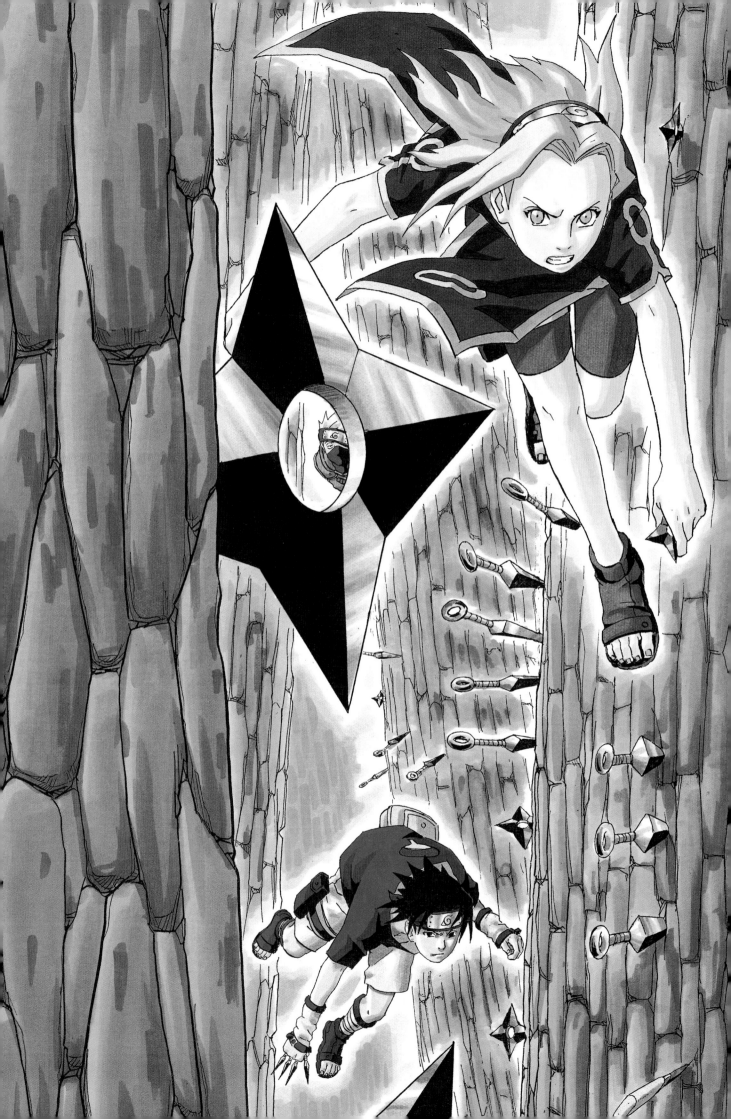

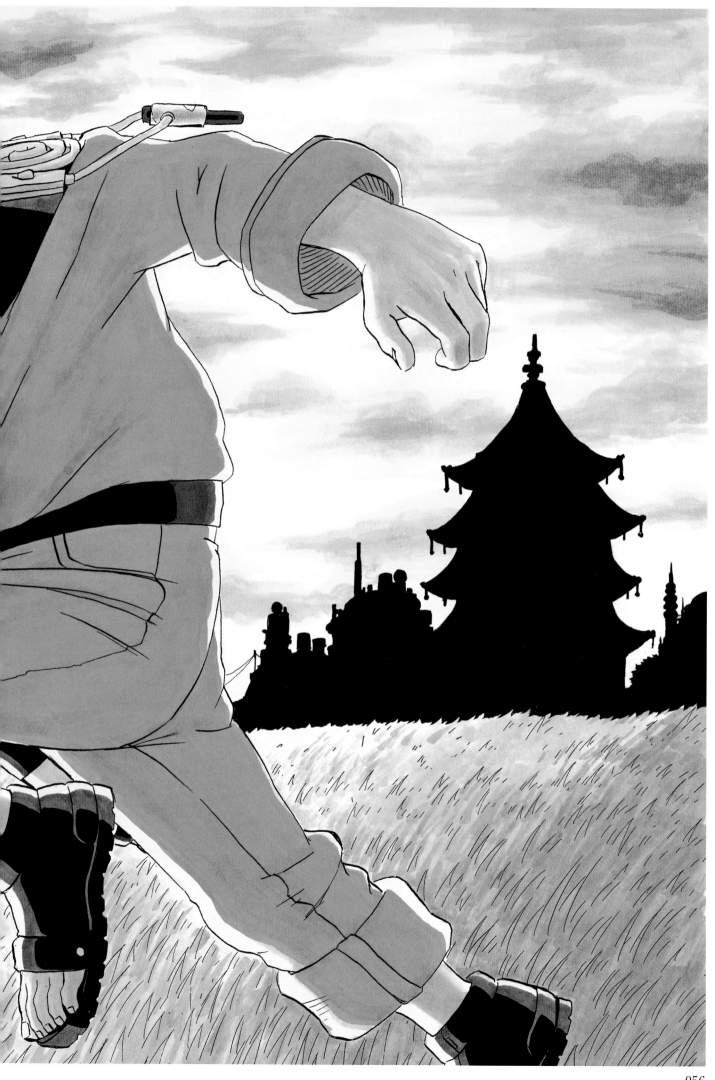

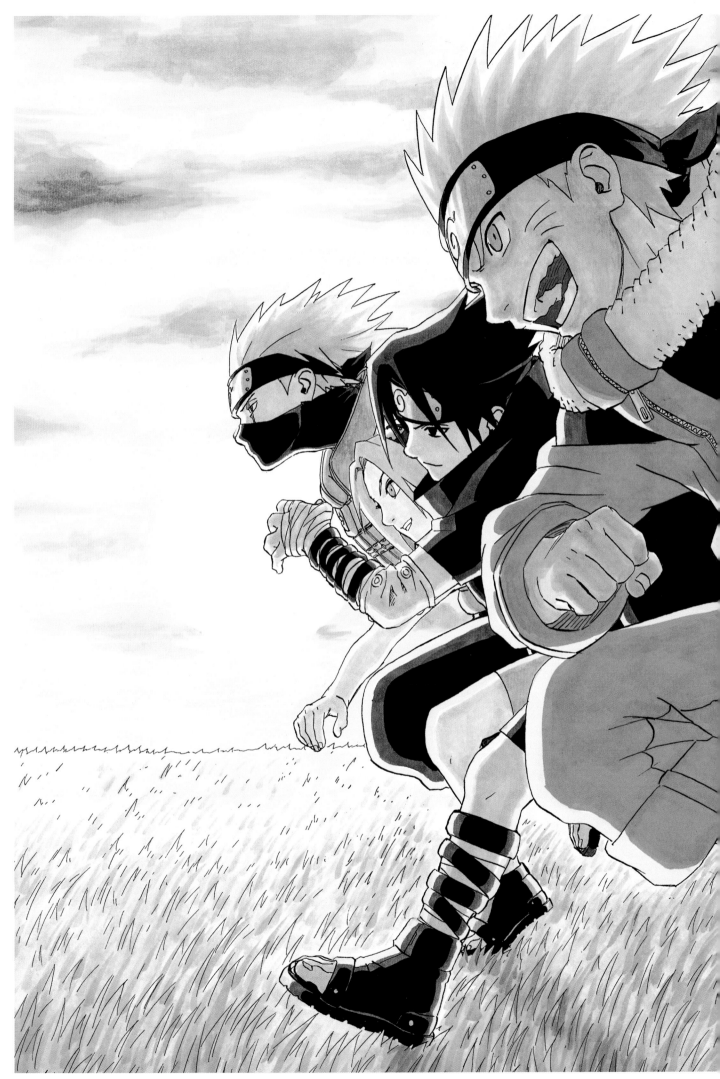

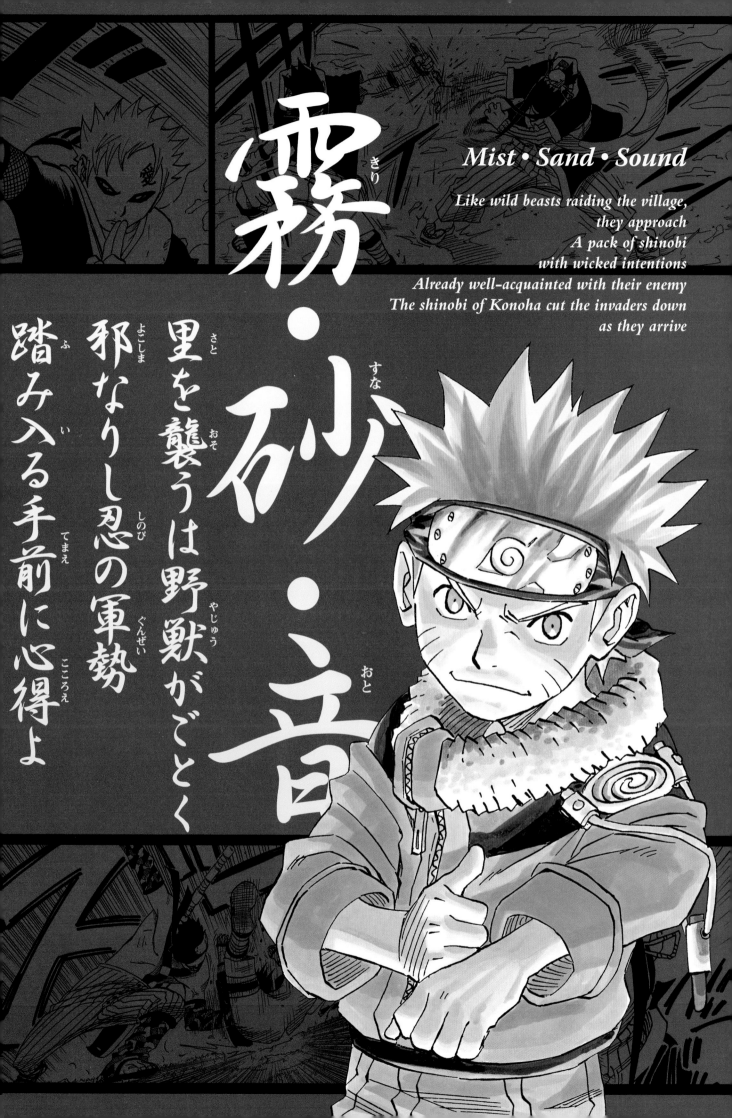

霧・砂・音

Mist • Sand • Sound

Like wild beasts raiding the village,
they approach
A pack of shinobi
with wicked intentions
Already well-acquainted with their enemy
The shinobi of Konoha cut the invaders down
as they arrive

里を襲うは野獣がごとく
邪なりし忍の軍勢
踏み入る手前に心得よ

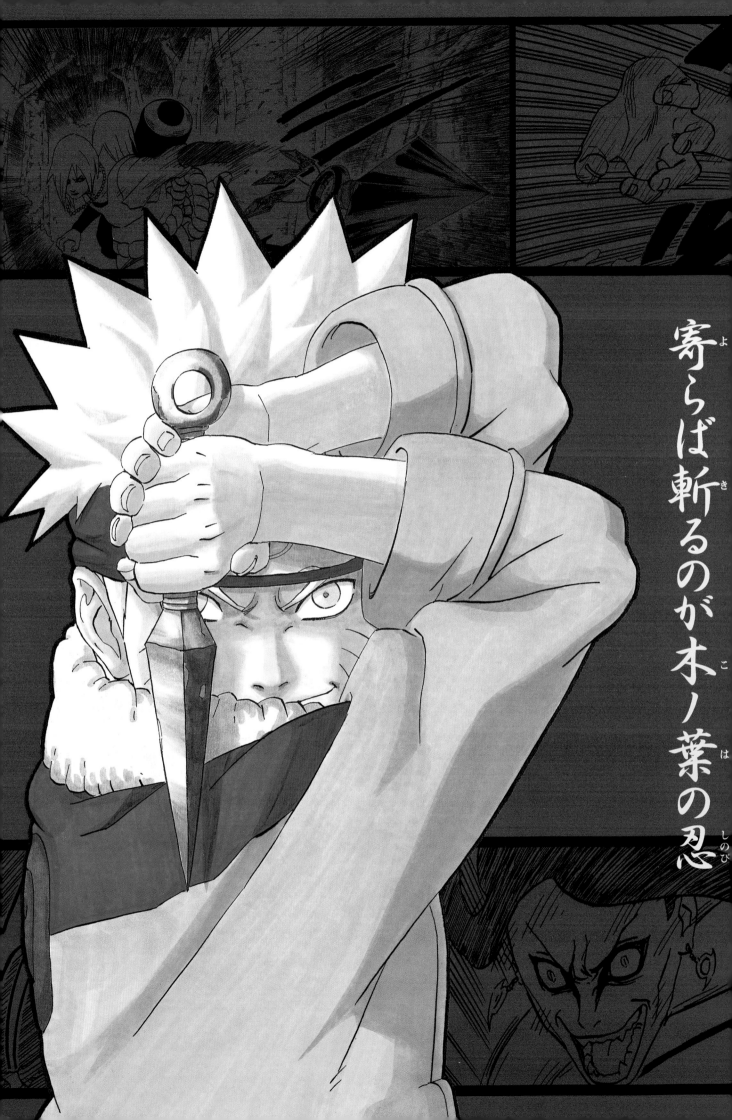

寄らば斬るのが木ノ葉の忍

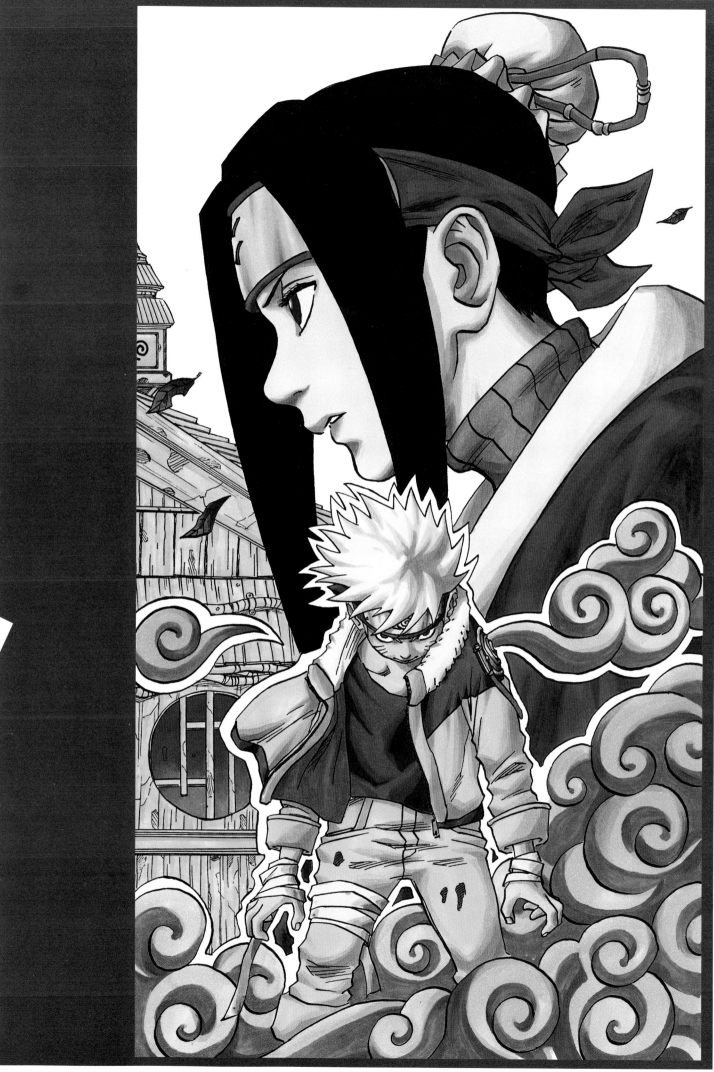

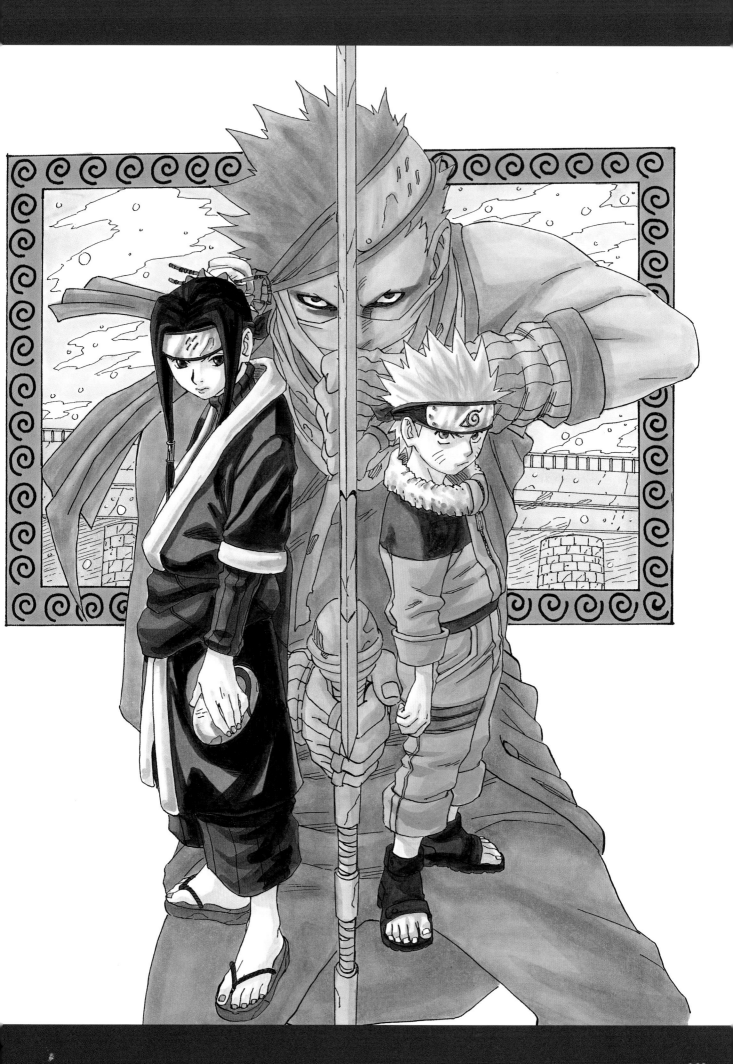

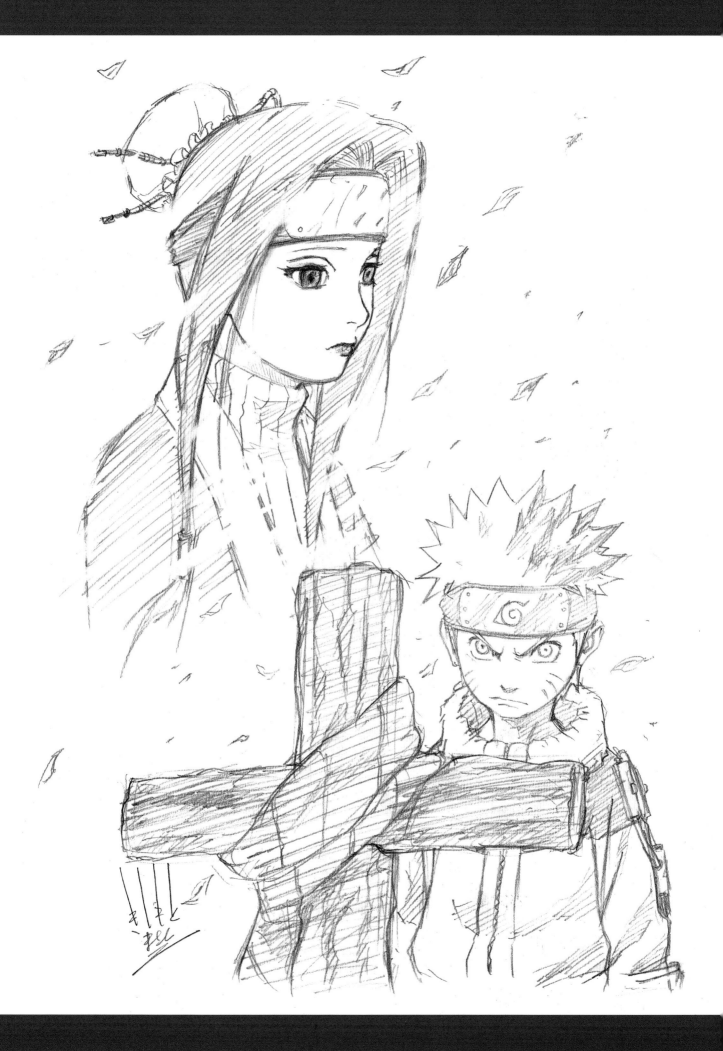

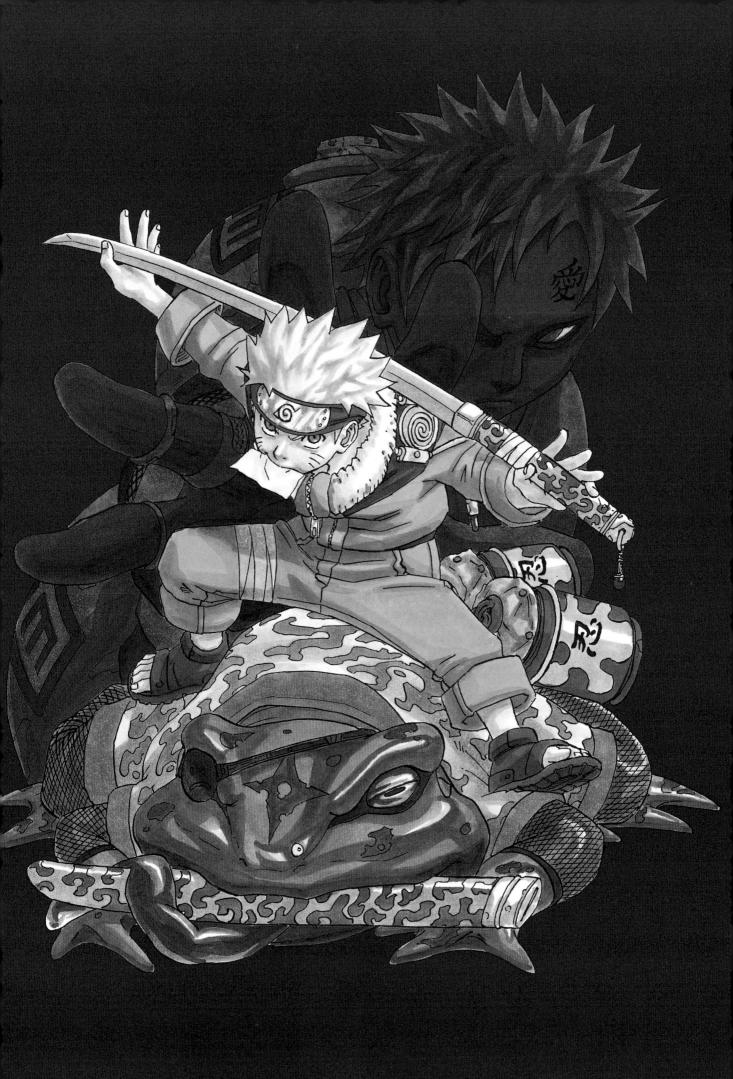

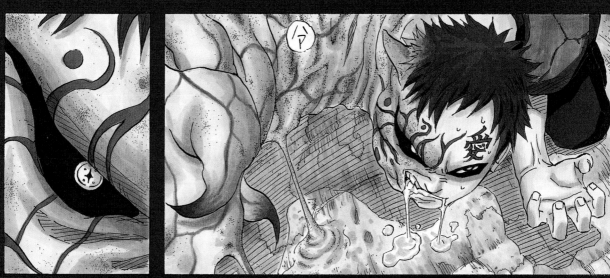

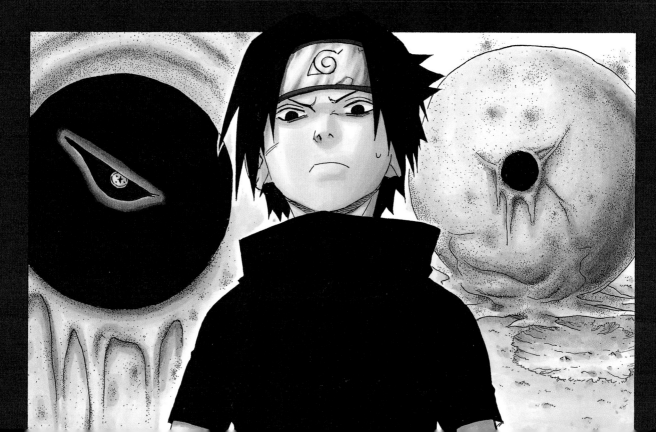

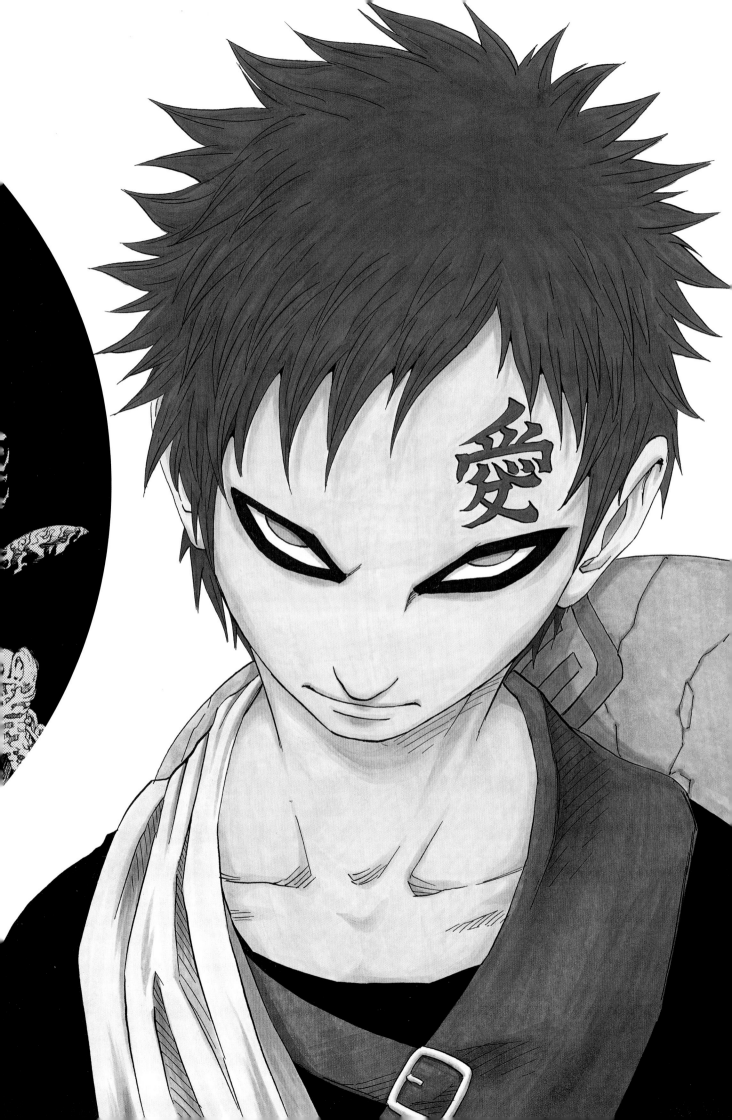

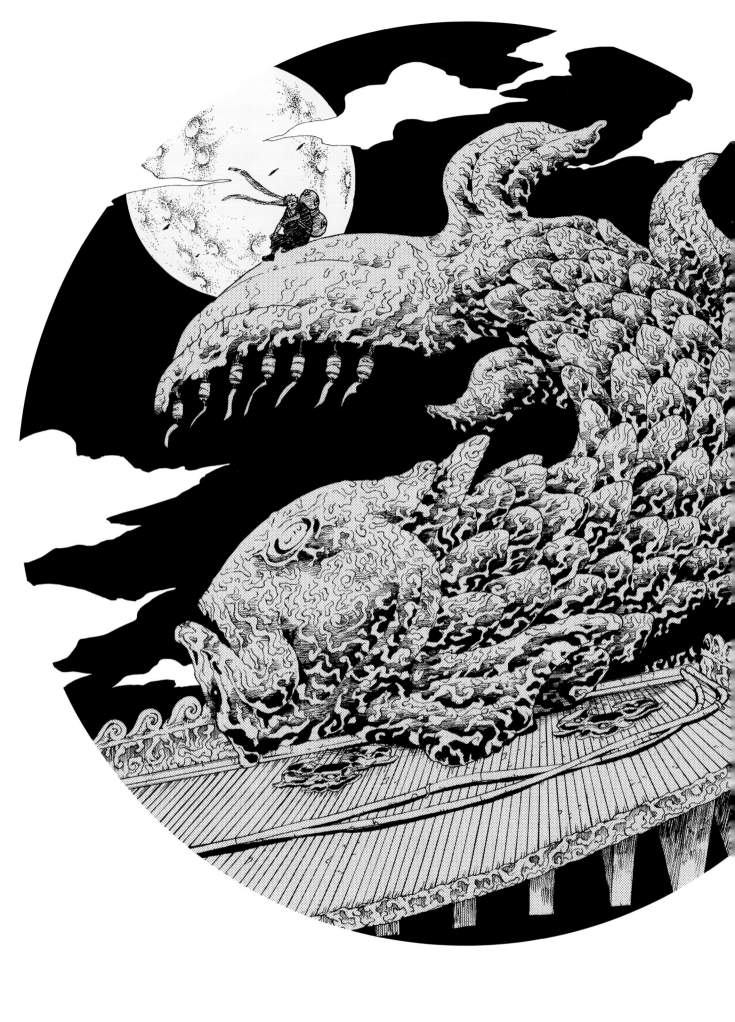

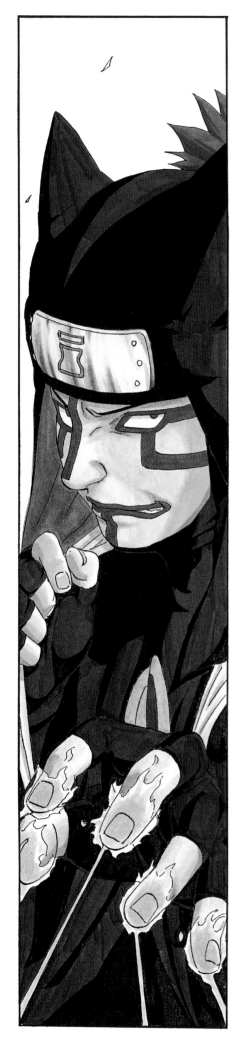
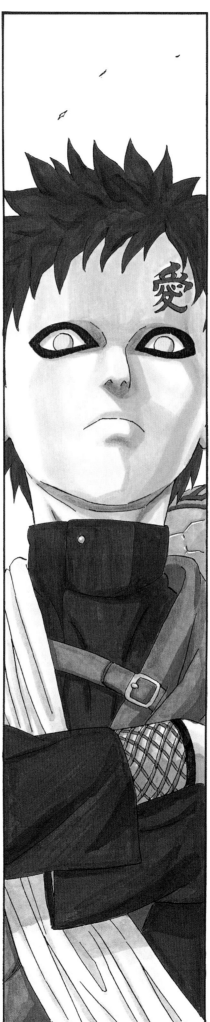
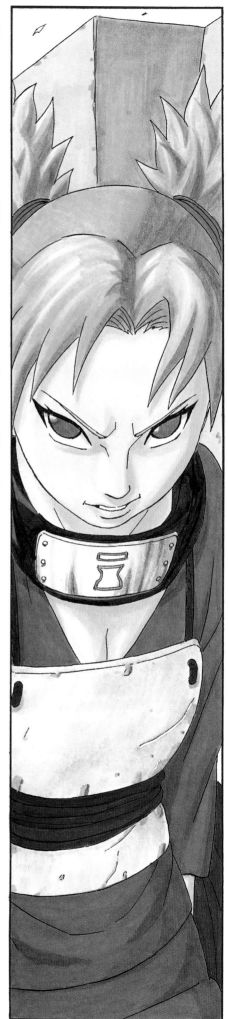

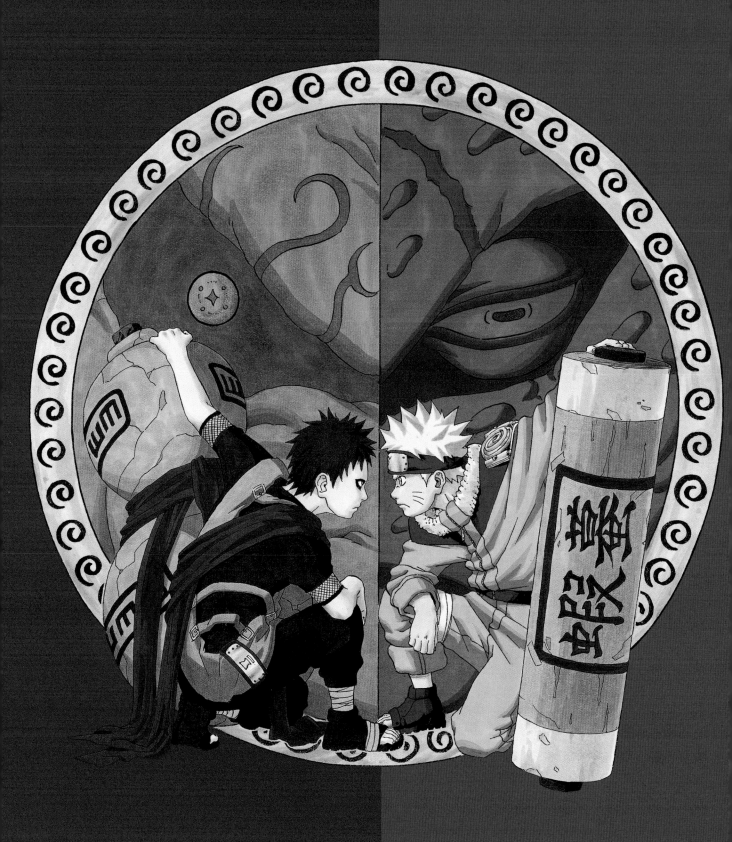

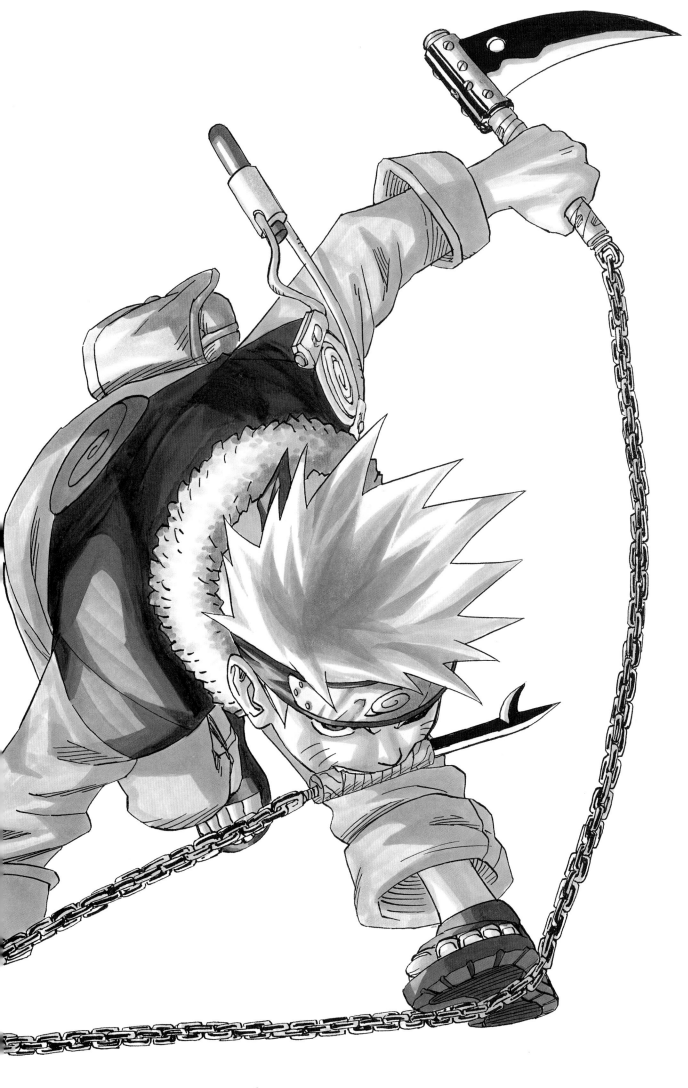

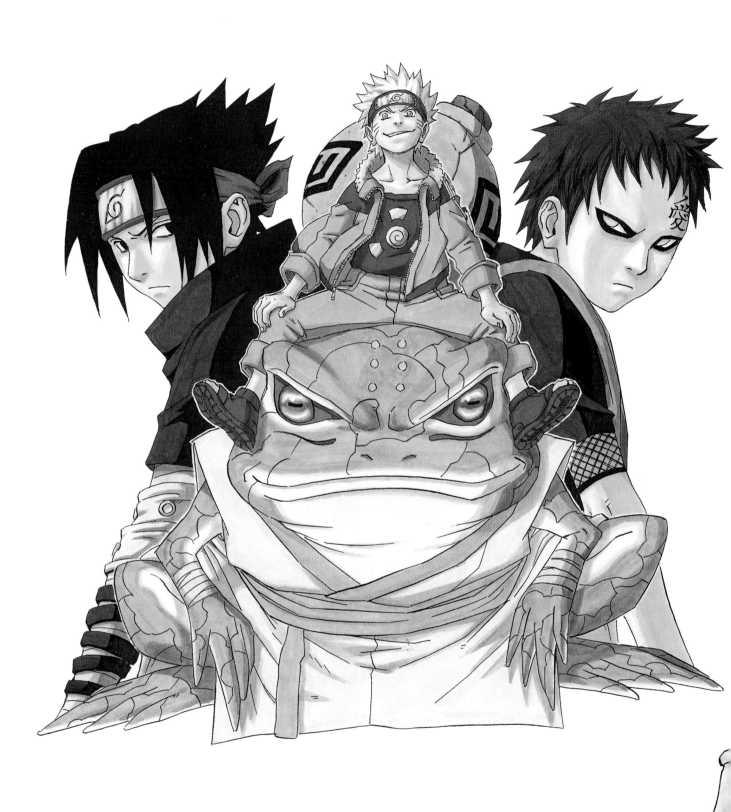

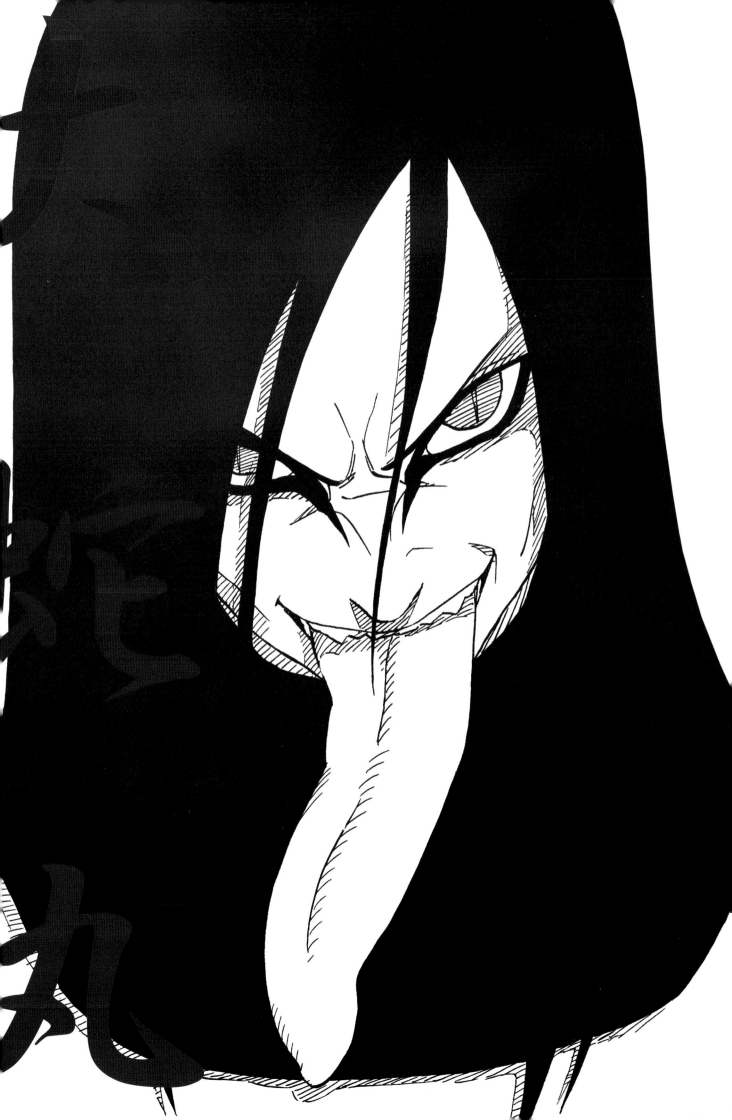

動いているものを見るのは面白い…止まっているとつまらないでしょ……

Orochimaru
It's so amusing to watch
things squirm…
Doesn't it get boring when
they cease to move…?

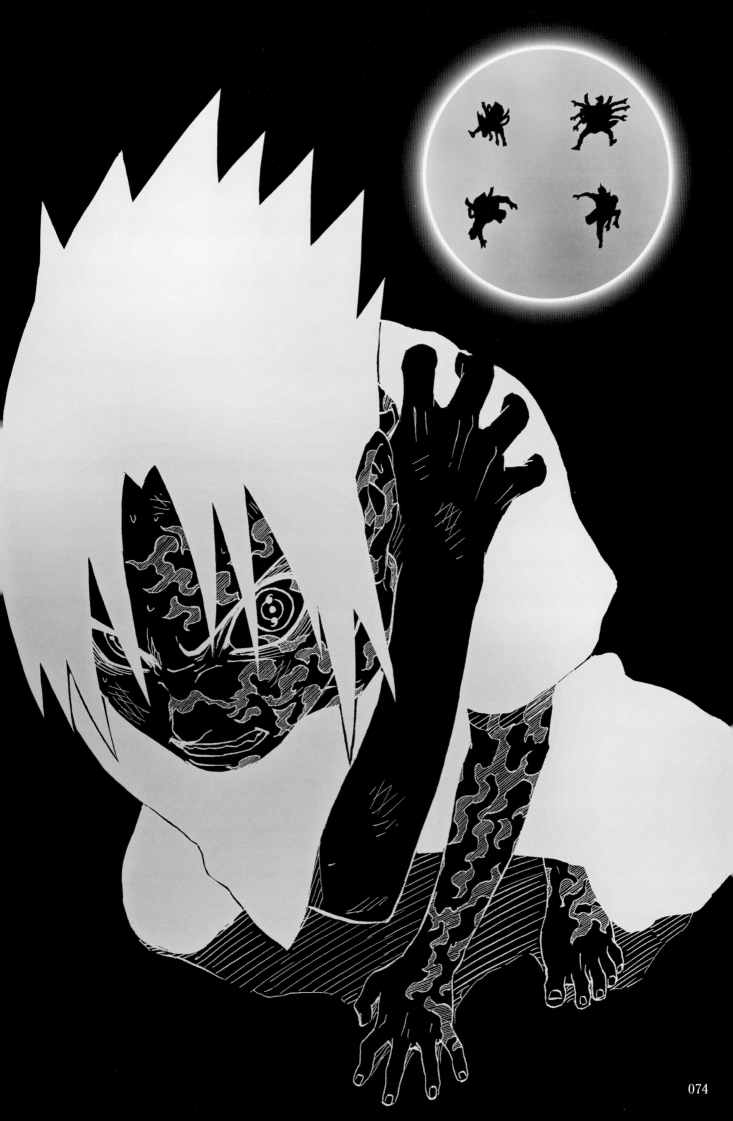

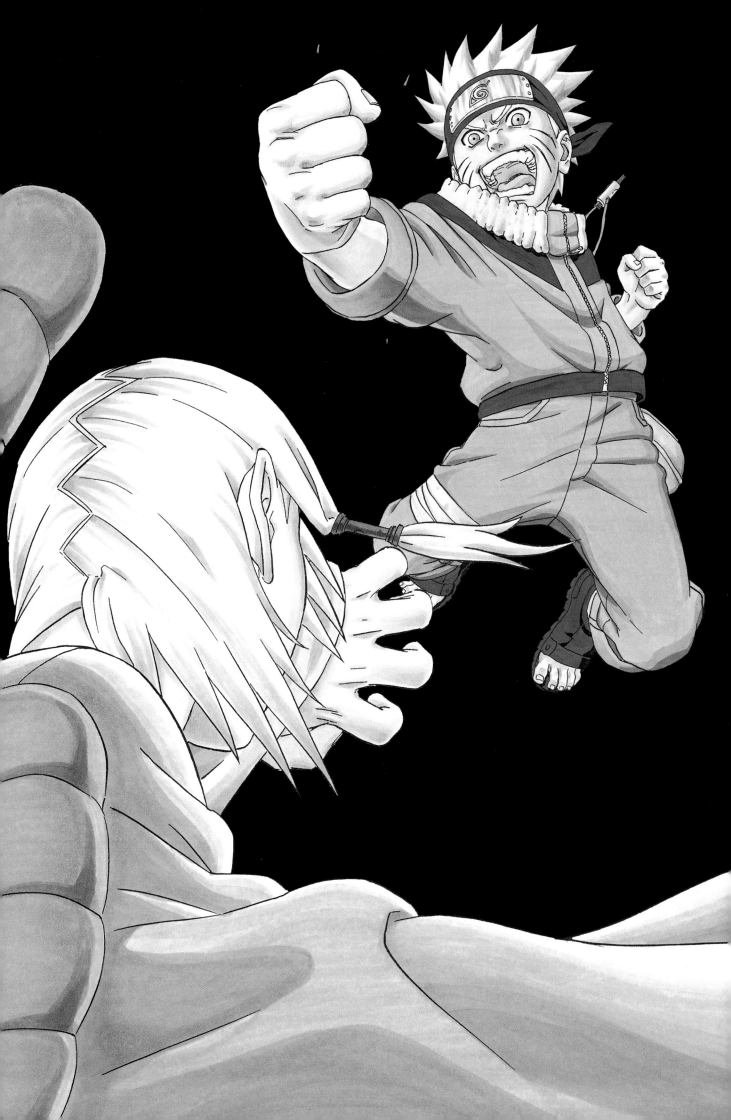

師弟

共に修羅場をくぐり抜け

血肉を分けたこの体

忍の師弟は鋼鉄の縁

矢とて剣とて崩せぬ絆

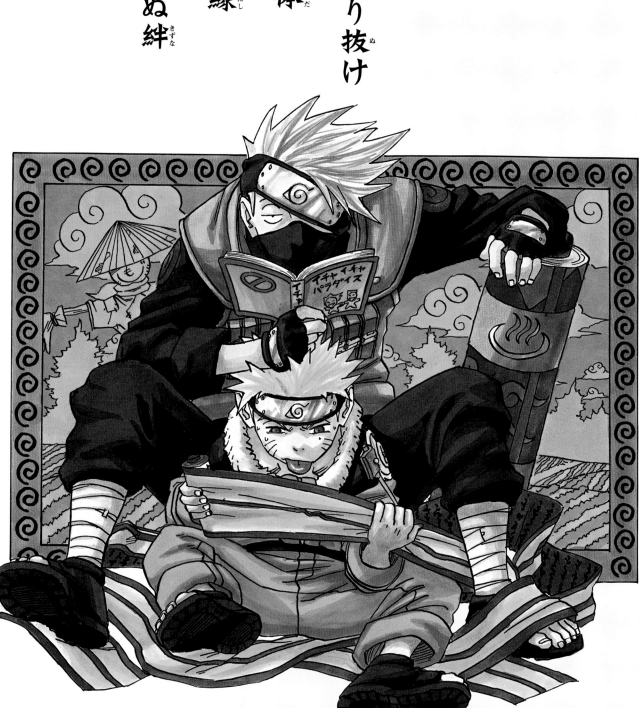

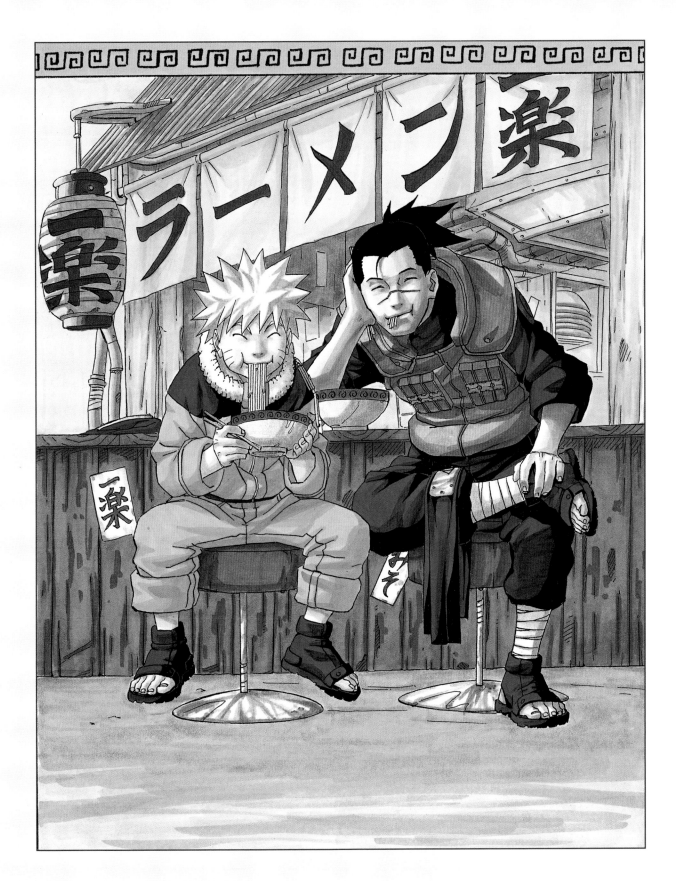

Master and Pupil

Together through thick and thin
As though they're of the same flesh and blood
The bond between shinobi master and pupil
As solid as steel that no sword or arrow can pierce

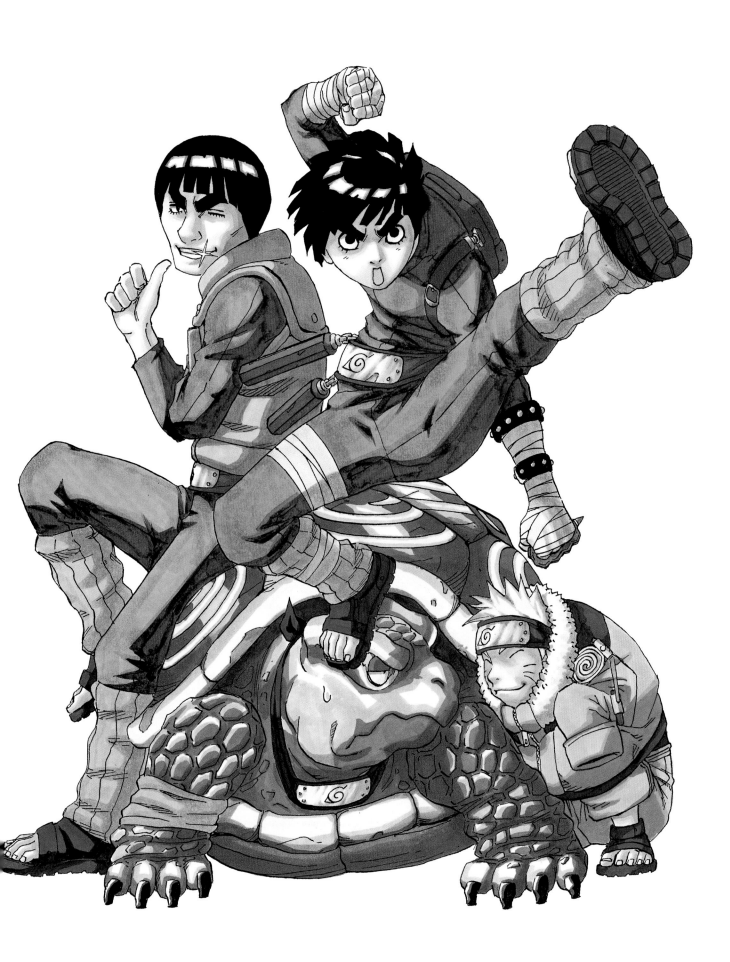

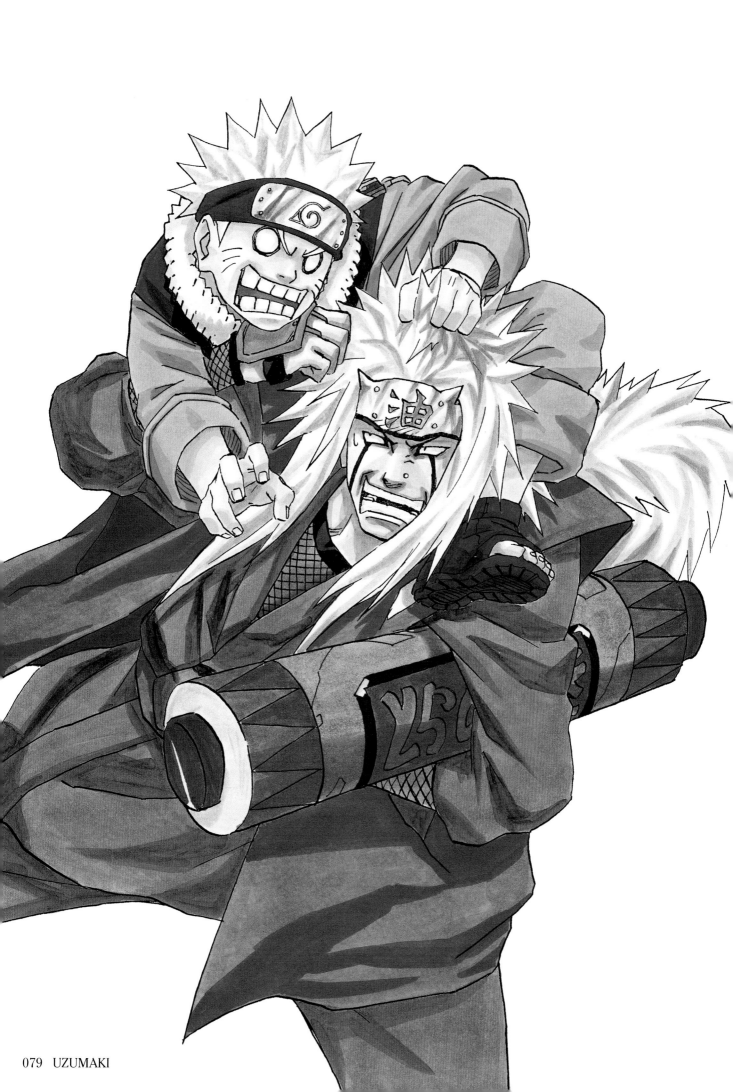

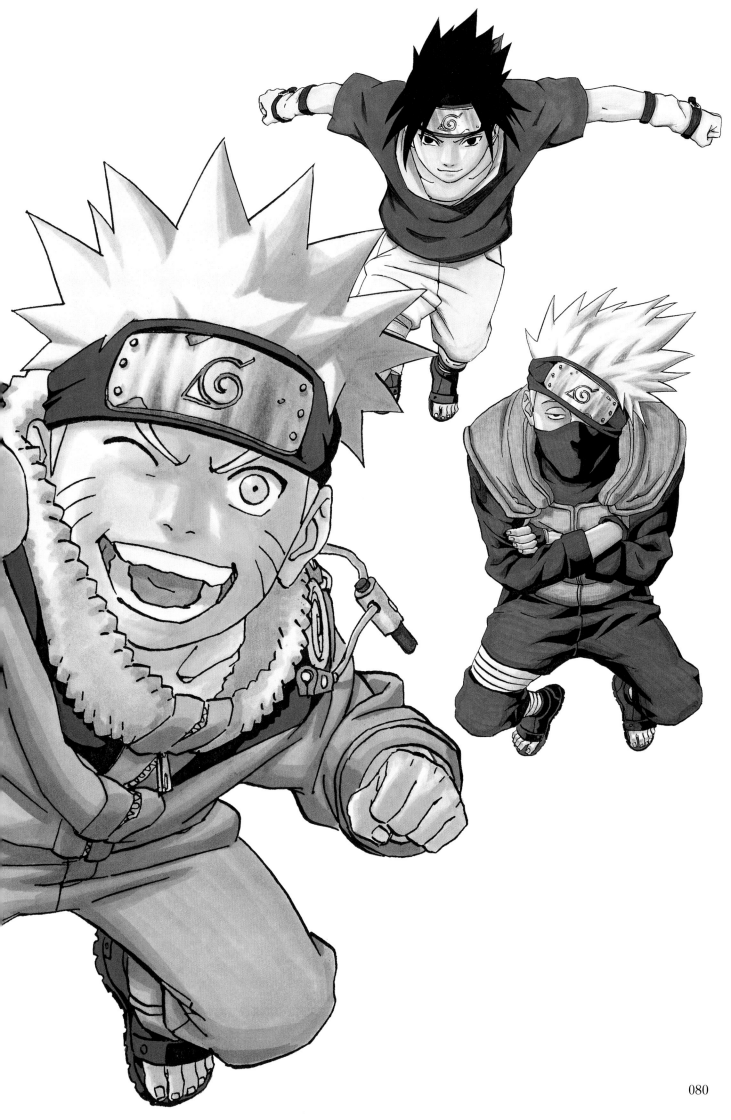

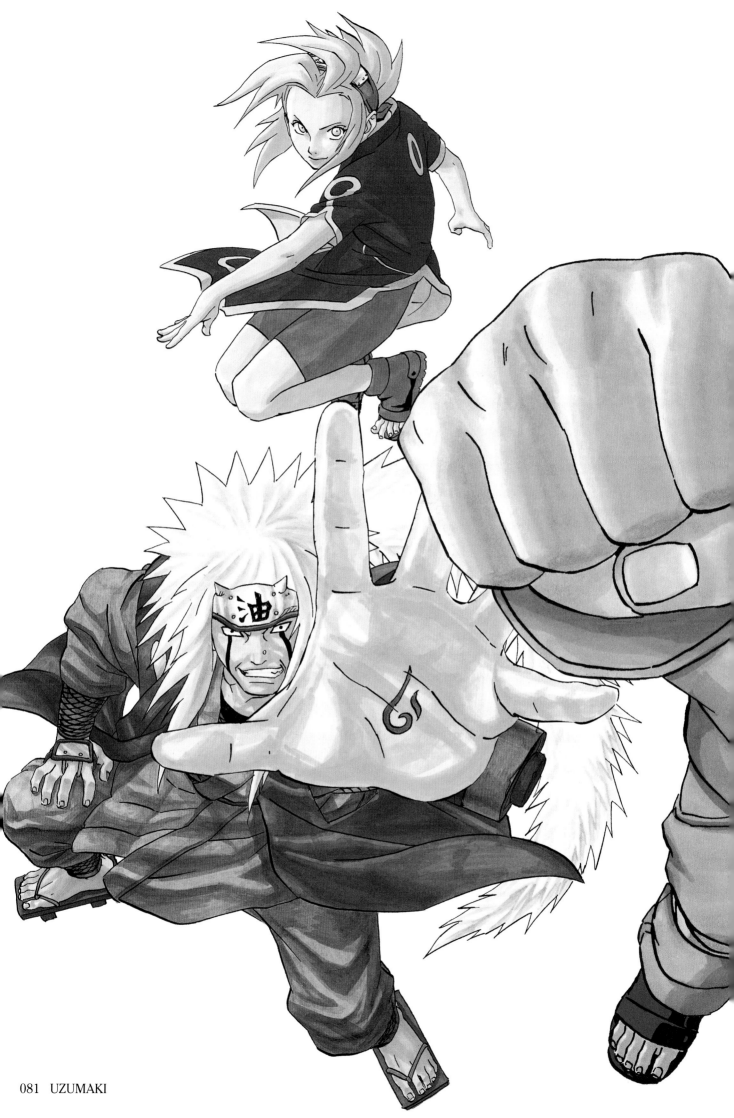

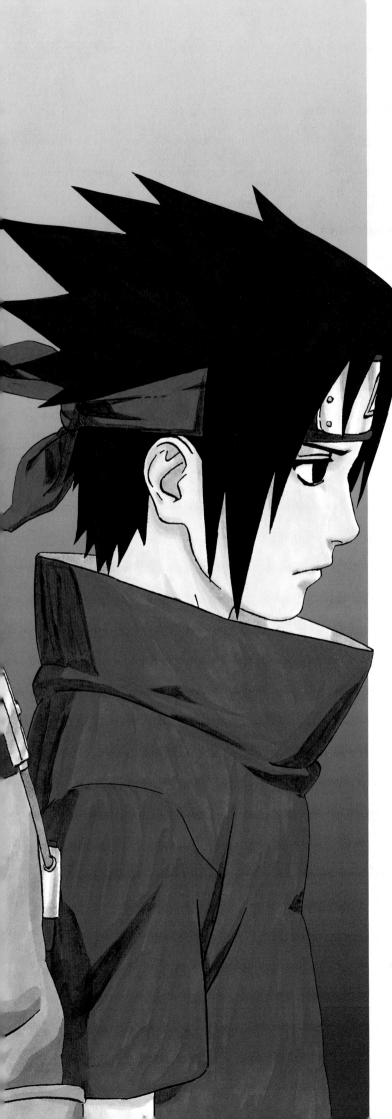

視線 その先に—

霞の果てに眼をこらし　差す陽光を追い求む

大志は遥か空高く　まだ見ぬときをやがて招かん

What lies ahead...
Vision clouded by fog
They watch for the sunlight to break through
Their ambitions soar skyward
Awaiting the unknown future

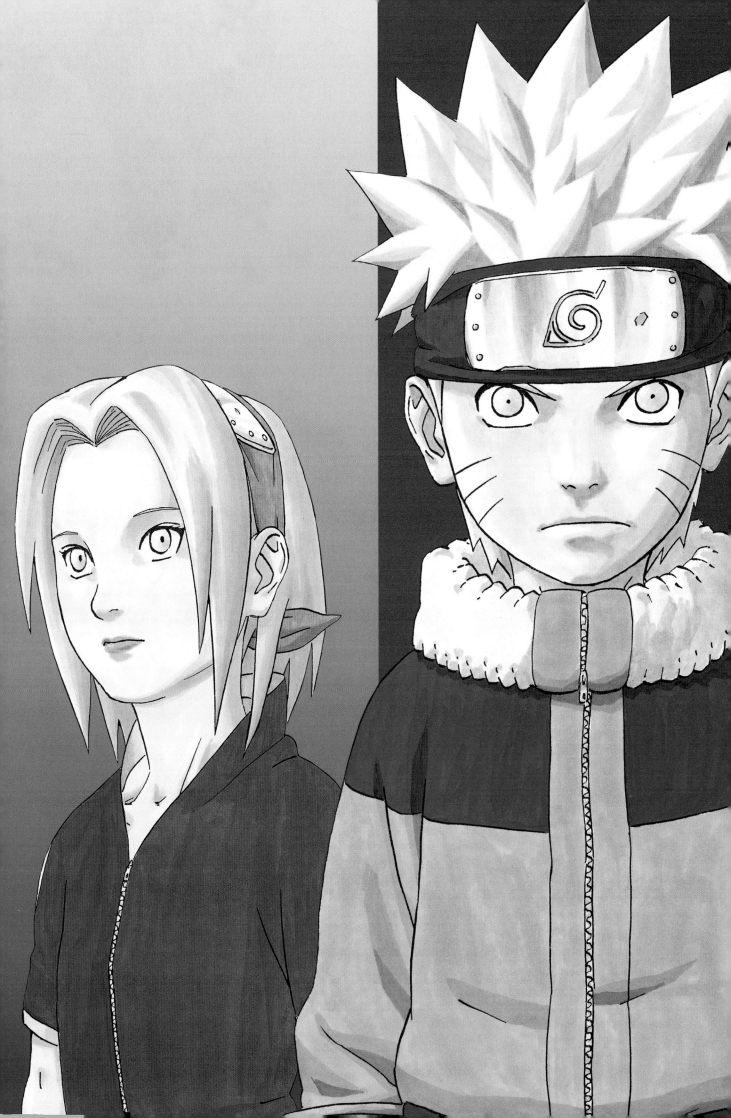

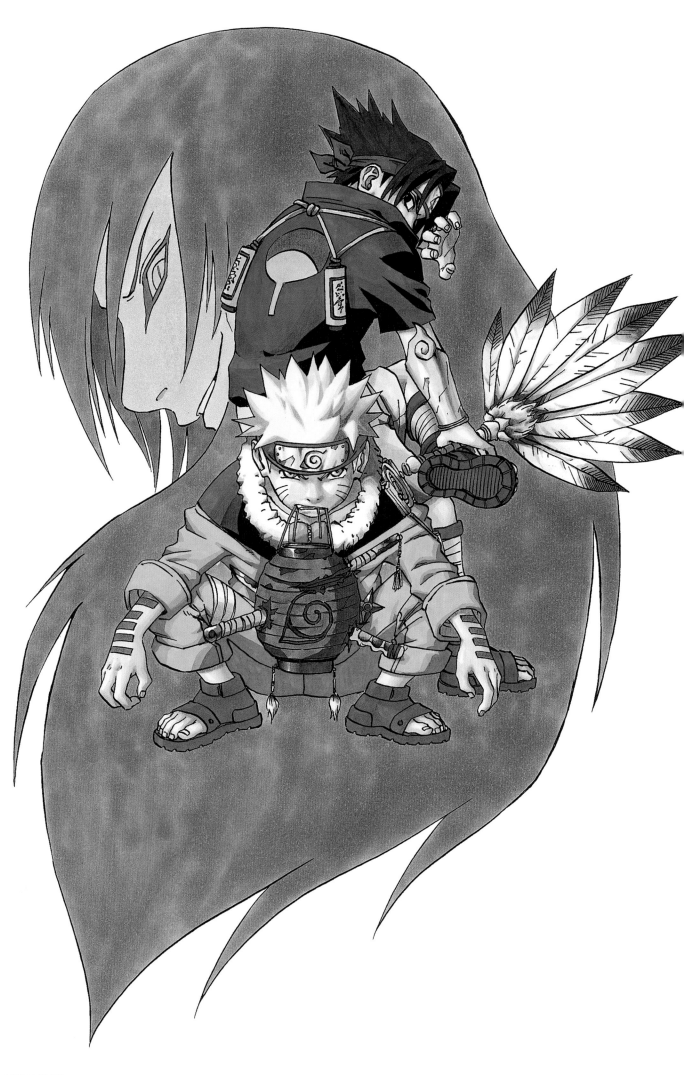

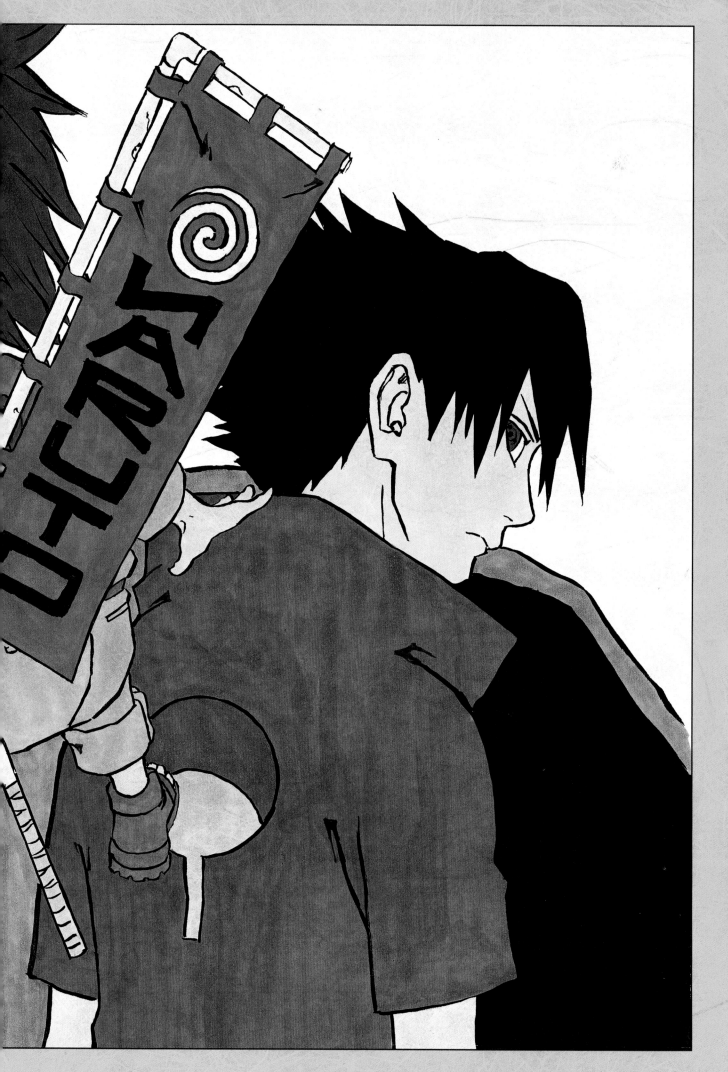

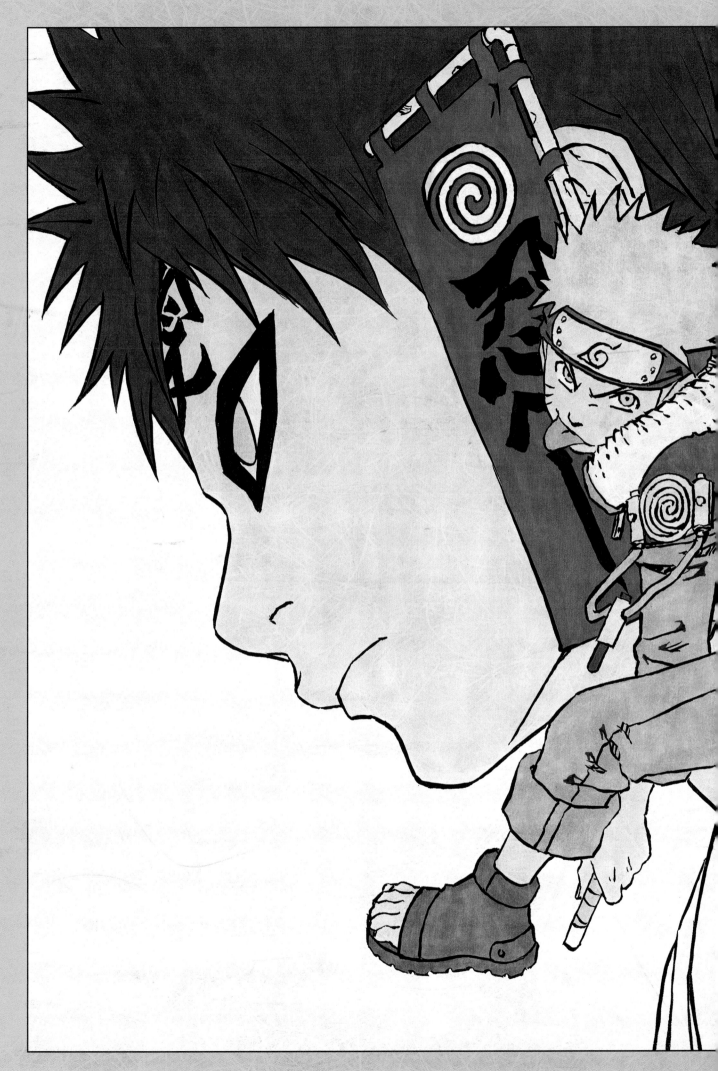

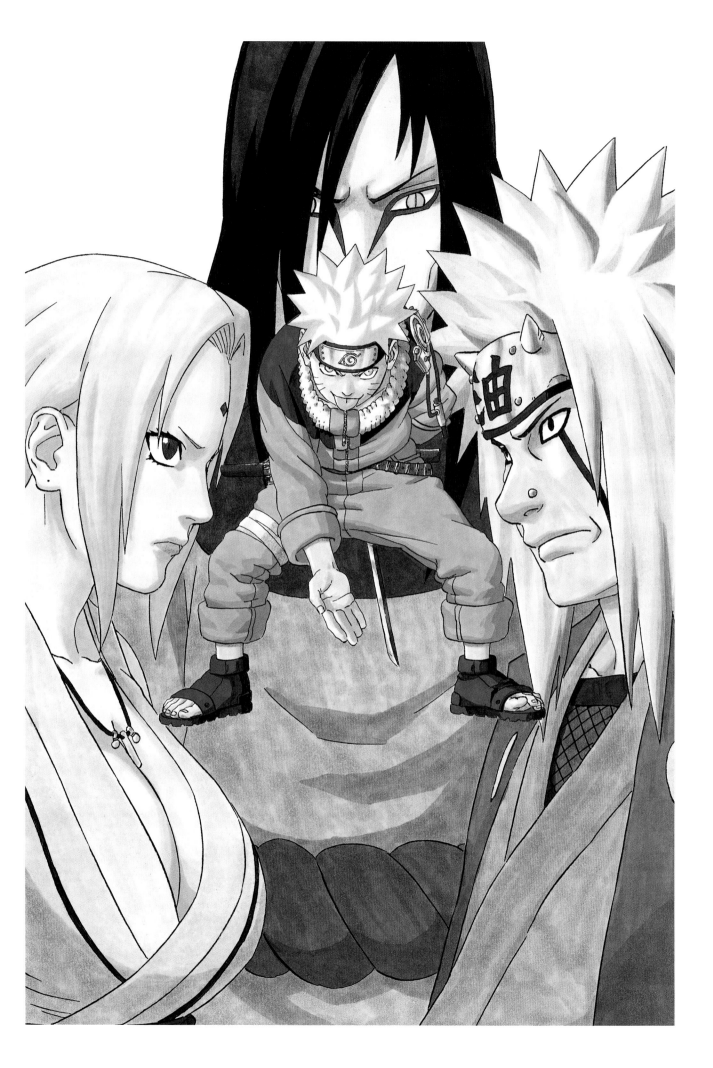

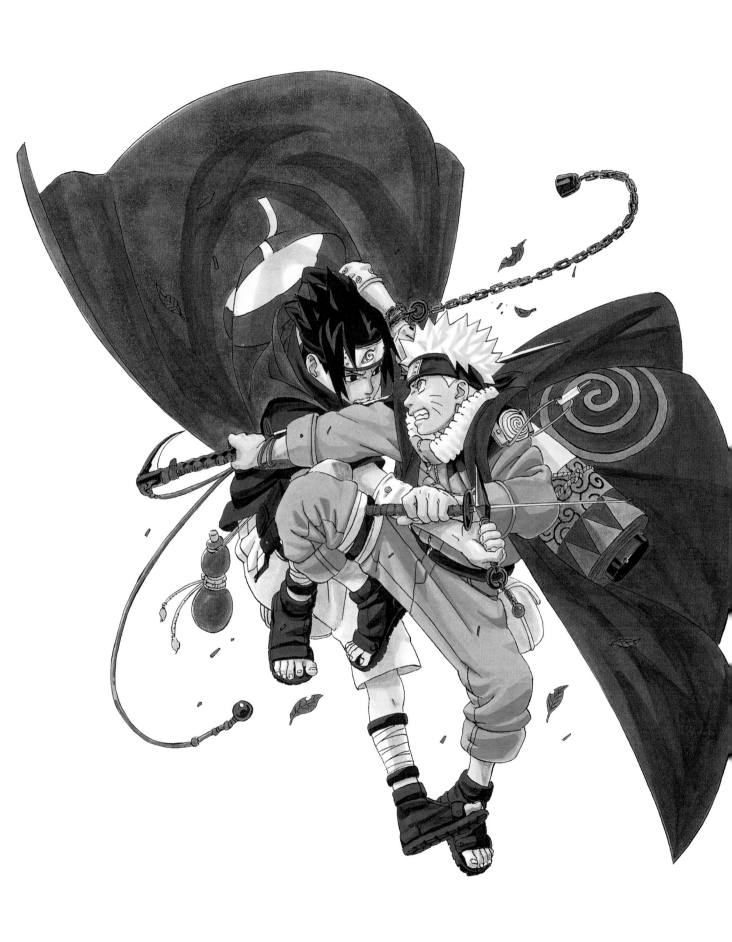

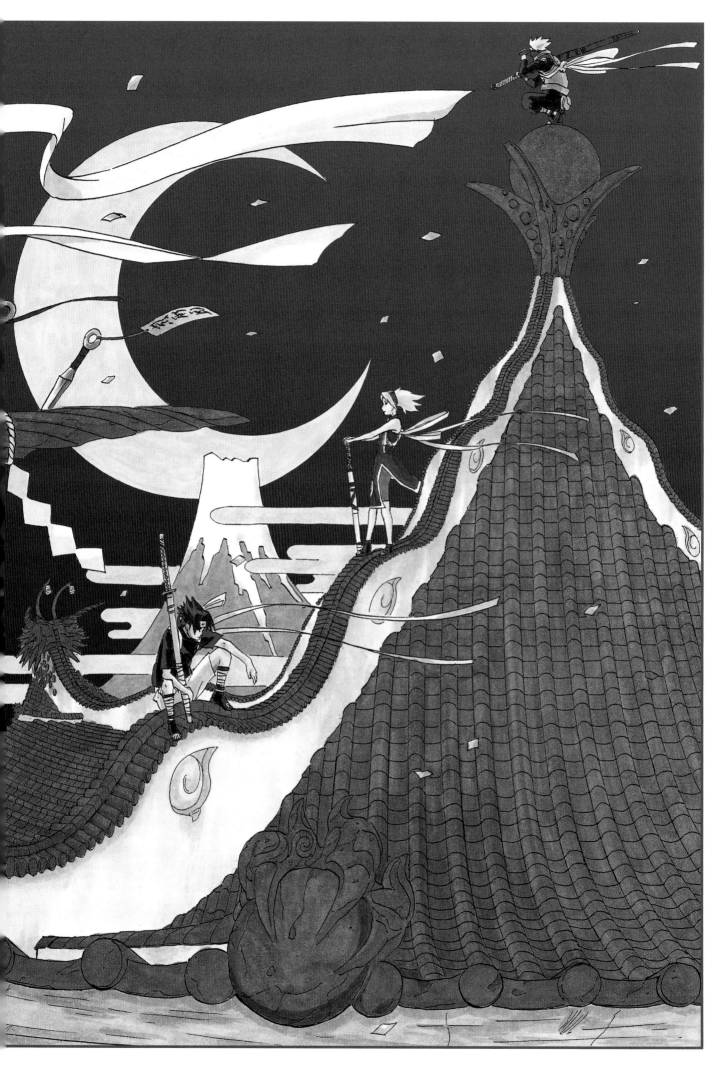

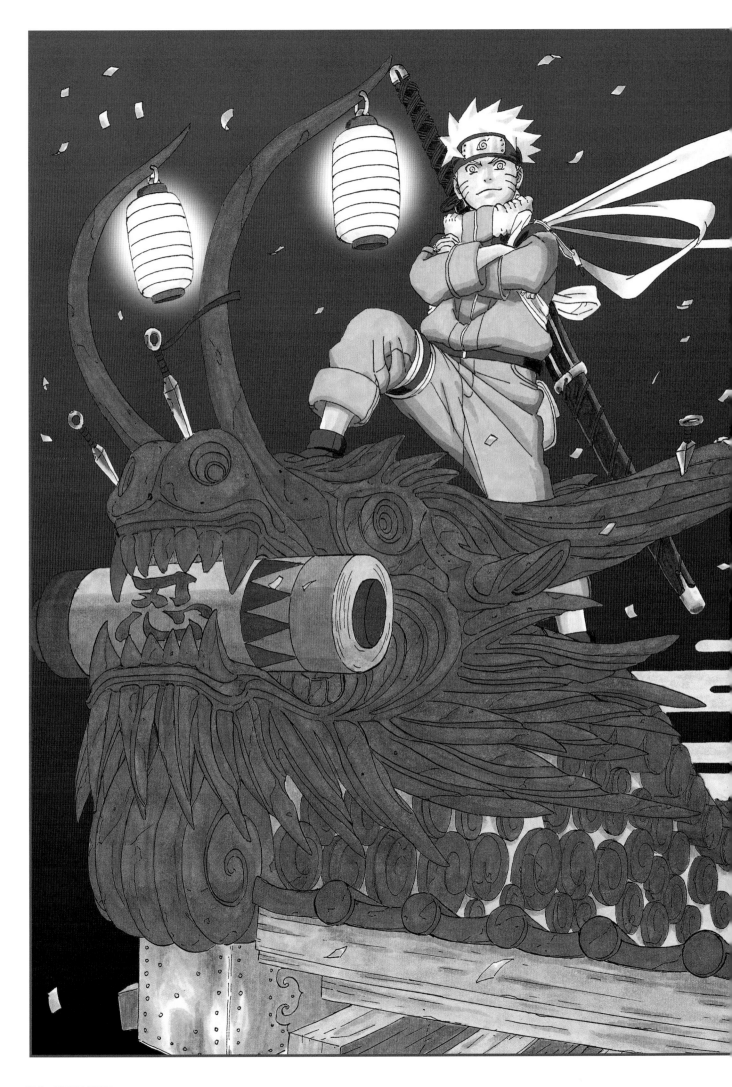

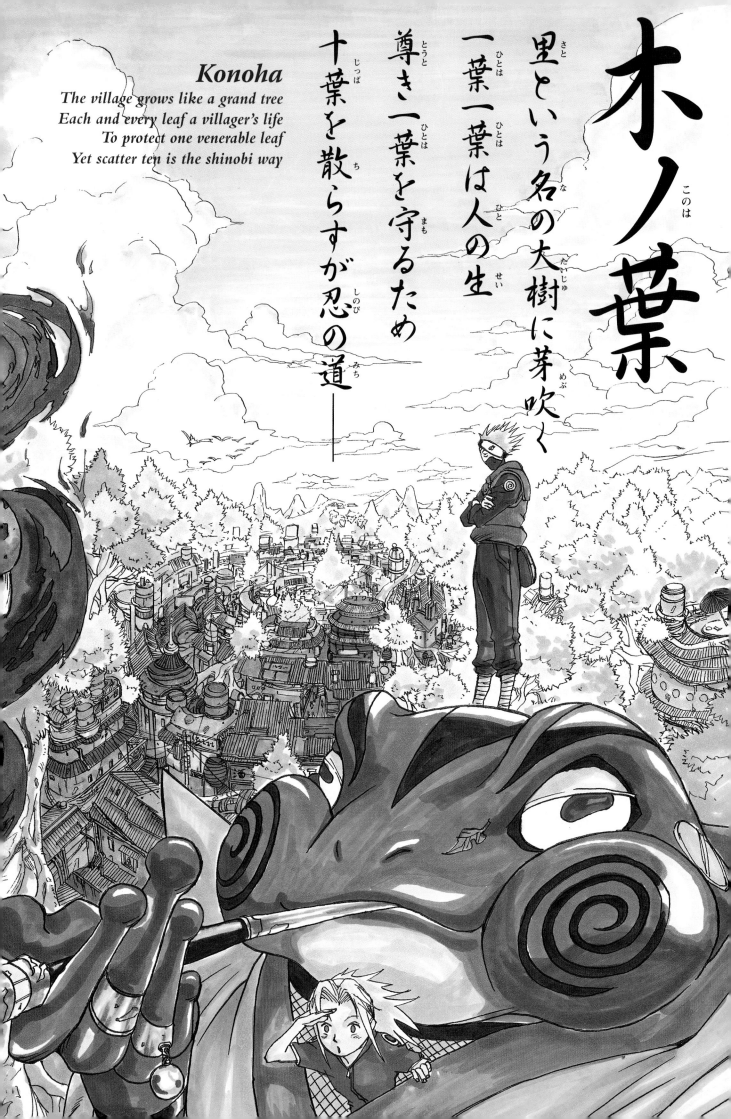

Konoha
The village grows like a grand tree
Each and every leaf a villager's life
To protect one venerable leaf
Yet scatter ten is the shinobi way

木ノ葉

里という名の大樹に芽吹く

一葉一葉は人の生

尊き一葉を守るため

十葉を散らすが忍の道——

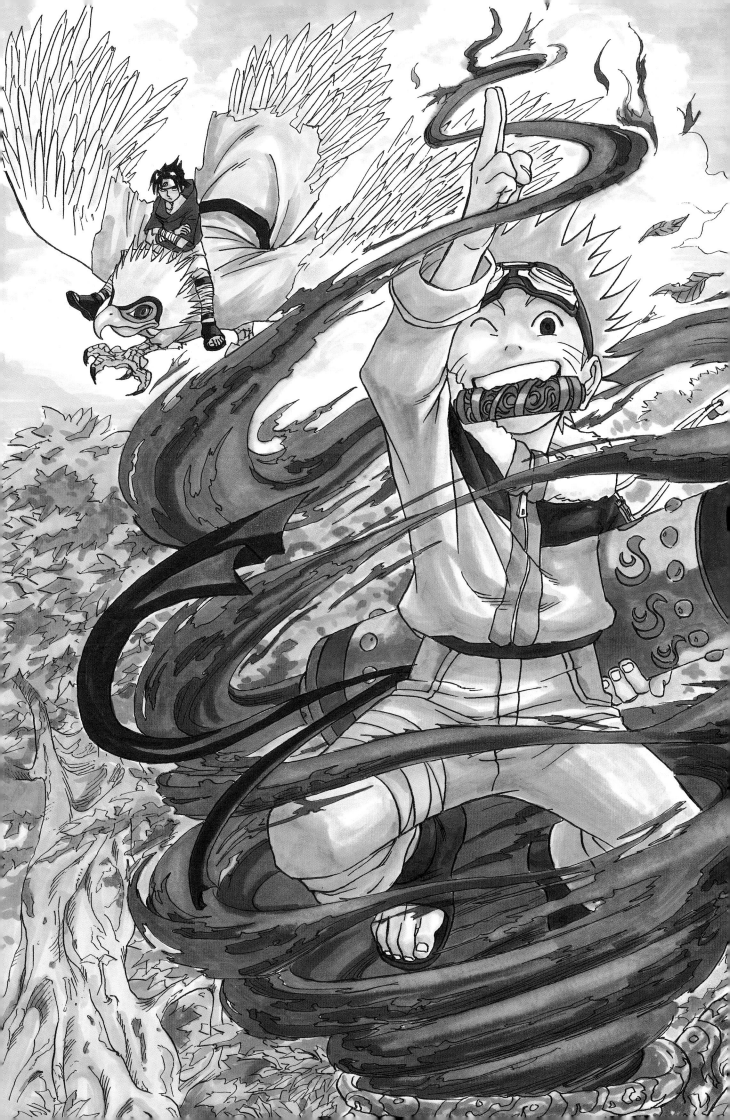

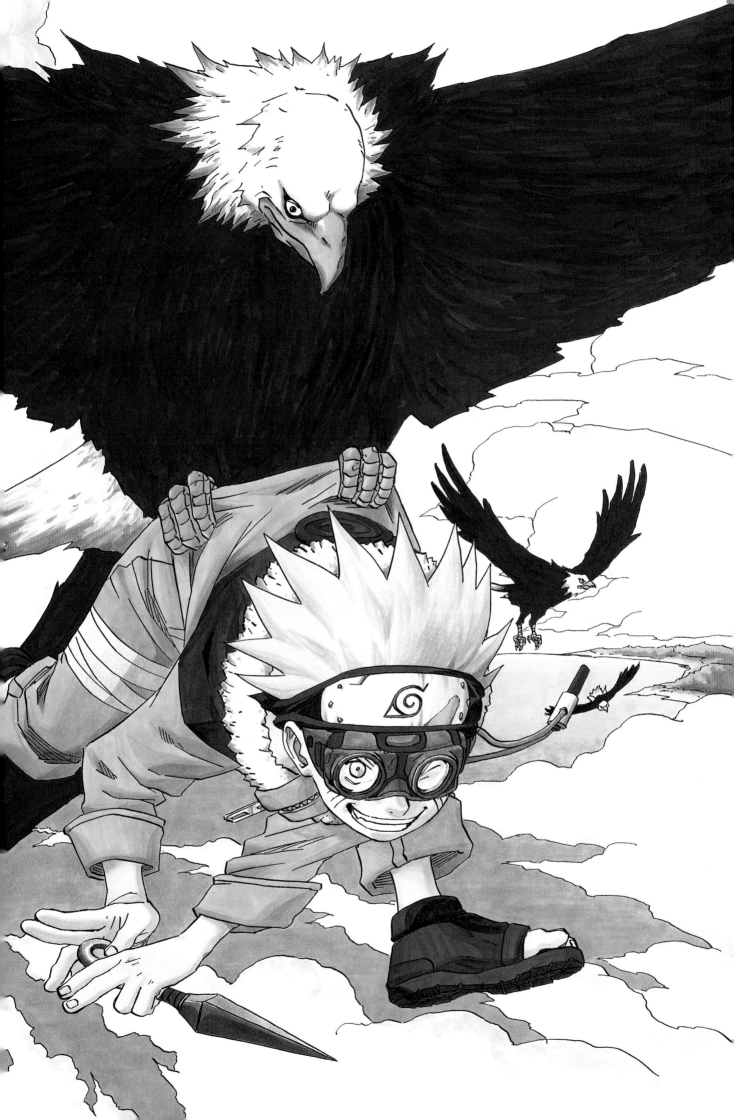

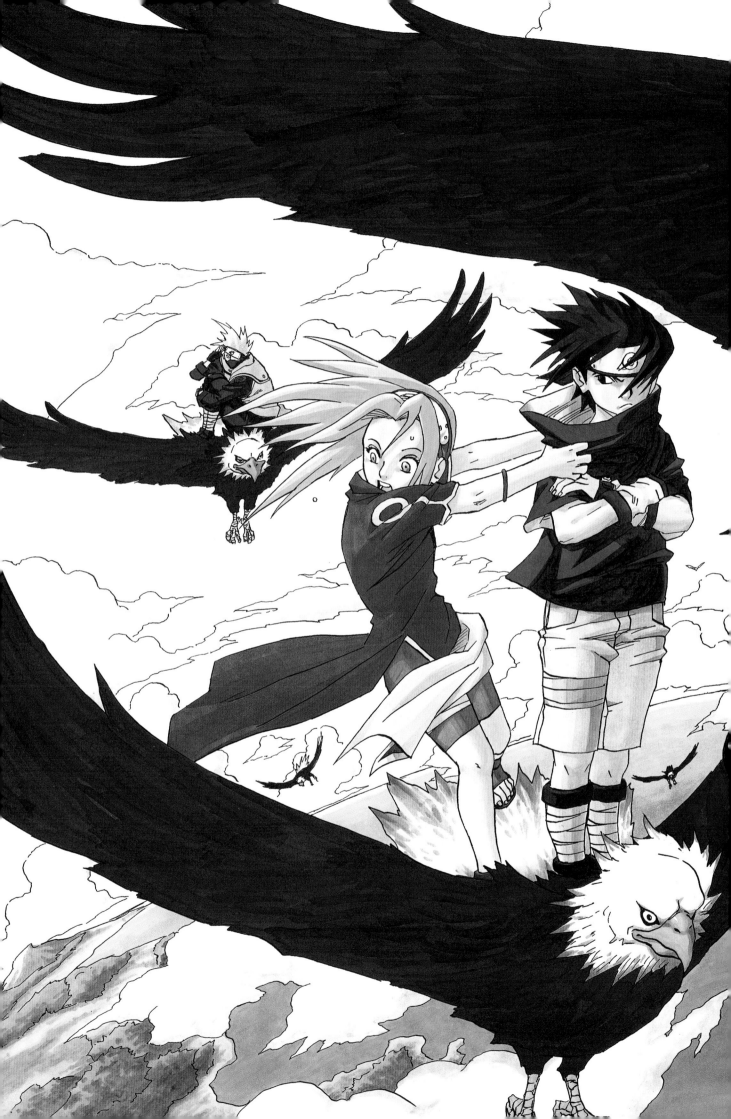

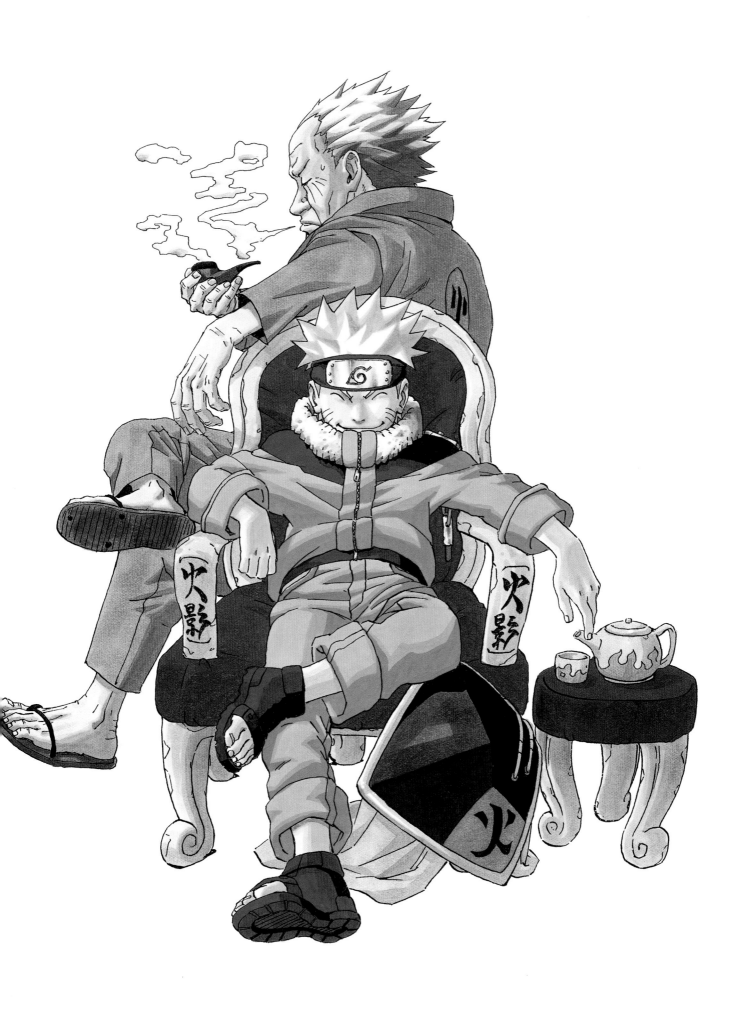

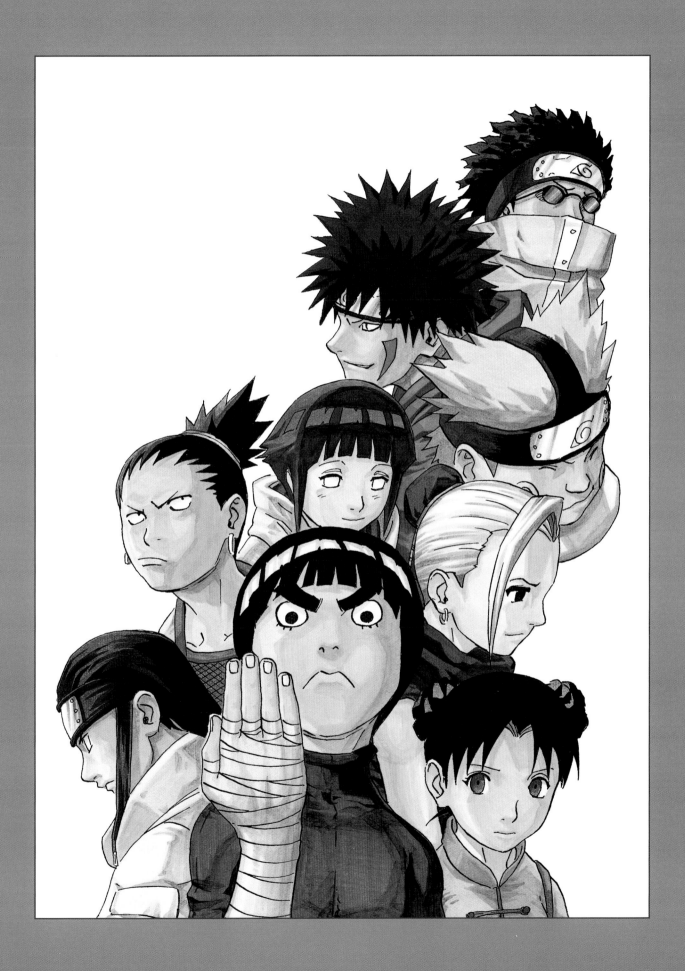

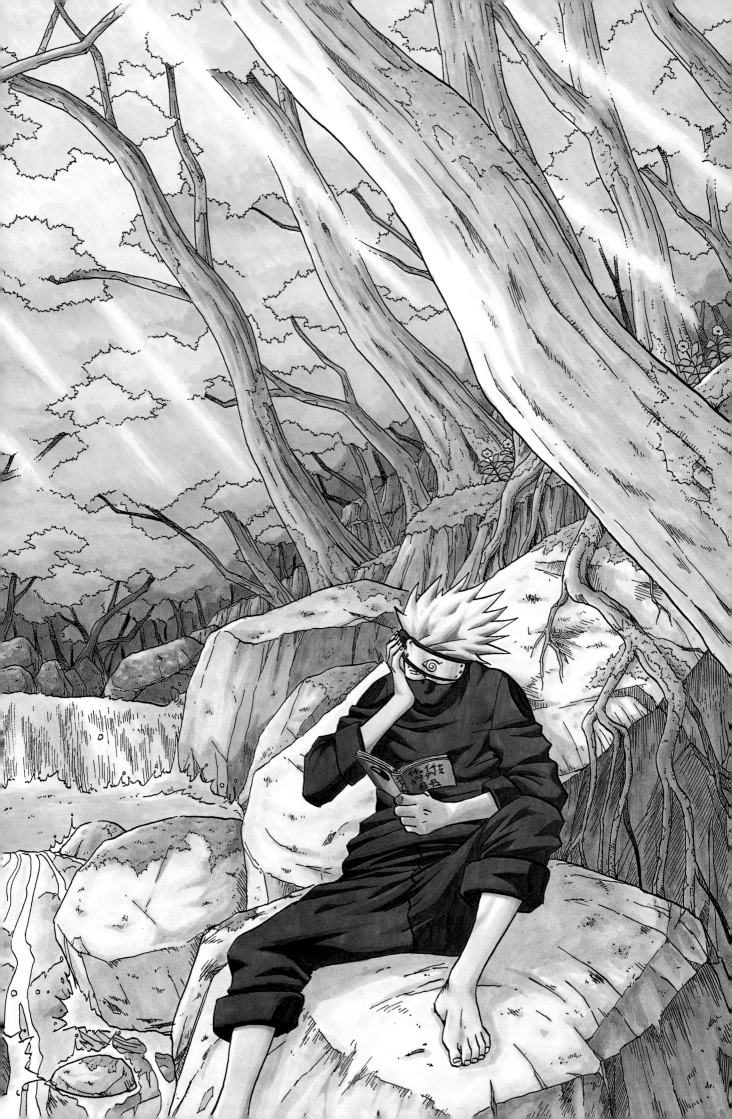

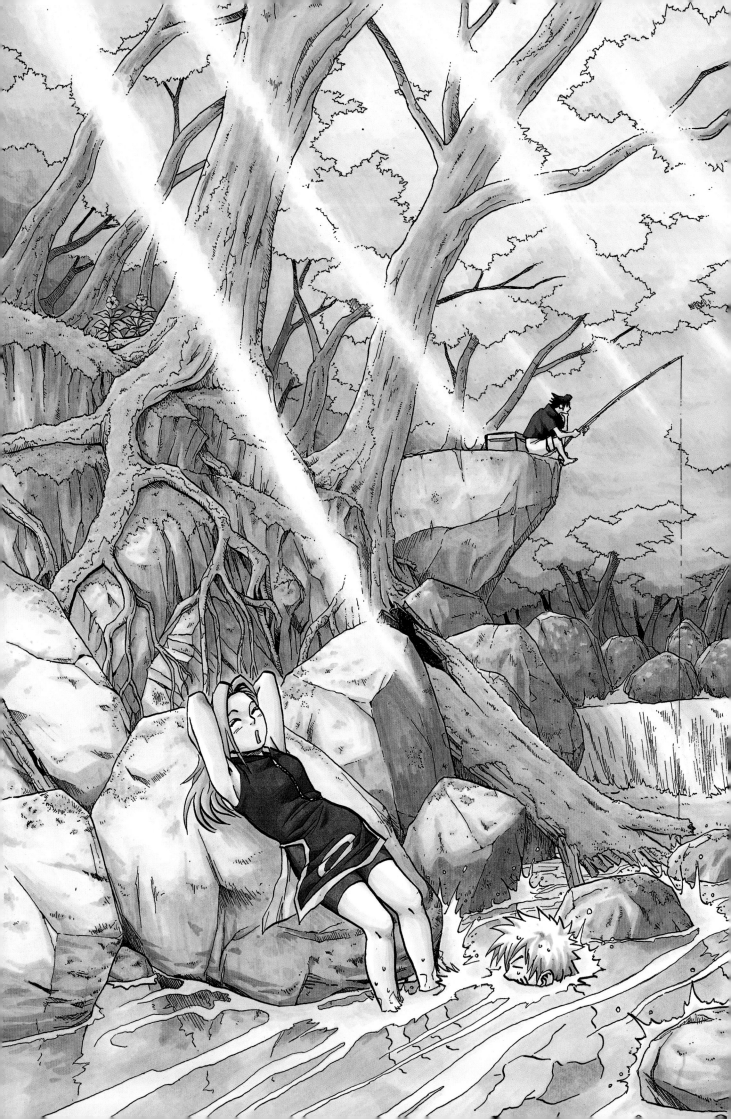

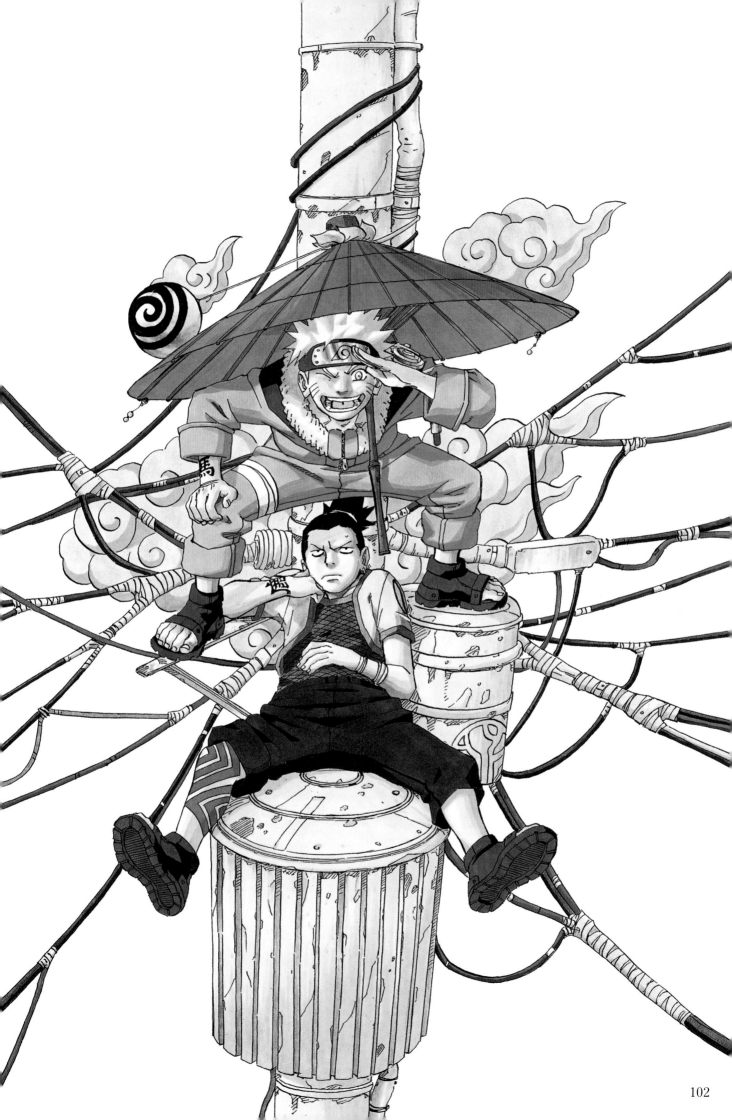

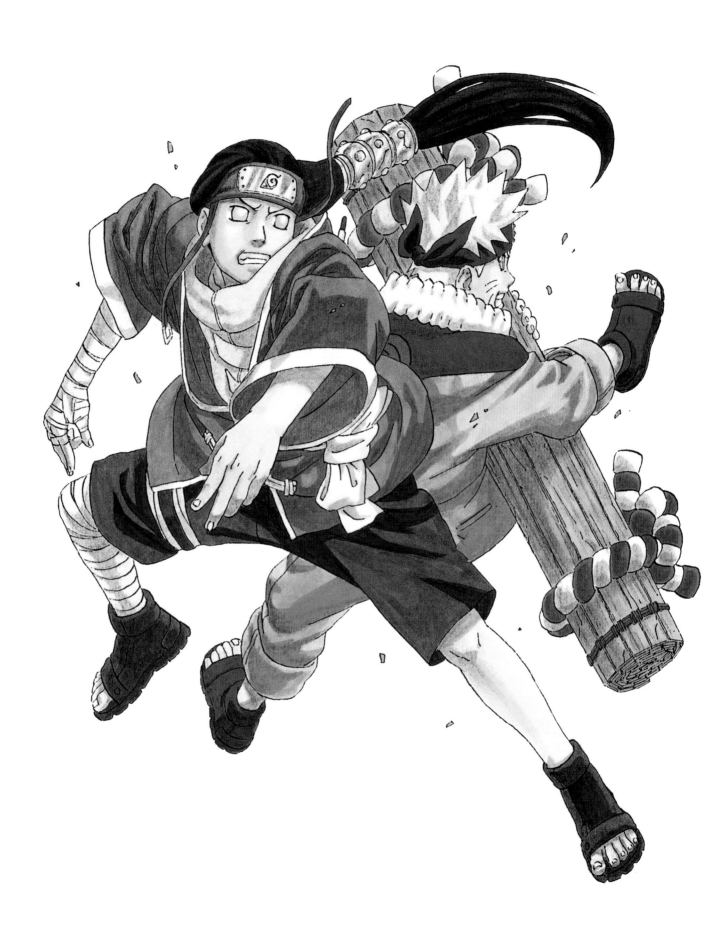

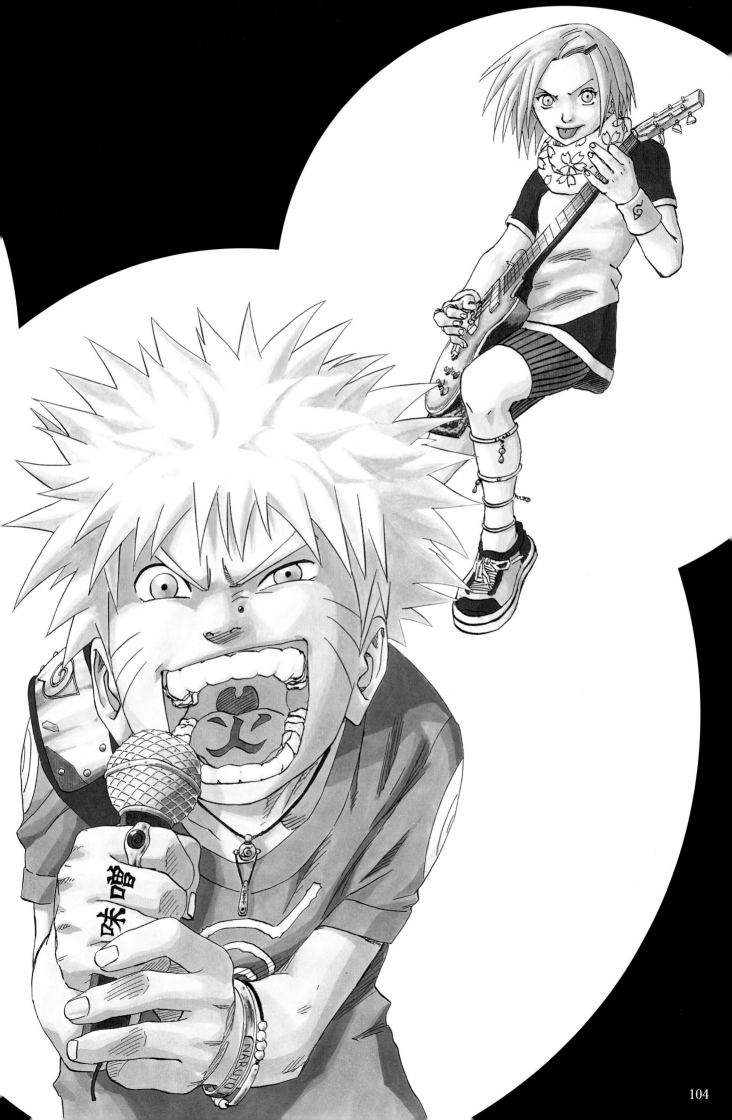

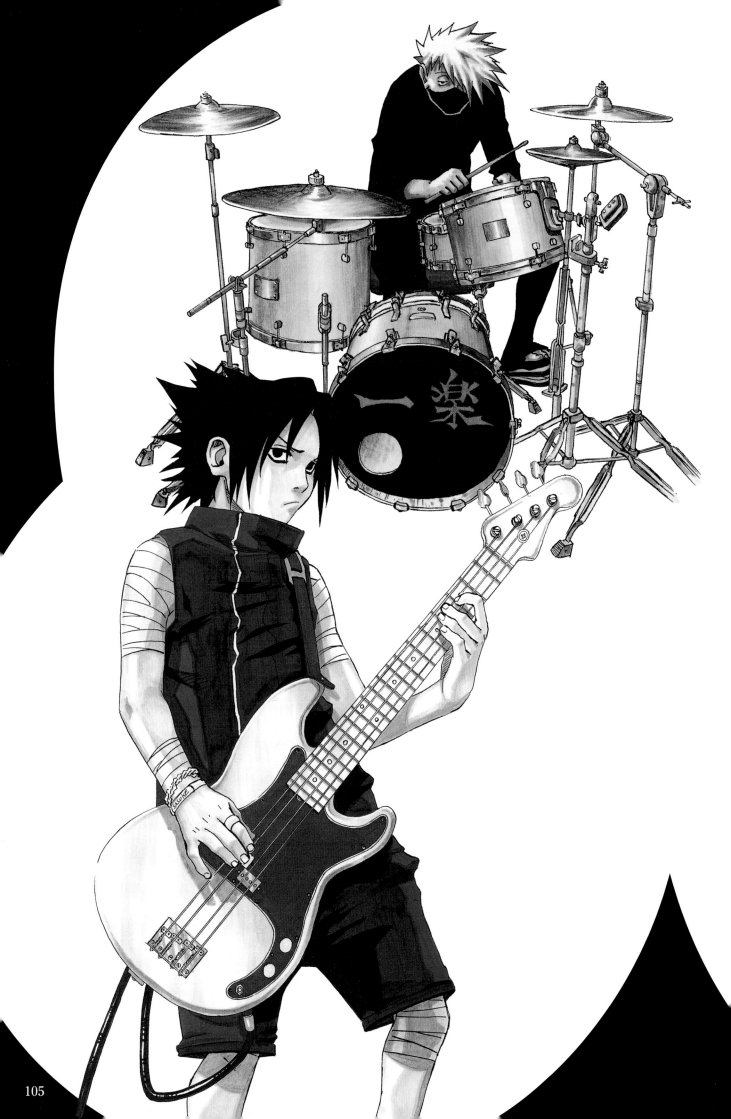

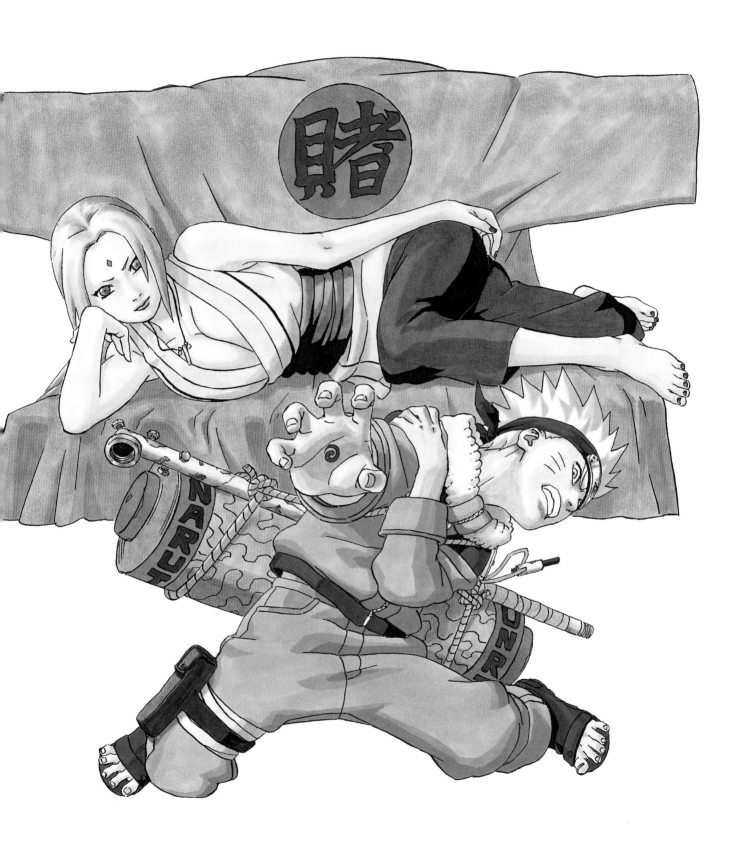

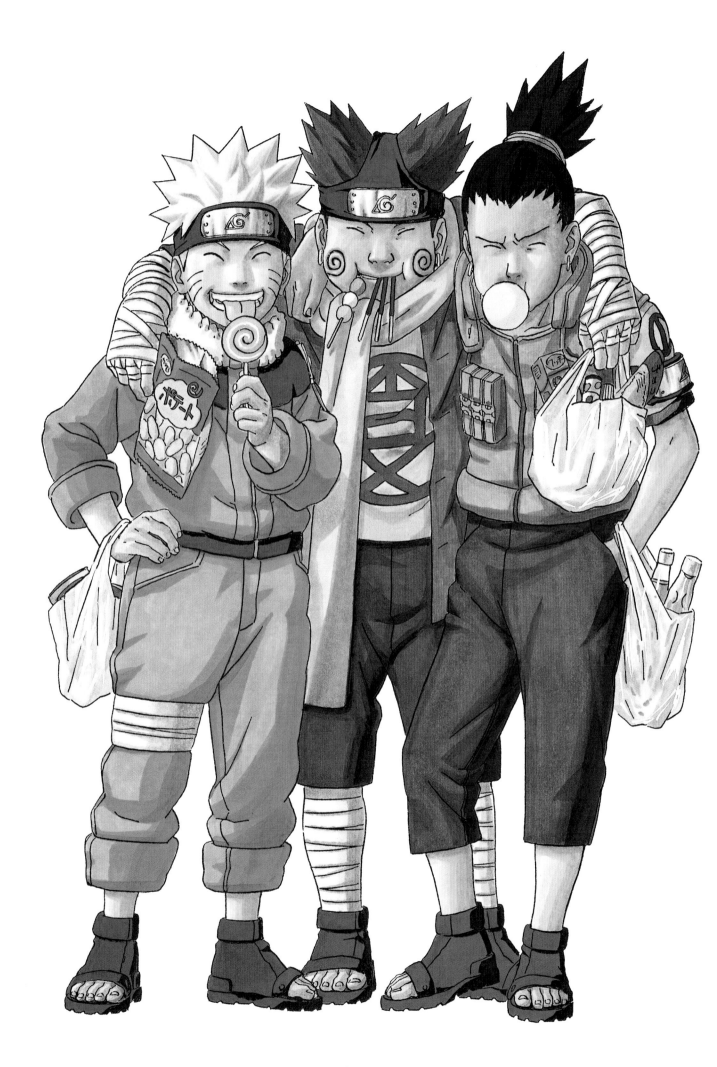

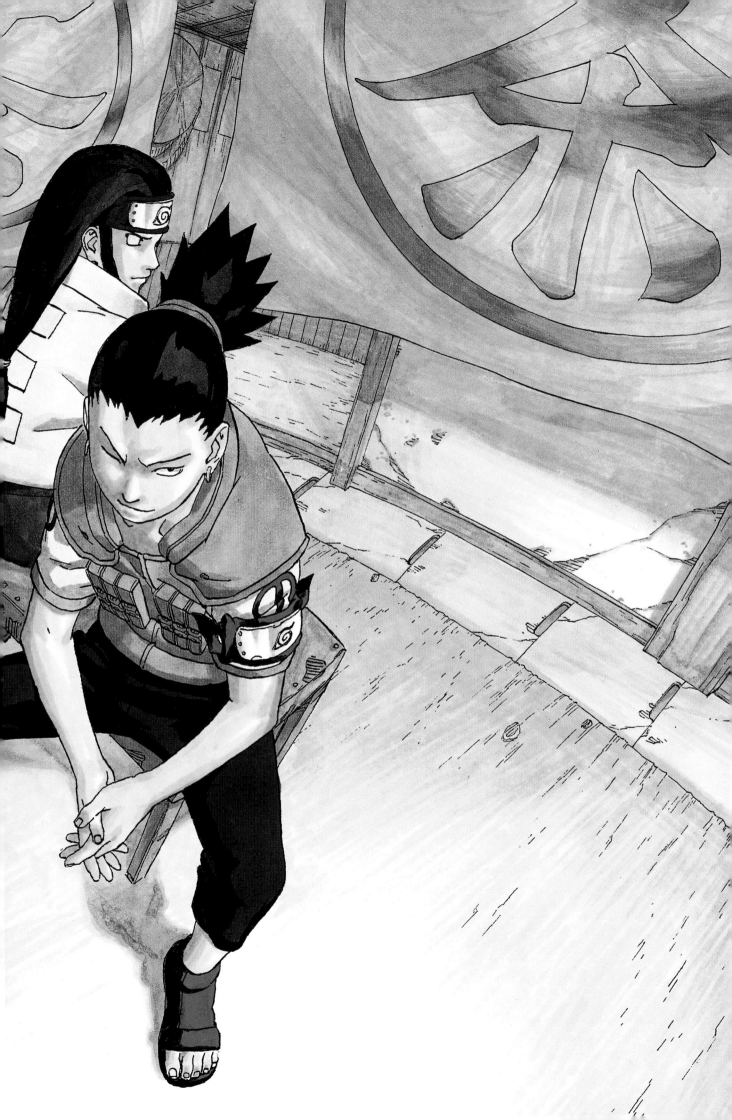

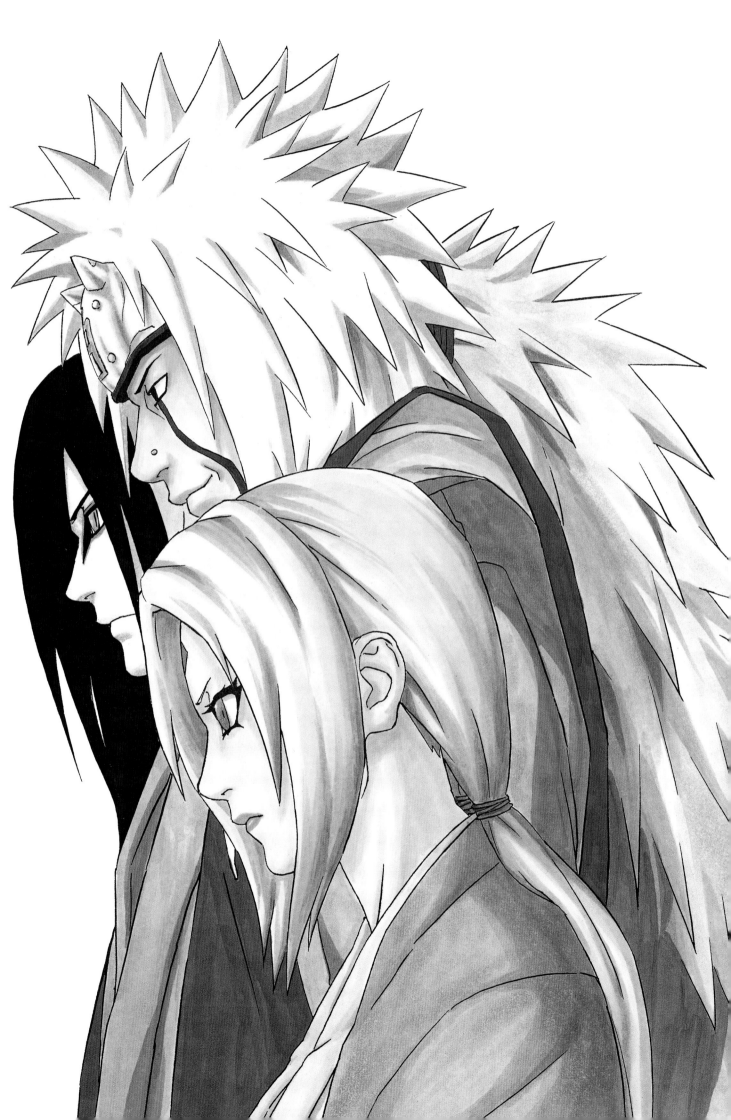

The Making of a NARUTO Illustration

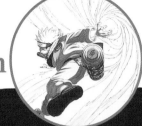

Kishimoto-style Artwork Secret Scroll

—The Way of Ninja Art—

*See the creation of the cover illustration from start to finish.
We checked out Kishimoto-sensei's workshop and documented and
photographed his artistic process from planning to realization.
Each and every moment of the Kishimoto-style
Artwork Secret Scroll will now be revealed!*

The workflow from start to finish

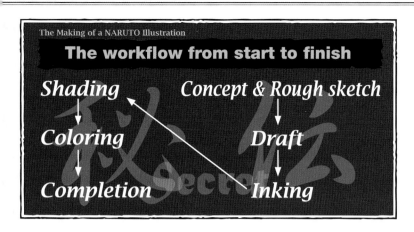

Shading → Coloring → Completion

Concept & Rough sketch → Draft → Inking

The path of an illustration from concept to completion...

The intricacy and vivid colors of Kishimoto-sensei's *Naruto* illustrations are consistently awe-inspiring. However, each illustration begins with a simple drawing and requires a multistage, detailed and delicate creative process to bring the initial idea to fruition. We took an in-depth look at Kishimoto-sensei's intense workshop and tracked the progress of this book's cover illustration from start to finish. The chart on the left gives a summary of the process.

Rough sketch

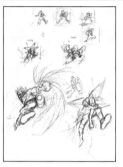

Since this is going to be the cover illustration, the composition of the image needs to be especially strong. A sketch of Naruto paired with Sasuke can be seen here.

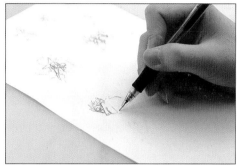

Drawings start on run-of-the-mill paper, such as copy paper. At this stage the size of the drawing is quite small, making it easy to evaluate the overall balance and composition.

Concept & Rough sketch

First, the fundamental elements, such as the character's pose and the overall look and feel of the illustration, are taken into consideration. In Kishimoto-sensei's case, he works out his ideas not only by picturing them in his head, but also by doing several sketches of the ideas that come to mind.

Draft ❶

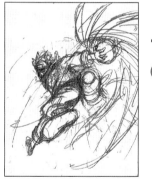

This is the enlarged rough sketch. As you can see, the composition and pose are already nearly finalized at this point.

Draft ❷

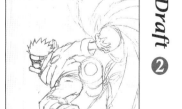

Outlines of the eyes and face are drawn and the illustration becomes clearer. Further detail, such as the pattern on the scroll, is also added.

He places a photocopy of the rough sketch—enlarged to the approximate size of the final illustration—on his beloved light box.

He places a sheet of manga drawing paper over the backlit photocopy and traces the lines. Little by little, the draft takes shape.

● Main tools

Mechanical pencil
He uses normal mechanical pencils with a 0.5mm lead and alternates between B and HB depending on the situation. He actually prefers regular pencils, but sharpening them can be a bother.

Manga drawing paper
He uses I.C 135kg paper, a rather thick, heavy paper made exclusively for manga drawing. To avoid running out, he always keeps a large stock on hand at the workshop.

Draft

After the pose and overall composition are chosen, he moves to the drafting stage. First, he makes an enlarged copy of the rough sketch and then draws clean outlines with a mechanical pencil based on the copy.

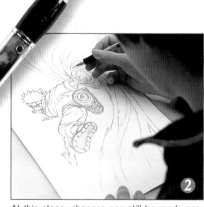

At this stage, changes can still be made easily with an eraser, so he experiments with several variations before deciding on the final lines. Tweaking and developing the design can take some time.

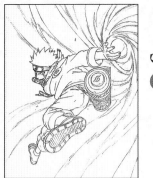

Here, inking of the top portion is done. In order to emphasize the flow of the wind, effects were added in the drafting stage.

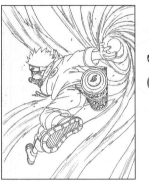

Inking is almost finished. There are no inconsistent lines or smudging and it is now largely complete. A plastic-nib precision pen is used to draw the detailed patterns on the scroll.

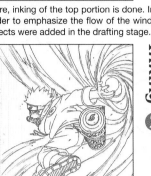

Shadows have been added to Naruto's face, jacket and the wrinkles in his clothing. This gives the illustration a three-dimensional effect and brings it to life.

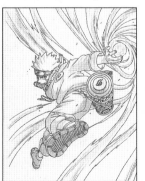

By copying in photo quality mode, the pencil shading is made softer. He copies it several times until one with the best tones is achieved.

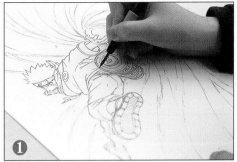

①

Taking a closer look, his determination and seriousness can be perceived just by looking at his hand gripping the pen. He is especially careful drawing the round lines of the scroll.

● Main tools

Maru-pen
Normally he mainly uses a G-pen to draw manga, but this time he's employing a single Maru-pen to draw the fine lines. He has always preferred Pilot pens for daily inking use.

Eraser
He's not terribly picky about his erasers, but he usually uses kneaded erasers that don't produce debris. To erase large surfaces, he just uses an everyday eraser.

The most important aspect of shading is the location of the illumination source. In this illustration, the source of light is the Rasengan in Naruto's right hand.

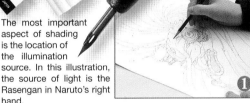

①

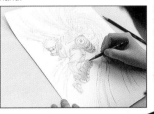

He employs a few pencils with different hardnesses and shades, holding the pencil slightly tilted to use the side of the lead instead of the point. After finishing shading...

● Main tools

Pencil
Depending on the desired shade, he chooses a 2B or 5B pencil. He uses soft lead pencils because they're good for shading large areas. He does not have a preference for any particular brand of pencil.

Kent paper
Kent paper is the hardest type of drawing paper and it has a smooth, flat surface. These features allow for smooth coloring.

Stage 3

Inking

After completing the draft he moves to the inking stage. Based on the draft, he carefully draws the main lines in with a Maru-pen. At this stage his expression suddenly turns dead serious. His concentration noticeably increases and his hand moves more carefully and precisely.

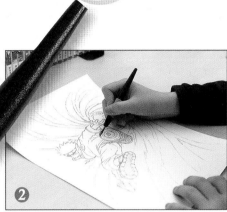

②

Holding the page steady with one's free hand is a basic skill. In order to view the entire drawing, he keeps his eyes about 40 cm away from the page!

Stage 4

Shading

This is done before coloring to add depth to the illustration. Kishimoto-sensei is a stickler for shading and he uses a special technique involving applying pencil shading to the inked illustration and then making photocopies in photo quality mode to adjust the tone.

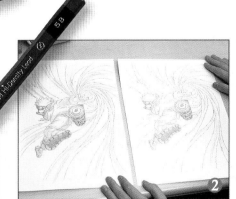

②

...he makes copies in photo quality mode. When the best shading percentage is achieved using the photocopier, he makes a copy on Kent paper.

The Making of a NARUTO Illustration

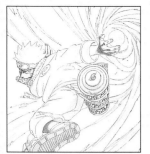

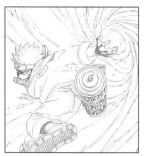

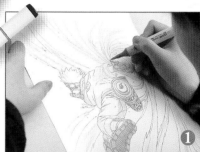

Coloring

After achieving the desired shading, he finally moves on to coloring. Color gradation is easily altered by the slightest pressure change on the pen, so the utmost attention and care is required. Here again, the light source has to be taken into consideration, and he begins to apply color from the paler areas.

He gets ready by placing boxes of COPIC markers on his desk. It's important for him to have everything in reach, and each tool has a designated position.

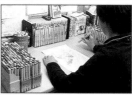

Coloring requires special care because it is difficult to fix errors. Whenever uncertain of a color, he tests it on another sheet of paper.

● Main tools

COPIC markers
These pens can be used to color the illustration without fear of the inked lines dissolving or becoming blurred. They come in a vast variety of colors, and Kishimoto-sensei owns 300, making full use of them all.

Correction fluid
He uses Misnon brand white correction fluid, applied with a brush, to erase unneeded lines and colors. For this illustration he also used a white correction pen to draw some effects.

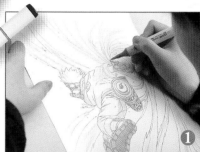

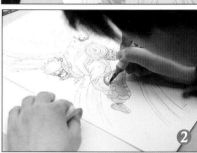

First he colors parts of the skin, such as the face, hands and feet. The right hand, which is closest to the light source, has the darkest shading. Coloring with confident strokes is key, since hesitating mid-stroke with COPIC markers creates unevenness in the color.

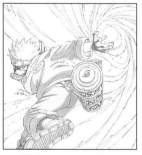

A paler color than usual is used for the skin since the strong Rasengan light source is close to Naruto. In contrast, the shadows are quite dark.

The hair is also brighter than normal. As you can see, the light source is strong enough to make Naruto's original hair color look lighter.

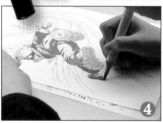

By this point, around two hours have elapsed. He often steps back from his work to evaluate it carefully before choosing colors for the still-uncolored portions.

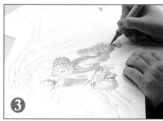

After finishing the skin and hair, he colors the clothing. The depth of color is determined according to the distance from the light source, so he must continuously adjust the angle at which he holds the page.

Three different color variations are used for the orange fabric, which has significantly differing tones in the shading. His coloring is highly detailed, paying attention to each wrinkle in the clothes.

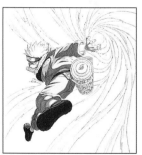

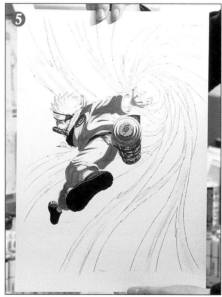

It took about another hour to color the Rasengan effects, but now the illustration is finally complete... and a brand new piece of Naruto art, as of yet unseen by the outside world, is born!

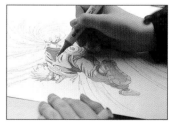

Since the light source is strong in this area, he needs to use colors outside of his default color set. After careful deliberation, he fills in the color details.

Inking is almost finished. There are no inconsistent lines or smudging and it is now largely complete. A plastic-nib precision pen is used to draw the detailed patterns on the scroll.

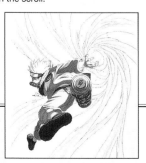

The swirling air around the Rasengan is expressed by adding white lines over the colors. The final result is an illustration full of overwhelming power.

The Making of a NARUTO Illustration

イラスト集 各画解説

渦巻

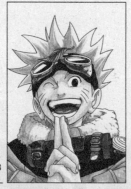

Weekly Shonen Jump 1999 No.43
Front cover

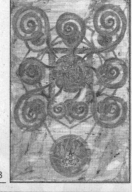

Weekly Shonen Jump 1999 No.43

UZUMAKI NO.02 P.013

This appeared on the front cover of the issue of *Weekly Shonen Jump* in which the serialization of *Naruto* began. **I mainly wanted to establish that this character is a ninja and convey his personality** by doing things like putting a leaf on his head, having him make a hand sign, making him look cheerful…but putting all these elements into one picture ended up making it appear jumbled. Also, I used a coloring pen called a COPIC marker here for the first time, and because I wasn't used to it yet, I colored little by little as if I were using a brush. As a result, the coloring came out uneven.

UZUMAKI NO.01 P.011

The overall image here is like that of a hanging scroll, something old and weathered. I drew a similar scroll for the front page of a *Naruto* one-shot before it became serialized. (The one-shot story originally appeared in *Akamaru Jump*, an extra issue of *Weekly Shonen Jump*, published in August 1997, and is now contained in the *Naruto Official Fan Book*.) The picture in the middle was my design for the Nine-Tailed Fox, **and the ninja appearing at the bottom are the Fourth Hokage (who sealed the Nine-Tailed Fox) and Gamabunta**. In order to convey the image of a ninja, I drew some smoke and shuriken around the Fourth Hokage. I also drew the Chinese character for "shinobi" on Gamabunta's stomach just to make it a little more obvious (*laugh*).

UZUMAKI

UZUMAKI NO.03 P.014

Here's another one I drew for a *Shonen Jump* cover commemorating the second anniversary of the *Naruto* series. Naruto's making peace signs, but holding up two fingers also represents the number 2, for the second anniversary (*laugh*). When I was drawing this picture, my schedule was so tight that my editor suggested, "Maybe it'd be easier to do a design where Naruto is appearing out of smoke?" As it turned out, **it was difficult drawing the right amount of smoke to cover Naruto's body (*laugh*).** I just couldn't decide how much of Naruto should be hidden or visible, or how to show him emerging from the smoke. The bluish color of the smoke was used to make Naruto stand out. I usually use this kind of color scheme so that Naruto's orange outfit will "pop."

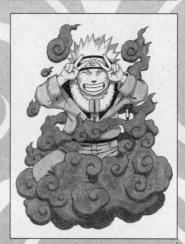

Weekly Shonen Jump 2001 No.48 Front cover

渦巻

Weekly Shonen Jump 2003 No.43

UZUMAKI NO.05 P.016–P.017

I created this piece based on **the catchphrase "Hide your appearance, but don't hide your dream"** (the winner of a catchphrase contest held by *Weekly Shonen Jump* in 2003). Naruto is hidden but his dream is not…I had a really hard time coming up with a composition that would express this idea while sticking to the *Naruto* style. Boy, this was a handful (*laugh*). [Naruto's banner reads "Number one under the sun! Hokage Naruto." -Ed.]

Naruto Vol. 1 Front cover

UZUMAKI NO.04 P.015

I spent a lot of time drawing this because it was for the cover of the first volume of *Naruto*. **It took me a week just to do the rough draft and about a day and a half to color it.** One reason it took so long to color is that I used gouache (a kind of opaque watercolor paint) I had had since college. I personally like gouache because you can use it to give a lot of depth to the colors. I ended up having to redraw the main lines with a precision pen because the paint covered them up. How's that for double work? (*laugh*).

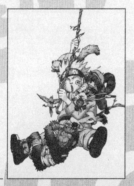

Weekly Shonen Jump 2001 No.26
Front cover

UZUMAKI NO.07 P.019

I actually like drawing animals, too. Partially because of Akira Toriyama-sensei's influence on me, I've always felt that **a manga artist has to be good at drawing animals.** So I've practiced them since junior high school. In this picture, I paid close attention to balancing the layout of the animals. I also wanted to draw some small object to spice up each animal, such as an apron for the dog, a hat for the *tanuki* (raccoon dog), a bandage for the monkey and a scroll for the weasel. But actually, the bird doesn't have anything… (*laugh*).

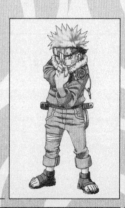

Weekly Shonen Jump 2001 No.14
Front cover

UZUMAKI NO.06 P.018

I wanted to draw Naruto's hands creating a sign, so I designed this to emphasize his hands. Also, I wanted to show the sign from the side instead of straight on. **I like drawing hands, fingers and toes.** But they're difficult…and I can't do them very well. Actually, I could've chosen at the beginning to have Naruto wear boots instead of sandals, but I picked sandals because I really wanted to draw toes. It's a major headache for the animators (*laugh*).

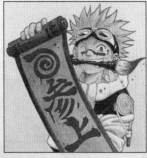

Weekly Shonen Jump, 1999, No.42

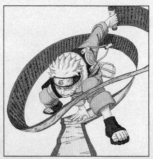

Yomu Jump, a supplemental issue of
Weekly Shonen Jump, 2002 Front cover

UZUMAKI NO.09	P.021

I drew this before the serialization of *Naruto* became a sure thing. I just drew it on my own…without any particular reason or plan to use it. I did it sitting under the *kotatsu* at my parents' home in Okayama (*laugh*). [A *kotatsu* is a small, Japanese-style low table with an electric heater underneath. A quilt is usually draped over the kotatsu to hold in the heat, and people sit with their legs in the toasty warmth under the table. -Ed.] I colored Naruto and his scroll with gouache and colored pencils and did the background with an airbrush. **This is the only picture I used an airbrush for.** The reason I stopped using an airbrush after this is…cleaning up afterward was a major pain!

UZUMAKI NO.08	P.020

I came up with this design in response to a request for a "cool pose." I think I did pretty well at **expressing Naruto holding on to the paper of the scroll through the placement of his right hand and the tension in his fingers!** I had intended this composition to be like a wide-angle lens shot, but it doesn't look that way, does it? The scroll in the foreground should be a little larger. The letters on the swirling scroll don't work, perspective-wise, either. Yup…I screwed this one up (*laugh*).

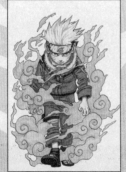

Weekly Shonen Jump 2000 No.26
Front cover

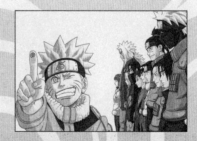

Weekly Shonen Jump, 2004 No.6 & 7, double issue

UZUMAKI NO.11	P.024

The editorial department requested a picture of Naruto walking out of smoke. Just like with the earlier image, I had a hard time figuring out how the smoke should cover Naruto and how much smoke there should be overall. What's more, **they specifically asked for a frontal light source, so it was difficult to shade it.** Around that time, my schedule was so tight that I even forgot what color Naruto was supposed to be wearing… Pretty careless, huh? Even the hair is random (*laugh*).

UZUMAKI NO.10	P.022–P.023

I drew this for the third *Naruto* character popularity poll. There's Naruto, who took first place in the readers' votes, and many of the other popular characters that populated the top of the list. Naruto is proudly facing forward. But when I look at his face now, he looks scary…! **Well, Naruto took first place, so it's okay for him to disturb the order of things** (*laugh*). The other characters are lined up according to their ranking in the poll. The composition here was easy. It's sometimes difficult to balance the layout of pictures for popularity poll results because there are so many characters in them…it can be really tough.

Of the pictures I drew in the early days of the series, this one is my favorite! In particular, **I was pleased with how the right hand turned out, and I really like the way it appears behind him.** In this design, Naruto is hurling a shuriken into the air, but I drew the shuriken on another sheet of paper. The movement of his hair and left hand really express that he's flying through the air. For this picture alone, I can really say "Man! This turned out good!" every time I see it.

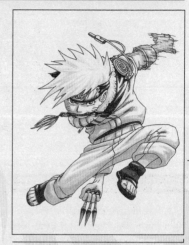

Weekly Shonen Jump 2000 No.14 Front cover

UZUMAKI

Weekly Shonen Jump 2000 No.50 Front Cover

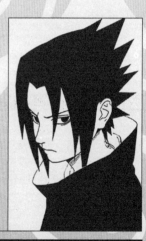

Weekly Shonen Jump 2004 No.27

Of all the characters, I had the most difficult time creating Sasuke's look when I started the series. In particular, I couldn't get a concrete idea of his face. Sasuke was supposed to look the same age as Naruto, but he looked far older and more mature. Also, the light source in this picture is supposed to be from below, but the shading doesn't express that well. In fact, the scroll's shadow doesn't cover Sasuke's face the way it should. I guess I cheated a little.
Even now, **I have difficulty drawing Sasuke (*laugh*).**

I wanted to make Sasuke look menacing, so I drew his eyes fiercer than usual. I used to make Sasuke's hair shorter so it wouldn't be so difficult to draw, but it's getting longer now.

渦巻

UZUMAKI INDEX & COMMENTS

Naruto Vol. 17 Front cover

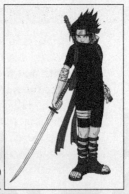

Weekly Shonen Jump 2002 No.30
Front cover

UZUMAKI NO.16　　　　　　　　　P.030–P.031

I wanted a sense of symmetry in this picture with Naruto rolling over Sasuke's back. **I positioned these two with their arms and legs in similar stances**, then I balanced the overall composition by putting two crossing scrolls in the background. Also, the scroll Naruto is holding forms a circle…yep, it's an X and an O (*laugh*). Basically, it was symmetry that kept me focused on the overall balance in this one. Looking at this picture now, it appears that my drawing style has changed a bit since then. Maybe I've been influenced by the anime? This is one I like a lot.

UZUMAKI NO.15　　　　　　　　　P.029

This picture of Sasuke appeared as part of a composition for a *Shonen Jump* front cover alongside images of Naruto and Gaara. Due to space considerations, I ended up drawing Sasuke in a long, vertical pose. One problem here was whether or not the sword Sasuke's holding would fit in the scabbard—I remember **I had to carefully measure the length of both the sword and the scabbard.** Also, the picture appeared somewhat plain after coloring it, so I made Sasuke's sash red. Because of that detail, this may be a pretty rare picture of Sasuke.

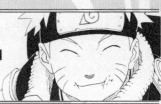

UZUMAKI

ILLUSTRATION

INDEX

UZUMAKI NO.17　　　　　　　　　P.032–P.033

I wanted to express the concept of the main storyline, where Naruto and Sasuke come into conflict, in a single image. Since they know each other so well, they aren't showing hostility even as they cross knives. They look rather calm. I thought that if I gave them obviously antagonistic expressions, it would come off as too deliberate. By hiding their feelings, I hoped the calm atmosphere would seem chilling.

I put the **two motifs of sky and sea** in the background in order to express a sense of the characters' conflict and contrast. The green and red, and the sky and sea, represent things that never mix.

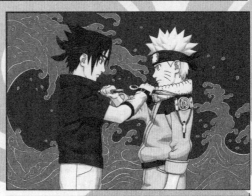

Weekly Shonen Jump 2003 No.37 & 38, double issue

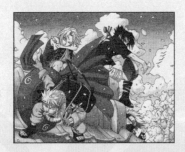

Weekly Shonen Jump 2002 No.17

UZUMAKI NO.19	P.036–P.037

Cherry blossoms in full bloom…it's springtime in Konohagakure. My concept for this picture was the characters having a cherry blossom viewing party, so I gave them some objects to suggest that. Naruto has a drinking cup, Sasuke has a Japanese musical instrument, and Sakura has a bento box containing rice dumplings and other foods. Fun, lots of fun. Kakashi was…actually kind of a distraction in this one. But I felt bad for him and decided to leave him in (*laugh*). And I showed that there's a breeze by drawing the cherry blossom petals as if they are being blown. **It feels good when I can make the wind blow in a picture.**

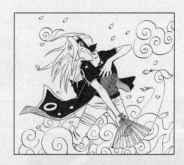

Weekly Shonen Jump 2000 No.49

UZUMAKI NO.18	P.034–P.035

Sakura is twirling in a storm of cherry blossom petals. **For this picture, I imagined Sakura dancing** rather than fighting. This was for the title page of the episode where Sakura fights the Sound ninja in the Forest of Death, so I drew her with a resolute expression. Her clothes are different from what she usually wears. She usually wears leggings, but here she's wearing something more like pants. Maybe that was her look in the early years? When she first started appearing in the series, she wore something like the pants shown here.

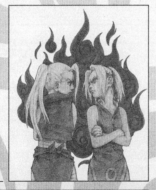

Weekly Shonen Jump 2001 No.17

UZUMAKI NO.21	P.039

I wanted to keep this picture looking like a pencil sketch. I lightly colored in the already fully shaded pencil drawing. I tested out a method of using two similar colors for each character's hair, skin and clothes, and another similar-toned pair of colors for the background. **I tried to make the picture look three-dimensional by changing the level of contrast in these colors.** I made one large mistake, though…I forgot to draw Ino's earrings (*laugh*).

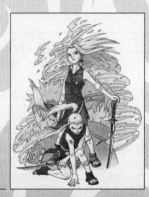

Naruto Vol. 6 Front cover

UZUMAKI NO.20	P.038

Naruto doesn't figure prominently in the story of this volume (vol. 6), so I thought **it might be a good idea to feature only Sakura and Ino on the cover.** Of all the cover art I've done for the manga volumes, this is the only one in which Naruto doesn't appear as a featured character. Although this seems extraordinary now, at the time I was actually considering featuring different characters on the cover of every volume…but I ended up putting Naruto back in as the featured character starting with the next volume (*laugh*). From a composition perspective, by having wind blowing in opposite directions in the upper and lower parts of the picture and by putting Naruto and Sasuke in the background, I was trying to juxtapose Naruto and Sasuke's rivalry with that of Sakura and Ino.

渦巻

UZUMAKI INDEX & COMMENTS

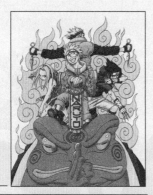

Weekly Shonen Jump 2000
No.30 Poster

| UZUMAKI NO.23 | P.042-P.043 |

When I drew this, I was focusing on balancing all the elements in the layout. To maintain symmetry in the image, I kept Naruto in the center, Kakashi with his arms outstretched, and Sakura and Sasuke on either side, both with one arm extended and the other bent. All together, **they form the image of the Chinese character for tree (木).**
Since this picture was going to be made into a poster, I had to think about where the fold lines would go. It made things harder, because there are only so many compositions that would work.

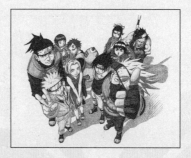

Weekly Shonen Jump 2001 No.5 & 6, double issue

| UZUMAKI NO.22 | P.040-P.041 |

Looking at this picture makes me tired. **The composition is like something viewed through a fisheye lens.** However, the characters' positions and the balance in their height differences are… What can I say? I lacked the ability at the time and couldn't draw them well. Even now, it takes so much time and effort to draw a picture that looks like it's viewed through a fisheye lens… It takes me two or three times as long to make a rough draft. That's why just looking at this picture makes me tired (*laugh*).

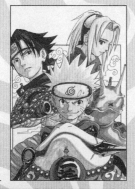

Weekly Shonen Jump 1999
No.46

| UZUMAKI NO.25 | P.046 |

I used many layers of color for the snake scales here, but I still couldn't get the colors I wanted… (*laugh*). As I layered more and more colors with the COPIC markers, the color went further and further off. Then it got to the point of no return… Also, I distinctly remember drawing Sakura. She's known for her broad forehead so I focused on the forehead when I drew her, and then I realized that **her forehead was way too broad (*laugh*).**

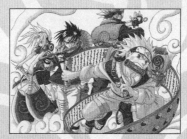

Weekly Shonen Jump 2000
No.7

| UZUMAKI NO.24 | P.044-P.045 |

I drew this picture for the front color pages in the magazine. It was only my second time doing it, and as you might expect, I was pretty excited about it.
Not only had it been a while since I was last asked to do color pages, but I also heard that **if your manga isn't popular, you don't get offers to do the first story with the color pages.**
When I thought, "Wow, so my manga is getting popular?!" I got pumped. So I really enjoyed drawing this one.
…But I almost missed the deadline, so it was pretty brutal (*laugh*).

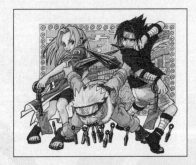

Naruto Vol.2 Front cover

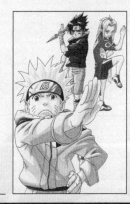

Weekly Shonen Jump 2000 No.7 Front cover

UZUMAKI NO.27 P.048

This is the front cover of volume 2. These three look much younger here than they do now.
I tried to draw them cute because the main characters are children. After all, I didn't yet have a concrete image that said, "This is Naruto!" at that time.
Anyway, **Naruto and the other kids have been growing up throughout the story,** so they look really young when I see them in this picture now.
I drew background scenery for this one.
When I look at comics on bookstore shelves, covers without backgrounds look simpler and the characters stand out more. So recently I've started to think that I shouldn't do backgrounds for my covers.

UZUMAKI NO.26 P.047

This was on the front cover of *Jump*. I got a request to draw something like a superhero team for kids. **Those heroes really strike great poses, don't they?**
This is Naruto, Sasuke and Sakura in hero poses.
I wondered if Sasuke's personality would allow him to pose like that. But I knew Naruto would be willing to pose for sure, and so would Sakura, so I thought it'd be okay for Sasuke to strike a pose, if somewhat bashfully.

渦
巻

UZUMAKI INDEX & COMMENTS

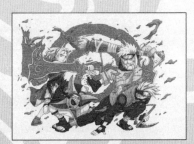

Weekly Shonen Jump 2001 No.48

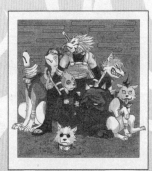

Weekly Shonen Jump 2001 No.39

UZUMAKI NO.29 P.050–P.051

Kakashi always seems really laid-back, but here I drew him to look dashing and cool.
All the members of Kakashi's team are posing heroically here.
I drew the blade of Sakura's sword like it's a flickering flame. See how it looks kind of like it's too hot to handle? (*laugh*).
I didn't want Naruto to hold a sword because I thought that **a hero holding a sword would look too stereotypical…**Besides, then it would suggest that this is a samurai manga.
That's why I thought something subdued but still Japanese, like a brush, might suit Naruto.
While drawing this I realized it wasn't very dynamic, so since Naruto has a brush, I added a huge swirl in the background to give it some oomph.

UZUMAKI NO.28 P.049

This is Kakashi with his ninja dogs during his time with the Anbu Black Ops.
Around this time, I was thinking about using Pakkun again in some other scene **because pug dogs are cute (laugh).**
Basically, I like dogs. So I wound up wanting to have them play various important roles in the story.
I got a cat recently, though…
When I examined the way my cat moves, I started thinking, "Cats are good, too."
Maybe I'll draw a ninja cat next time (*laugh*).

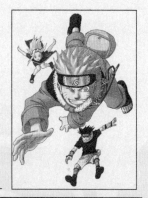

Weekly Shonen Jump 2002
No.43 Front cover

UZUMAKI NO.31　　　　　　　　P.053

I focused on angles here in order to give this picture an appearance of depth.
I drew all three characters separately, and then, when I composed it, I adjusted their proportions to express the depth. This picture shows Naruto coming headfirst **from a straight-on angle,** so it needed to have depth.

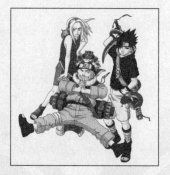

Weekly Shonen Jump 2003 No.17

UZUMAKI NO.30　　　　　　　　P.052

I drew this picture focusing on three characteristics: Naruto's lively energy, Sasuke's snobbery and Sakura's annoyance at the slug on her shoulder (*laugh*). When I draw these three, **I always draw them in several poses on separate sheets of paper.** Then, I pick out my favorites at the moment and combine them.

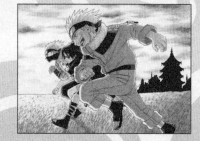

Weekly Shonen Jump 2002 No.43

UZUMAKI NO.33　　　　　　　　P.056-P.057

This is embarrassing…
I wanted to draw Naruto and the others in **an embarrassingly typical youth scene, "running through a field with the sunset behind them!"** (*laugh*) in high spirits.
Then, this scene was used for the opening of the animation (*laugh*).
What bothered me here was deciding whether Sakura or Sasuke should be closer to the foreground.
As the main character, Naruto appears in the very front and Kakashi, the teacher, humbly appears in the rear. Those were easy decisions, but…
It was really difficult for me to decide on the relative positions of the other two.

Weekly Shonen Jump 2003 No.5

UZUMAKI NO.32　　　　　　　　P.054-P.055

This is a scene in which the three main characters are pursuing their targets with weapons in hand.
The shuriken stuck in the trees show that they're meeting resistance.
In order to create **a ninja-like "chase"** I thought it'd be better to include things like shuriken.
The hard part here was Kakashi. I couldn't decide where to put him, so in hopes of keeping Kakashi at a distance but still making him stand out, I made his tiny figure visible through the shuriken hole (*laugh*).
There's a contrast between the seriousness of the three young ninja and Kakashi's lighthearted humor.

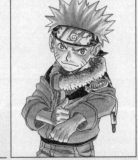

Weekly Shonen Jump 2003
No. 37 & 38, double issue

UZUMAKI NO.35 P.059

I drew this for a *Jump* cover. This pose was based on a request from the editorial department.
In this posture, his face is supposed to be covered by his jacket's collar, **but it turned out horribly.** His hands are too small and the head is way too big!
It's a total failure (*laugh*).

UZUMAKI NO.34 P.058

I drew this picture for a group cover with other *Shonen Jump* characters.
At the request of the editorial department, I was supposed to draw "Naruto with a light source from below."
But it didn't turn out very well…
His neck is not in the right position…
He is kind of in a cool fighting posture, though.

Weekly Shonen Jump 2001
No. 5 & 6, double issue

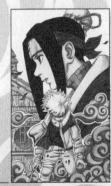

Weekly Shonen Jump 2000 No.7

UZUMAKI NO.37 P.061

This series of pictures is supposed to be from the point of view of **a camera on a shuriken.**
I drew the scenes from this perspective in an effort to express speed and dynamics. These were some of the first color pages I had the opportunity to create, so it seems like I put maximum "excitement" into these (*laugh*).

Weekly Shonen Jump 2000
No. 21 & 22, double issue

UZUMAKI NO.36 P.060

This is Naruto with the Nine-Tailed Fox awakening inside him.
Basically, the atmosphere is dark.
Naruto is glaring downwards and not smiling like usual, so I used dark colors here instead of bright ones. I put dark colors on his face and made the outlines of his eyes dark too.

UZUMAKI INDEX & COMMENTS

渦巻

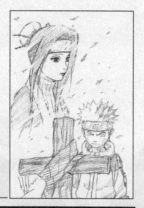

Naruto: Innocent Heart,
Demonic Blood Illustration

UZUMAKI NO.39 P.063

I almost forgot that I drew this one (*laugh*).
Rather than use a pen, I thought **it'd look cooler to use pencils to shade it.**
I wanted to create something different from what's usually seen in the manga.
Actually, I wanted to express this picture in lighter tones.
This is the scene where Naruto determines his ninja path while standing in front of Haku's grave, realizing that Zabuza and Haku's way of life was wrong.

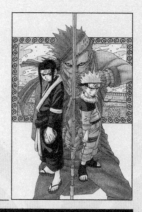

Naruto Vol. 4 Front cover

UZUMAKI NO.38 P.062

I think **Naruto and Haku are very similar.**
They had similar upbringings and experiences.
In the story, they accepted each other when they first met, so I had them stand back to back.
But the image here has Zabuza standing between the two as if to disallow or cut off their relationship.
Naruto looks pretty serious here… I rarely draw his face like this.

Weekly Shonen Jump 2002
No. 30

UZUMAKI NO.41 P.065

The point here is Gaara's metamorphosis.
This is one of my favorites. I think **I executed the picture in the middle panel especially well.** In terms of the composition and color scheme, you can see the quality in things like the connection between the sand and his skin.
His left hand turned out well too. His pose looks so powerful. I like this one, even looking at it now.

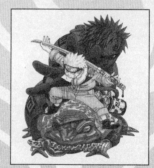

Naruto Vol. 8 Front cover

UZUMAKI NO.40 P.064

This is another picture where the color scheme was my major focus.
I colored Gaara red and used green as a complementary color for the frog. And there's Naruto in orange standing imposingly in the center.
I made Naruto stand out through color selection and positioning.
By the way, the frog's eye patch has an **"unhappy face"** symbol (*laugh*).
The mouth is tight-lipped with both ends turned down…(*laugh*). I drew this symbol a lot.
Konohamaru wears this unhappy face badge too.

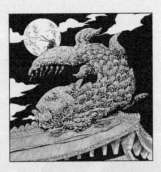

Weekly Shonen Jump 2001 No.40

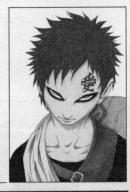

Weekly Shonen Jump 2002
No.30 Front cover

UZUMAKI NO.43	P.067

Some people may wonder about the tubes on the roof. I drew them just because I like pipes and tubes (*laugh*).
I like things that look chaotic.
I love to gaze at things like electric poles and outdoor air-conditioning units. When I was in Okayama, I often took pictures of electric poles (*laugh*).

UZUMAKI NO.42	P.066

I drew him glaring upwards with a pretty menacing look but…whenever I draw boyish faces, they tend to get off track for some reason.
It happened here too…
There wasn't enough time (*laugh*).

Naruto Vol. 15 Front cover

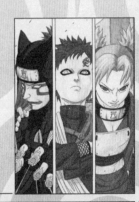

Weekly Shonen Jump 2004
No.22 & 23, double issue

UZUMAKI NO.45	P.069

This is one of my favorites! I might like this one the best of all.
I still remember that there was an opening page of *Dragon Ball* with Goku and Freeza glaring at one another.
I wanted to draw that kind of "eyeball-to-eyeball rivals" type of picture.
I made this composition of Naruto and Gaara symmetrical to draw attention to their confrontation.
I drew the eyes of a *tanuki* and a toad in the background. Originally I'd wanted to draw a fox instead of a toad. I had a lot of trouble deciding, but I chose the toad in the end, taking into consideration the story context and the color contrast between green and red.

UZUMAKI NO.44	P.068

This is a scene where the three siblings from Suna-gakure come to help Naruto and his friends. I changed all three of their costumes because **their old costumes were too difficult to draw (*laugh*).**
Of course, it also shows the image change, implying the change in their relationships with Naruto and the rest.
Of these three, my favorite is Gaara's upright collar costume.
Costumes that cover the neck look pretty cool. They look like something out of *The Matrix*.
I really love that movie.

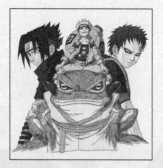

Naruto Vol.13 Front cover

UZUMAKI NO.47 P.071

Actually, I wanted to draw only Sasuke and Gaara here, because they're the two who fight each other in the Chûnin Exams. But this was for a book cover so I had to put Naruto in as the main character.

This picture represents a scene where sparks are flying between Sasuke and Gaara, while Naruto plays the spectator sitting on the toad (*laugh*).

This toad is a Shaolin kung fu master! That's why he wears a uniform.

There are many other unique toads besides him, and I'm sure I'll want to draw them in the future.

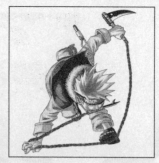

Weekly Shonen Jump 2000 No.50 Front cover

UZUMAKI NO.46 P.070

This is also a favorite. It has a really dynamic feel. Because the equipment on his left shoulder bounces hard, a momentum-driven Naruto sinks down into his next movement. By expressing the constrained force through the tightly pulled chains, I could **imply the explosive power coming in the very next moment.**

Incidentally, I often include weapons in my drawings, but I don't reference anything in particular. This chain scythe didn't have a model, but it's not original either…I was inspired by weapons I've seen in many other manga.

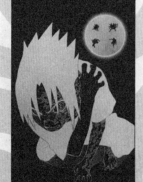

Weekly Shonen Jump 2003 No. 33

UZUMAKI NO.49 P.074

Kidomaru was the first character I created of the Sound Ninja Four. This image shows him with insect-like hands and legs so he looks like a spider…The next character was Tayuya because I wanted to include a lone girl in the boys' group. After that came Jirobo. I wanted to put a huge guy in the group and have a character different from the others. I created Sakon last, **but it took me some time to decide who I should have Sakon fight against.** In the end, I imagined a two-on-two battle with Kiba and Akamaru, and combined the Sakon and Ukon twins into one person…When I create adversary characters, I keep in mind who and how they fight to make the battles interesting.

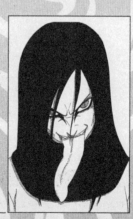

Weekly Shonen Jump 2003 No.21

UZUMAKI NO.48 P.072–P.073

Orochimaru's scary looks are his trademark. His look is just badder than bad; even his complexion looks pasty and sickly.

I created a creepy atmosphere here by blacking out most of this picture and drawing in a small white face to make it come at you off the page.

I usually put highlights in his hair, but I didn't this time so the white of his face would stand out more clearly.

This picture represents a scene in which Naruto attacks Kimimaro. I composed it so it looks like Naruto is jumping out at the viewer.

I was really focused on perfecting Naruto's pose, but on the cover of *Shonen Jump* his left foot, which I was pretty proud of, wasn't really visible.

Also, **Naruto's facial expression might be a little too scary** (*laugh*).

I don't usually draw this kind of scary face for a front cover. It's a little too much.

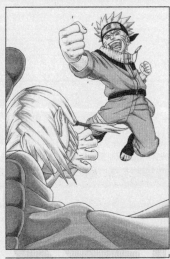

Weekly Shonen Jump 2004 No.12 Front cover

UZUMAKI

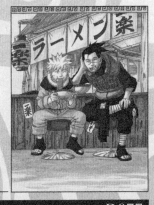

Naruto Vol.16 Front cover

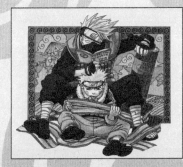

Naruto Vol. 3 Front cover

UZUMAKI NO.52 P.077

This one is of Naruto and Iruka. I thought that if I used a lot of color on the Ichiraku ramen shop in the background, then the two characters in front wouldn't stand out. So I used tones of sepia, an intermediate color that matches both warm and cool colors.

I thought that if the colors looked too flat, then I could just add more colors later. When I was finished, though, it worked out fine with just the neutral tones.

Naruto and Iruka aren't wearing their headbands here because I wanted to convey a laid-back atmosphere. I imagined that even ninja want to relax and eat ramen sometimes. I was really concerned that the **pieces of green onion were properly interspersed with the noodles** (*laugh*).

UZUMAKI NO.51 P.076

Here's Naruto being forced to study.

Kakashi is attentively watching over Naruto, who will make a break for it at the first opportunity.

But **Kakashi really has nothing to do, so he's reading *Make-out Paradise*** (*laugh*).

There's another *kakashi* (scarecrow) in the background, as if he's watching over both of them… That's not really what I intended, though.

A real Japanese scarecrow has a tight-lipped mouth with both ends turned down, in the shape of the letter *he* (へ), but I put a smile on this one's face. The whole atmosphere in this picture is kind of heartwarming.

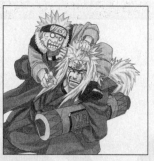

Weekly Shonen Jump 2003
No.11 Front cover

| UZUMAKI NO.54 | P.079 |

In this one Naruto is grabbing Jiraiya, pestering him to explain the techniques in the scroll Jiraiya is holding. But Jiraiya is refusing, saying that it's too soon.
…There's no particular reason why the scroll is pink. I guess I didn't have any other colors around at that time (*laugh*).
Naruto's anxious-looking eyes were originally drawn normally, but I changed them **to make them look more comical.**
In an earlier version of the image, Jiraiya's eyes were also white, but it didn't seem appropriate for both characters to have their eyes that way on a front cover. So I corrected Jiraiya's eyes.

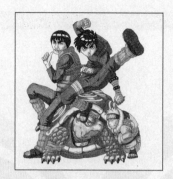

Naruto Vol. 10 Front cover

| UZUMAKI NO.53 | P.078 |

I imagine that Lee has all kinds of weapons in his backpack.
Actually **I want my characters to always carry lots of tools and weapons** just like Lee.
I wish I could draw a lot of different action scenes with Lee holding things like nunchucks.
However, while doing the series I just don't have the time…
Naruto is mimicking the ninja tortoise like a child would, being simply mystified by such a strange creature and copying it.

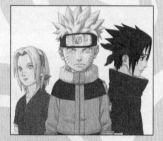

Weekly Shonen Jump 2003 No.46 Front cover

| UZUMAKI NO.56 | P.082-P.083 |

Sasuke's costume changed when he reappeared at the final match of the Chûnin Exams.
But, in terms of the color and design, **it was a bit difficult to draw Sasuke in that outfit.** That's why I went back to his original clothing when he left the village (*laugh*).

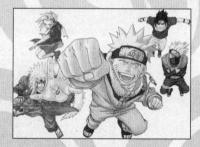

Weekly Shonen Jump 2003 No. 22 & 23, double issue

| UZUMAKI NO.55 | P.080-P.081 |

I got **a request from the editorial department to draw about 20 characters…** I thought I'd just draw as many as possible (*laugh*).
I began creating the image with Naruto and Jiraiya drawn big in the foreground. Then, I tried to add a lot of other characters, scattered around Naruto and Jiraiya. But in the end only the five regulars appeared (*laugh*).

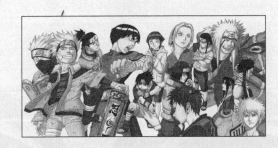

Naruto Vol.9 Front cover

| UZUMAKI NO.58 | P.086 |

This is another symmetrical composition.
Because both Neji and Hinata have kind of dark expressions, I deliberately made Naruto's posture and expression bright and vivid by **emphasizing his mischievousness.** There were originally seven scrolls for the seven days of the week on Naruto's back. However, as I drew them, I started thinking that nobody would care about such details, figured six rolls would be plenty, and erased one.
That's why Monday is missing (*laugh*).

Weekly Shonen Jump 2002 No. 6 & 7, double issue

| UZUMAKI NO.57 | P.084-P.085 |

Because this was for a pullout poster for *Weekly Shonen Jump*, I had to be careful about **not putting the characters' faces on the fold lines.**
That's why it turned into something like a shinobi collage.
I drew 12 people altogether. It's fun and relatively easy to draw figures in different sizes and in individual poses like this.

渦
巻

UZUMAKI INDEX & COMMENTS

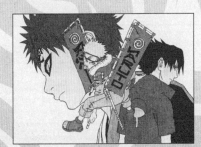

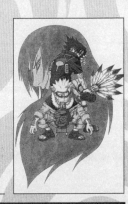

Weekly Shonen Jump 2002 No.30

| UZUMAKI NO.60 | P.088-P.089 |

I drew this with a brush.
I used a thick brush, especially for blacking out, so even a little pressure caused too bold a line. That made it difficult to draw thin lines.
I colored this picture in blurred monochromic colors so that it looks like a Japanese painting.
However, some letters from readers suggested that it looks like I cut corners. That hurt because it actually took me a lot of time and effort…
In many ways, it ended up seeming like a big waste, so I'm through with brushes (*laugh*).

Naruto Vol.7 Front cover

| UZUMAKI NO.59 | P.087 |

Around this volume, Naruto started getting involved with Orochimaru in the main story, so I created an image representing **the power and terror of Orochimaru.**
Because this is a book cover, if I'd tried to draw Naruto and Sasuke in upright poses, their faces would've appeared very small.
That's why I have them sitting down like this… I considered many different possibilities (*laugh*).

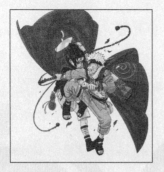

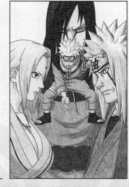

Naruto Vol.20 Front cover

Naruto Vol. 19 Front cover

| UZUMAKI NO.62 | P.091 |

This is one of my favorites.
I focused on making a symmetrical composition here too. The symmetrical elements include the chain and the cord, and Naruto and Sasuke's arms.
To keep the picture from looking cramped and static, I added the cloaks blowing in the wind. I think **Naruto's and Sasuke's tangled limbs turned out nicely.**

| UZUMAKI NO.61 | P.090 |

In this volume, Tsunade appears along with Jiraiya and Orochimaru, and Naruto gets tangled up with them. So I drew those Three Legendary Ninja on the book cover.
I put Naruto on the cover because I had to, more than for any other reason (*laugh*).
I wanted Naruto in some kind of pose, so **after some agonizing, I had him make the formal greeting of the yakuza from the movie** *Jingi.* I've seen many of the films in the *Jingi* movie series, and I like those kinds of Japanese modes and customs. [*Jingi* is a yakuza movie series that describes humanity, justice, and moral relationships between a boss and his henchman, or a master and his pupil. -Ed.]

UZUMAKI

| UZUMAKI NO.63 | P.092-P.093 |

This dragon head actually exists in China.
There's a dragon on top of the roof tiles of the wall of a house or something.
That image was so impressive to me that I wanted to put it on top of a roof, not just a wall.
The top of the roof tiles form the backbone of the dragon, and it connects the dragon's tail and face.
Naruto and the other three on the roof are wearing sashes.
Naruto's sash ties his sword to his back, and the wind is making all the sashes float on the air.

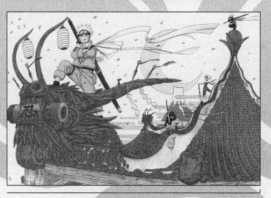

Weekly Shonen Jump 2004 No. 22 & 23, double issue

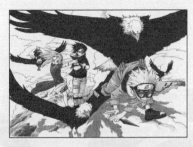

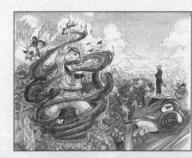

Weekly Shonen Jump 2000 No.43

Weekly Shonen Jump 1999 No.43

UZUMAKI NO.65	P.096–P.097

I wanted to draw my characters enjoying a nice flight through the clouds, so I had Naruto and his friends being carried by giant birds. I wanted to express a brisk and fresh feeling, and **I just like clouds for some reason.**
I added Naruto's goggles because he's flying high up in the air, and I just thought, "Why not?"

UZUMAKI NO.64	P.094–P.095

The colors look uneven in places because I drew this on copy paper. This was the very first illustration of the *Naruto* series, so I wanted to set the tone for the story and present some of Naruto's world.I drew a detailed landscape and then packed it full of characters and ninjutsu, so it took me quite a long time to finish.
When I look at this picture now, the sizes of the various elements seem way off. Naruto is way too big (*laugh*).
I didn't think much about that at the time and just went with the flow. It's such an old illustration, I actually don't remember it all that well… (*laugh*).
I like the way one color stands out against the background in this picture, which shows the vermilion buildings in stark contrast with the Japanese-style green mountains and trees.
I really worked in the Japanese elements here.

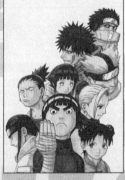

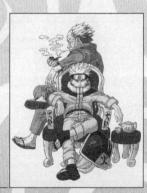

Official Fan Book Back cover

Naruto Vol.14 Front cover

UZUMAKI NO.67	P.099

I drew this picture pretty carefree, without giving too much thought to the composition or perspective.
Lee is one of the more popular characters, so I put him in the front.
Then I drew Neji and Tenten because they're on the same team as Lee. After that, I drew the rest in random order.
I drew Kiba and Tenten in color for the first time here.
It hadn't been decided yet how they should be colored in… Kiba's clothes are red here, although actually they should have been light purple (*laugh*).

UZUMAKI NO.66	P.098

Aren't there always scenes from the office, when **the boss is away and the employee sits gleefully in his chair?** This is that image.
Naruto knows the Hokage is there, but he's dreaming, "Someday this will be my seat."
And the Hokage, exasperated by Naruto, waits patiently until he's satisfied.

UZUMAKI INDEX & COMMENTS

渦
巻

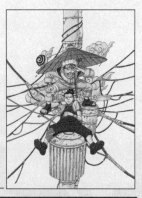

Naruto Vol.12 Front cover

UZUMAKI NO.69 P.102

I really like electric poles.

That wasn't my only inspiration, but I drew this picture with an electric pole in mind.

Shikamaru played an active part in this volume, so I put Shikamaru on the cover along with Naruto.

Rather than say I like this picture, I'll say **I'm satisfied just because I got to draw an electric pole.**

I didn't use any references to draw this electric pole. That's why the details are so random.

I wish I could draw more awesome electric poles…but there's no time…

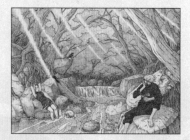

Weekly Shonen Jump 2000 No.30

UZUMAKI NO.68 P.100-P.101

There's a place like this where I grew up, and that's what I was imagining when I drew this picture. Summers there are beautiful.

But I'm so busy that I can't go there, so this picture expresses my desire to visit that place too!

I wanted to draw in the details of the background properly, but then I ended up adding so much detail that the characters came out small (*laugh*). Naruto is about to play a trick on Sakura here.

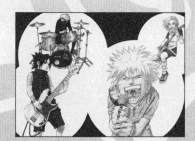

Weekly Shonen Jump 2002 No.17 Front cover

UZUMAKI NO.71 P.104-P.105

For this one, I had a really hard time getting the proportions exactly right between the characters and their musical instruments. But then when the picture actually appeared on the front cover of *Shonen Jump*, **most of the musical instruments were covered up… (*bitter laugh*).**

The bass was particularly difficult to draw.

Sakura's hairstyle didn't really turn out the way I wanted. I figured that since Sakura isn't wearing her headband here, her bangs would be in the way when she's rocking out… I wasn't sure what else to do with them, though, so I pulled them back with a hair clip (*laugh*).

Naruto Vol.22 Front cover

UZUMAKI NO.70 P.103

I featured Neji on the cover because he plays an important role in this volume.

I wanted to add some flavor to the image, so I thought I'd show Neji holding something small in his hands. But I couldn't think of anything appropriate, so I put him in a jacket instead.

I thought that Neji's normal white clothes wouldn't stand out well against the white background, so I made the jacket colorful.

But after I added ropes in red and white to the rolled-up thing that Naruto is carrying, Neji's jacket ended up looking like a *happi* coat…

They both look like people having a good time at a festival (*laugh*).

Naruto Vol.21 Front cover

Naruto Vol.18 Front cover

When I drew this picture, I was imagining ordinary kids getting together to pig out.

Choji is such a glutton, he's eating traditional Japanese treats and Western junk food at the same time. His bag is full of snacks.

Naruto is already associated with spirals, so he's eating a spiral-shaped lollipop, and he's carrying cups of instant ramen. Shikamaru only has bottles of soda in his bag.

As you can tell from this drawing, **there must be a convenience store in the Village of Konohagakure (*laugh*).**

This is a scene where Naruto is focusing the Rasengan with his right hand.

Tsunade is featured in this volume, and after spending a long time mulling over how to show her on the cover, I ended up just having her lying down.

The limited space of a book cover makes coming up with creative compositions difficult, so I often have characters lying down or bending their bodies to try to give them more substance.

This is a last resort…

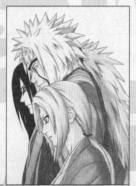

Weekly Shonen Jump 2003 No.17

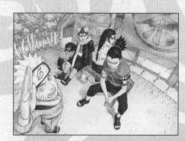

Weekly Shonen Jump 2003 No.46

I thought it wouldn't be interesting to draw the characters head-on, so I lined them up facing sideways.

Also, drawing people in profile is easier for me (*laugh*). There's no particular meaning to the order in which they're lined up.

Because Jiraiya is the tallest, I put him in the middle. Tsunade is the shortest, so I put her in front. What they are looking at…? I'm not really sure.

I made another attempt at a wide-angle lens style picture, but creating the composition was still tricky. This time, I had all the characters except Naruto sitting down, so it was much easier than my earlier attempt… Still, it took a long time.

It's difficult doing wide-angle shots.

渦巻

UZUMAKI INDEX & COMMENTS

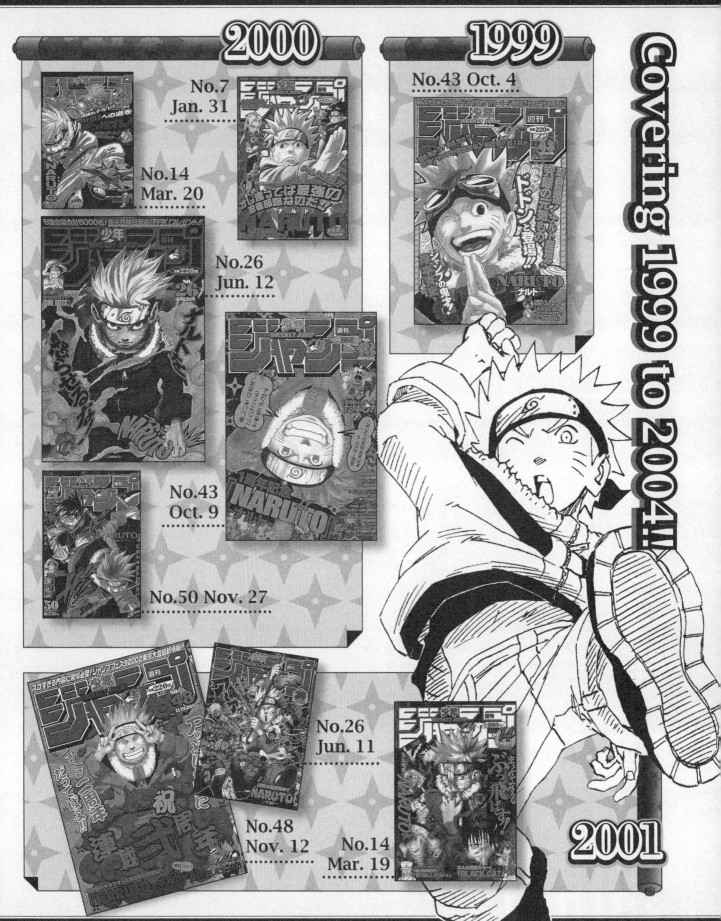

PERFECT COLLECTION

eaturing Naruto

2000

No.7 Jan. 31

No.14 Mar. 20

No.26 Jun. 12

No.43 Oct. 9

No.50 Nov. 27

1999

No.43 Oct. 4

Covering 1999 to 2004!!

No.26 Jun. 11

No.48 Nov. 12

No.14 Mar. 19

2001

Special Gallery

Here's the complete lineup of *Naruto* covers from *Weekly Shonen Jump* and *Jump* bonus issues! All 20, published between 1999 and 2004, are shown here just as they originally appeared. These mark the milestones in *Naruto*'s glorious history!

All 20 Weekly Shonen Jump cover

2003

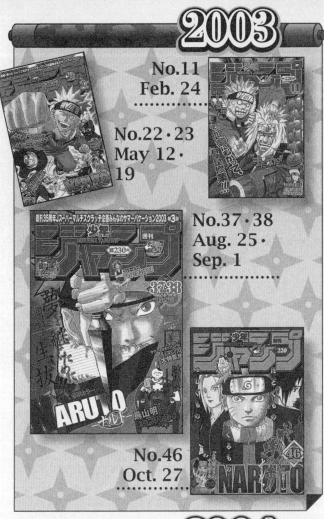

No.11
Feb. 24

No.22・23
May 12・
19

No.37・38
Aug. 25・
Sep. 1

No.46
Oct. 27

2002

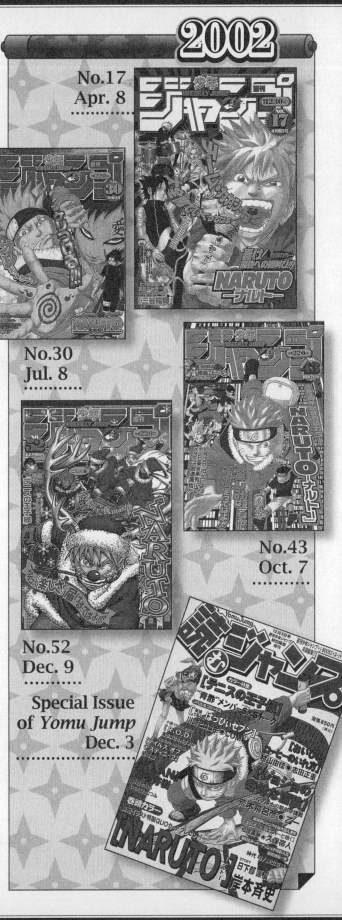

No.17
Apr. 8

No.30
Jul. 8

No.43
Oct. 7

No.52
Dec. 9

Special Issue
of *Yomu Jump*
Dec. 3

2004

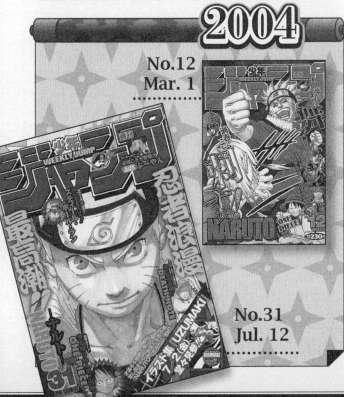

No.12
Mar. 1

No.31
Jul. 12

The creator of *Naruto* provides his insights on the eight key concepts of *The Art of Naruto: UZUMAKI*

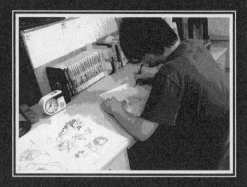

This book is sorted into eight key concepts. To understand them in greater depth, we interrogated Kishimoto-sensei and got the inside story of UZUMAKI's design!

Masashi Kishimoto reveals the secrets behind the creation of

the world of UZUMAKI

- Today, we'd like to ask you about the eight key concepts that serve as titles for each chapter of UZUMAKI.
We'd love to hear some of your secrets and untold stories behind the designs.

"Sure!"

- Let's begin with the title of the first section, Uzumaki Naruto. We assume that you read lots of manga when you were growing up; what's your idea of a great manga protagonist?

"Well, I think it depends on the characteristics and the target audience of the magazine in which the manga is serialized. To me, Son Goku of *Dragon Ball*[*1] represents the archetypal *Weekly Shonen Jump* hero, so I wanted to have a hero like Goku in my manga."

- What about Son Goku makes him stand out in your mind as an ideal main character?

"First of all, it's his straightforward way of thinking. It's also his mischievous side. Basically, he gets readers energized. They think, 'I wanna be like that.' So my ideal hero is a bit mischievous, too."

Concept

Uzumaki Naruto
(Pages 12~)

Naruto's jacket is modeled after one the author used to wear?!

Naruto refuses to grow up.
But that's what makes him so lovable!

- So...what is it that makes Uzumaki Naruto so charming?

"As you might expect, I try to incorporate into Naruto's character as many of my aforementioned ideal hero's charming attributes as possible. I always try to keep in mind that Naruto is 'simple and stupid'...(*laugh*). That's because I personally don't like smart characters very much."

- When we think of a smart character in *Naruto*, we think of Shikamaru.

"I like Shikamaru, though, because he's easygoing and doesn't show off. If there were a character with a personality like Sasuke's, but who was also very clever, I'd hate that character the most (*laugh*). It'd be difficult to identify with him... You'd be jealous of anyone that perfect, wouldn't you?"

- Was Naruto modeled on anyone in particular?

"Not really. Basically, I conceived him as childlike. But he has a little bit of a dark side too. He's lived alone—without parents—all his life and bears the burden of a harsh fate... Despite it all, however, he maintains an upbeat outlook and always gives his all in any situation. This kind of attitude makes Naruto different...and special. In short, a positive attitude is always best (*laugh*)."

- When you designed Naruto's costume, did you style it after any brand or designer, or any particular person?

"Naruto's costume was an original design based on clothes I used to wear. So I didn't do any hunting for reference materials. Designing costumes is difficult. If I were to copy an existing design, Naruto wouldn't look unique in it. If the costume were too cool, Naruto would look too pretentious and that wouldn't fit his character... I like costumes that are a little old and out of style, but still cool-looking."

- What about Naruto's speech pattern? Was that modeled on something? [In Japanese, Naruto ends most sentences with "*dattebayo*," which is sort of similar to using "you know?" to finish every sentence. -Ed.]

"That wasn't modeled on anything in particular, either. When I was thinking of a childlike phrase to use, "*dattebayo*" just came to mind. It suits Naruto's characteristics; I wanted to use this sort of verbal tic to show that he's a bit of a brat, too!"

*1 *Dragon Ball*:
Dragon Ball was serialized in *Weekly Shonen Jump* from December 1984 to May 1995. Son Goku, a Saiyan, battles on a grand scale to protect Earth.

- Tell us about the next two key concepts, Uchiha Sasuke and Haruno Sakura.

"For Sasuke, I kept the idea of him being Naruto's rival in mind while I was establishing his personality and designing his appearance. I studied rivalry by reading various kinds of manga, and I think that the relationship between Naruto and Sasuke demonstrates an ideal rivalry. To me, the cool genius is the archetypal rival character."

- Is there anything you're particularly careful about with Sasuke's behavior, in terms of keeping him in character?

"I try not to make him too emotional, whether through his behavior or his speech. I think that's about it. Besides that, I feel I can draw him freely."

Naruto and Sasuke are trying to best one another all the time, everywhere. Sasuke can't help losing his cool when competing with Naruto, can he?

- Next is Sakura. What is your ideal heroine like?

"I don't have a definite image of what a heroine should be, so even when I try to draw one, she doesn't turn out like a typical heroine. She just looks like a girl who can't understand men… That's the way it usually goes."

- Is that what makes Sakura charming?

"Probably. I didn't create Sakura to serve as the story's heroine, I suppose. I just thought it would be interesting to have a character who was slightly irritating, but who had a good head on her shoulders. I created Naruto first and Sasuke next, and then finally Sakura. But she's a great character. She's cheerful; she's a leader type. Her energy and her flirtatious spirit around Sasuke are her defining characteristics."

"Sakura hasn't acted sweet and endearing like this in a while, has she? (laugh)," says Kishimoto-sensei.

- What inspired Sakura's costume design?

"First, her leggings show that she's very active. When designing her costume, I focused on its simple silhouette and eliminated accessories and decorations as much as possible. This is a departure from the other characters' costumes, which have a lot of detail. I wanted her costume to be as simple as possible."

Should a tomboy like Sakura really be wearing a skirt…?!

Concept

Uchiha Sasuke
(Pages 26~)

Haruno Sakura
(Pages 34~)

When I designed Sasuke, I kept in mind that he's Naruto's rival. As for Sakura, I just kept her simple.

Kakashi and his students' strong personalities are the team's greatest weapons!

Concept

Cell 7 of the Village of Konohagakure
(Pages 42~)

The greater variety in their personalities, the more fun they are to watch!

- Next, we'd like to ask about Kakashi's team, Cell 7. First of all, what motivated your decision to put together teams of four—three students plus a jônin instructor?

"Basically, it's just easier to develop stories that way. It wasn't the result of trying to bring out any character's special qualities, or anything about aesthetic balance in the art."

- What do you consider an ideal team?

"I think that each member should be extreme. He or she should be outstandingly skilled at one thing but should have absolutely no aptitude at other things. Each member should have a different ability from the others and all the members together should possess tremendous power. I like that kind of team. When I was a child, I used to watch tokusatsu dramas*2 like, you know, 'The Something-or-other Five.' But on those kinds of shows, all the teammates are strong to the point of perfection. I didn't want that kind of team."

- So you like teams of the sort that you'd find in an RPG*3?

"Yeah. It's more interesting if individuals work together for the sake of the team by each assuming different roles, like wizards and soldiers. Each character stands out better that way."

- What makes Kakashi's team special?

"I guess it's the intense rivalry within the team. Lee and Neji are also rivals, but they still speak and act civilly. Lee is a good boy (laugh). Sasuke and Naruto's rivalry is different…it's more interesting."

- What makes Kakashi such a compelling leader?

"It must be his easygoing attitude (laugh). Kakashi is always totally unfazed and looks like he's half-asleep, no matter what the situation."

*2 Tokusatsu dramas:
Action/adventure TV shows for children that are heavy on the special effects. These shows typically star a team of three to five superheroes fighting a villain.

*3 RPG
An abbreviation of "role-playing game." *Dragon Quest* and *Final Fantasy* are typical video games in the RPG genre.

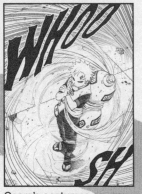

Gaara's costumes are particularly stylish. Perhaps the author obsesses over the details of Gaara's outfit more than any other character's…

Concept

Mist•
Sand•
Sound
(Pages 58~)

No matter what, I want my bad guys to make an impression!

- The next concept is "Mist, Sand, Sound." We'd like to hear the general story of the so-called "bad guys" here. What's your overall image for the villains in *Naruto*?

"Of course, villains are those who defy the heroes' values; in a diagram, the enemies are positioned opposite the heroes. But it's not as simple as saying 'the villains are the ones the heroes fight.' Sometimes the heroes have to fight people with whom they share values, so their opponents are not necessarily *villains*. When I create a villain, I don't really think about them in combat. I start by charting out their motives and values in opposition to those of the heroes."

- Zabuza and Haku were very popular villains when they appeared in the story…

"Yes. I remember drawing Zabuza as a very scary character. Haku is sort of coquettish, which is unusual for a character in *Naruto*. That might be the secret of his popularity."

- Gaara is also a popular villain. What does Gaara mean to Naruto?

"Gaara is almost like a mirror image of Naruto; they're opposites, but they're very similar. Gaara's upbringing was very much like Naruto's. He was universally rejected and ignored, living a superfluous existence*4. But Naruto and Gaara have different viewpoints on their backgrounds; that's why they come into conflict. I think Gaara is popular because he's from circumstances similar to Naruto's, so that makes him a very sympathetic character."

- You've created many of these appealing villains. What are the important elements to consider in designing a villain's appearance and attributes?

"The differences between the heroes and the villains must be obvious. That makes the story easier to follow. If readers are confused about who's the hero and who's the villain, they can't follow the battle scenes. I try to design the villains' faces and costumes so the reader can easily recognize that 'this character is a bad guy.'"

- What do you focus on in order to give these characters a typical "bad guy" look?

"Basically, I think that if they stand out, then they look like villains. Wearing a showy costume imparts a more powerful aura than wearing a plain costume; if nothing else, it makes a character more memorable. As I mentioned before, making the villains flamboyant is one of my guiding principles, in the sense of differentiating them from the heroes."

*4 A superfluous existence:
Gaara's father created him to be a killing machine. From the moment he was born, the villagers abhorred Gaara out of fear. When his power raged out of control, even his father wished him dead.

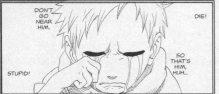

Gaara has lived life by channeling his dark past into negative power.

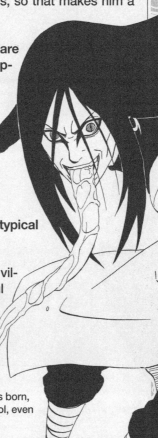

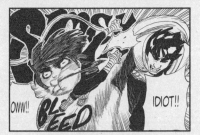

Guy and Lee share a truly bizarre master-pupil bond. Is Kishimoto-sensei trying to distance himself from them…?!

Concept

Master and Pupil
(Pages 76~)

I like the pairing of Naruto and Jiraiya.

- The next concept is "Master and Pupil." It seems as though Naruto has moved from teacher to teacher—from Iruka to Kakashi, and then to Jiraiya—in stages. Do you think that one must change "masters" throughout one's life? In other words, do you think that pupils can only learn so much from a single master, and when they have learned what that master is able to teach, they must move on to a new master in order to continue their progress?

"I think that there can be various patterns. I think, for instance, a science teacher who instructs a student for a single year is a master, and parents who take care of their children throughout their lives are masters of a different type. Various masters have appeared in *Naruto* in turn. The teaching methods also depend on the master; some masters scold their pupils. In Iruka's case, he helped Naruto grow by being the first to truly understand and respect him, and he's still Naruto's master even now."

- Guy and Lee have a very intense (and very amusing) master and pupil relationship. How did you come up with that kind of relationship?

"My gym teacher in junior high school was very passionate. He was a hot-blooded teacher like Guy, and was very funny. I liked that teacher very much."

- You mean that teacher was the model for Guy…?

"Hmm…come to think of it, my teacher was totally different from Guy (*laugh*). I wouldn't say that he's the model."

- Well, would you be happy if Guy were your teacher?

"No, I probably wouldn't get along with him (*laugh*). He's a little too intense for me."

- Out of all the master and pupil relationships in *Naruto*, which one fits your ideal best?

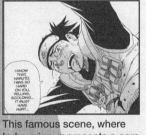

"Right now, I'm enjoying the bond between Naruto and Jiraiya*5 the most. The Kakashi-Naruto pairing is hard to beat, but the ongoing master-pupil relationship between Naruto and Jiraiya is still evolving, so it's new and fresh to me. It makes drawing them feel worthwhile."

This famous scene, where Iruka cries, represents a core trait of one type of "master."

- What do you focus on when you create a master and pupil relationship?

"It varies depending on the combination of characters. There's no absolute pattern."

*5 Naruto and Jiraiya:
Jiraiya is charged with training Naruto to perform a new and deadly technique. Jiraiya is a single-minded pervert, but he's extremely powerful. He's an effective teacher, but he maintains a hands-off approach.

How can Jiraiya maintain his dignity while being berated by his pupil, Naruto…?!

Concept

What lies ahead…
(Pages 82~)

Conveying ways of life, core beliefs and dreams through art

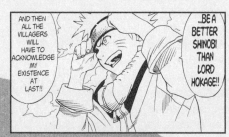

AND THEN ALL THE VILLAGERS WILL HAVE TO ACKNOWLEDGE MY EXISTENCE AT LAST!!

…BE A BETTER SHINOBI THAN LORD HOKAGE!!

Naruto pushes forward, believing in his ninja way. Even Kishimoto-sensei tips his hat to Naruto's fighting spirit!

- The next concept is "What lies ahead…." Expanding on this concept, we would like to ask you about what *nindo* or "ninja way" means to the characters in *Naruto*. First of all, what is the meaning of *nindo*?

"…Let's see…one's way of life, core beliefs, guiding principles, paths for the future, dreams…things like that."

- You mentioned a lot of things there! It's difficult to define *nindo* in one word, isn't it? The interpretation could be different depending on the person…

"Yes. *Nindo* means something like 'various life paths.' For example, some people study to become doctors because they lost a loved one to disease, and other people aim to become TV personalities out of admiration for a certain celebrity on TV. I think that everything about these various ways of living life—the motivations driving them and the goals to which they aspire—represent *nindo*."

- Right now, what is your *nindo*, Kishimoto-sensei?

"For the time being, a major goal is to complete *Naruto*. I can't run away from this goal halfway through."

- Then, let's say you've completed *Naruto*, what *nindo* is in store for you next?

"There're many things I want to do. I'd like to organize all of my accumulated research data, I'm interested in working in a totally different genre, and I want to play more games (*laugh*). I really want to do a ton of different things. But I'm a manga artist, so basically I think I'll continue to work on manga."

- Which character do you identify with most in terms of his way of living life?

"I guess it's gotta be Naruto. He fails at many things, but still keeps trying. He doesn't know whether or not he'll succeed at something, but he forges ahead on blind faith… I can sympathize with those traits. Others can excel effortlessly at some things from the very start, but Naruto can't.

- Do you have any real-world role models whose life you wish you had for yourself?

"I don't have anyone like that in particular. But I like people who talk about big dreams. They're cool. Besides that, since it's my job to draw, I have a lot of respect for people who have the same kind of job, such as animators*⁶ and manga artists, as you might expect."

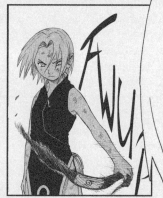

Sakura struggles to become the greatest kunoichi while keeping a positive attitude. Each person's *nindo* is unique.

*6 Animators:
Drawing for animated shows is well known as a physically demanding job. It requires top-level drawing technique and a professional spirit in order to accomplish perfect work.

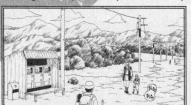

Looking at this tranquil scenery could make anyone feel nostalgic for home.

*7 Okayama:
Kishimoto-sensei is originally from Okayama prefecture. He grew up in a tranquil town and has loved drawing ever since he was a child. Perhaps the true roots of the Village of Konohagakure lie in Okayama…?!

Concept

The Village of
Konohagakure
(Pages 94~)

No guns or
vehicles

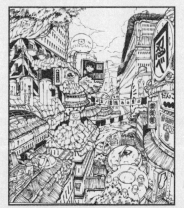

The peculiar scenery, which looks like a mixture of past and present, is compelling…

-Finally, we move on to the last concept. We'd like to ask you about Konohagakure, which is the central setting of the story. What inspires you when you're drawing the village? Is it the scenery around your parents' house in Okayama*7?

"Maybe so. Actually, I created the design for the village pretty spontaneously, without much thought. But I might've been unconsciously drawing the scenery based on Okayama."

- In what time period is the story set? Sometimes it looks like ancient times, but sometimes we see modern things like convenience stores…

"I suppose that the times are not so different from that of today. Maybe a little before the present day?"

-What about the location? Is it Japan? If so, which prefecture in Japan…?

"The location is totally original. I didn't set the story in any specific place. It's just a place in my head… If I had to specify, the climate and topography might be like Kyoto's. But even that's speculative because I've never actually been to Kyoto (laugh)."

- Do you use any reference materials?

"I like Japanese culture and do research on it in my own way. So I have lots of things that I like to refer to, such as family crests and folding fans… I often visit Japanese gardens and go to Kabuki performances."

- At first glance, it seems like anything goes in the world of Naruto. But have you set any hard, non-negotiable rules?

"One rule is that there can't be projectile weapons*8 such as guns in the story. No ninja would have a chance against the power of a gun. Gunpowder alone has appeared in the animation, and I didn't mind that, so gunpowder by itself is okay. Also, I don't draw vehicles like airplanes in the story. To some extent, I have to avoid drawing technological weapons that can be used for war… For instance, if missiles could be used, the story would be over (laugh)."

- Thank you very much for your time today.

"Thank you!"

Boats are one of the few types of vehicles that appear in the story. This boat is okay because it's man-powered!

*8 Weapons
You won't find any projectile weapons other than ninja weapons in Naruto. The only projectile weapon that appeared in the story was a crossbow that some people, such as Inari, have used.

Whenever people ask me whom I respect, I answer, "People who are good at drawing."

Since I'm a manga artist, I've seen many people's drawings.
I always wonder, "Why are there so many people who are good at drawing? How can they draw so well?" I envy them, and sometimes I feel resentful.
It's not just manga artists. I'm continually impressed when I see outstanding drawings by animators, illustrators and game character designers.
And from the bottom of my heart, I think, "Rats… I really wanna get better at drawing…»

Sometimes I feel sick about my poor drawing ability.
When I create a drawing, I realize how far I am from my goal and I get angry with myself for not being there yet.
I'm shocked and disappointed by the vast difference between where I am now and where I want to be.
Then I try to convince myself:
"I'm a manga artist. So it's not only about drawing. I'm an illustrator, but I write stories as well… So if I'm not so good at drawing, it's okay…"
…But…I know that deep down I'm still frustrated.

There really are so many people who are good at drawing.
I honestly have a long way to go, so I feel kind of embarrassed about taking this opportunity to publish my own art book… But here it is… Ha ha ha (*laugh*).
Anyway, thank you very much for buying my art book!

Masashi Kishimoto

UZUMAKI

UZUMAKI –NARUTO ILLUSTRATION BOOK– © 2004 by Masashi Kishimoto. All rights reserved. First published in Japan in 2004 by SHUEISHA Inc., Tokyo.
English translation rights in the United States of America and Canada arranged by SHUEISHA Inc. The stories, characters and incidents mentioned in this publication are entirely fictional.

No portion of this book may be reproduced or transmitted in any form or by any means without written permission from the copyright holders.

Printed in Singapore

Published by VIZ Media, LLC
P.O. Box 77010
San Francisco, CA 94107

The Art of SHONEN JUMP Edition
10 9 8 7 6 5 4 3 2 1
First printing, October 2007

The Art of Naruto: UZUMAKI
The Art of SHONEN JUMP Edition
···

CREATED BY
MASASHI KISHIMOTO
···

Translation/Riyo Odate and Kyoko Shapiro,
HC Language Solutions, Inc.
English Adaptation/Ian Reid, HC Language Solutions, Inc.
Design/Yukiko Whitley
Design Assistance/Andrea Rice
Editor/Frances E. Wall

Editor in Chief, Books/Alvin Lu
Editor in Chief, Magazines/Marc Weidenbaum
VP of Publishing Licensing/Rika Inouye
VP of Sales/Gonzalo Ferreyra
Sr. VP of Marketing/Liza Coppola
Publisher/Hyoe Narita

www.viz.com

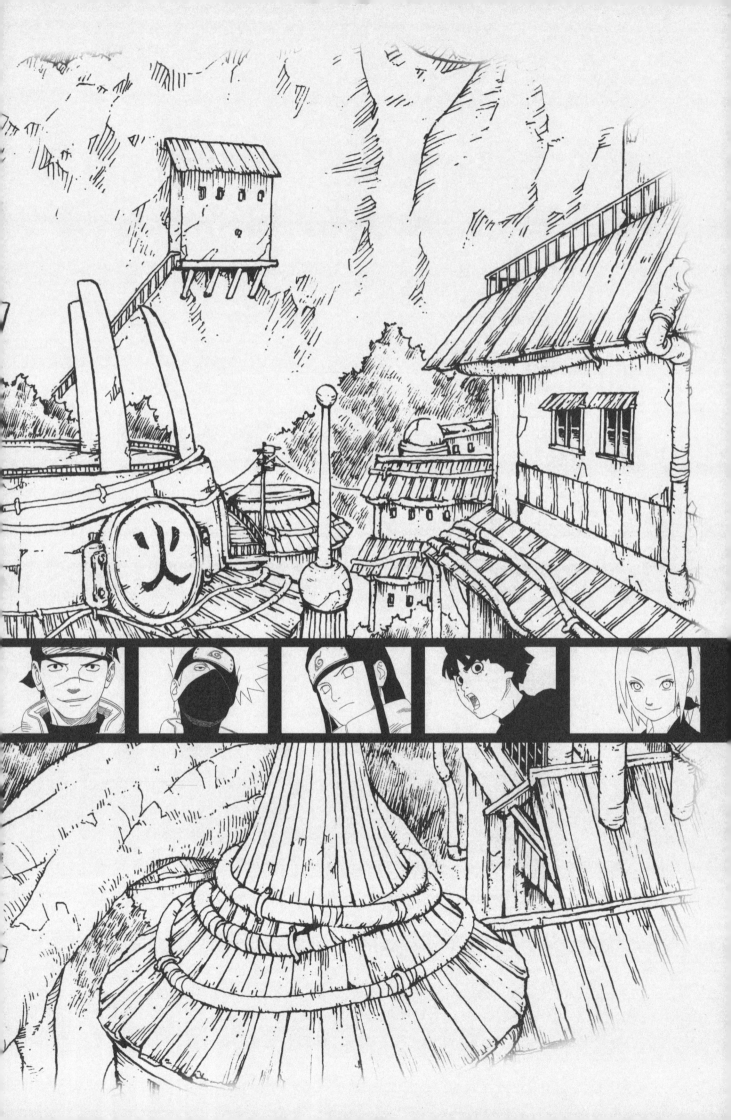